Marine Painting

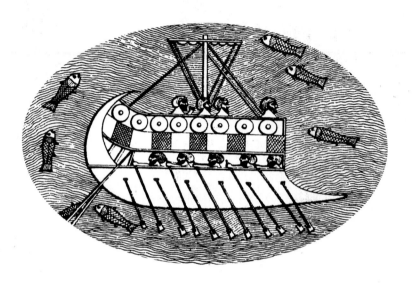

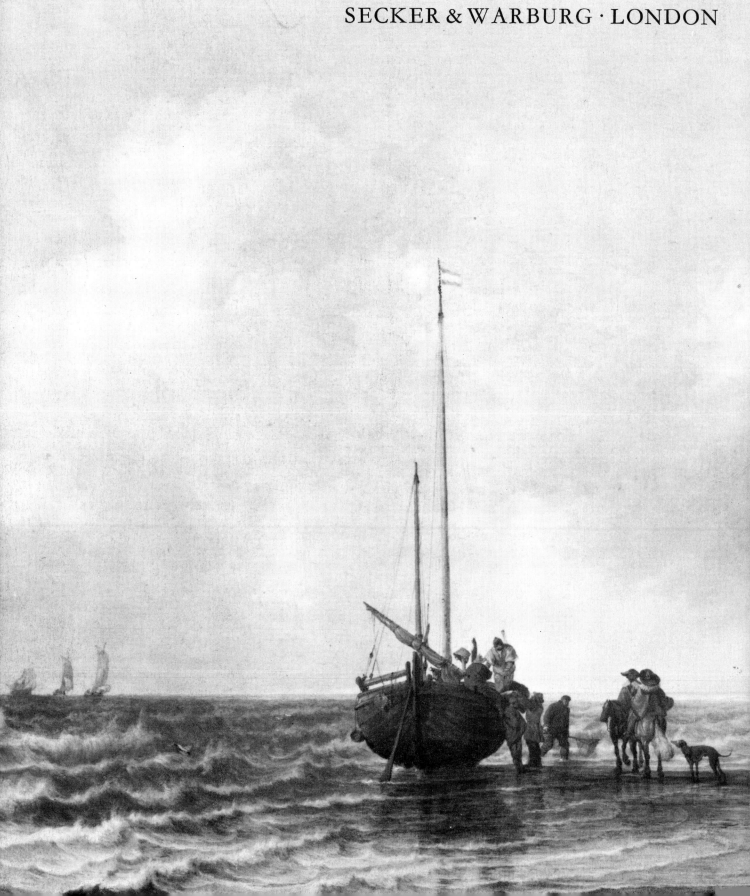
SECKER & WARBURG · LONDON

William Gaunt

Marine Painting

An historical survey

First published in England 1975 by
Martin Secker & Warburg Limited
14 Carlisle Street, London W1V 6NN

SBN 436 17315 8

Designed by Ruari McLean Associates, Dollar, Scotland

Printed in Great Britain by
Lund Humphries, London and Bradford

(frontispiece)
Simon de Vlieger. Beach at Scheveningen.
1633. Oil on canvas, 27 × 42 in. Greenwich,
National Maritime Museum.

Contents

Illustrations

6

9

SOURCES OF PHOTOGRAPHS: Bulloz, Paris, 188; Ferrers Gallery, London, 141; Giraudon, Paris, 10, 24, 34, 54, 74, 78, 79, 83, 89, 185, 190, 198, 222, 237; André Held, 9; Michael Holford 4; Mansell Collection, 8, 16, 21, 25, 75, 77; Mas, Barcelona, 13; Hugh M. Moss Ltd, 215, 216; Royal Academy of Arts, 112; Scala, Florence, 5, 6, 18, 19, 20, 46, 65; Eileen Tweedy, 3, 29, 45, 64, 99, 100, 102, 118, 123, 124, 126, 130, 144, 145, 177, 208, 213, 223, 235

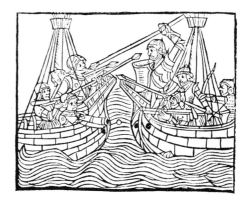

Foreword

The sea and ships have made a fascinating appearance in pictorial art from ancient times onward, though up to the sixteenth century usually as detail accessory to a main theme of some other kind. They provided illustration called for by mythological or Biblical stories in which there was maritime incident. This early history, before the emergence of marine painting as an independent genre, is here outlined in an introductory chapter.

Specialization developed in the periods of intensive competition between the maritime countries in sea-borne trade and overseas expansion so often accompanied by naval warfare. Pictorial records were needed of battles at sea, voyages of discovery, and celebrated ships. Yet these special purposes did not preclude Dutch painters of the seventeenth century and English painters of the eighteenth from producing pictures that can be appreciated as works of art as well as historical documents. It is likely that some painters have been underestimated because of their documentary role, even so talented an artist as Willem van de Velde the Younger. But the subject would be too narrowly treated simply as a record and without reference to the broader view of masters who have excelled equally in landscape and seascape. Nor is the distinction between the two always clear cut. The tidal river with its sea-going craft may be reasonably assigned to the marine category. Similarly, coastal scenes with the sea as background and pictures of ports and harbours as viewed from the water claim inclusion.

In that age of expansion, the nineteenth century, a new generation of ship portraitists chronicled the performance of record-breaking tea-clippers and depicted the novel forms of early steamships. Credit is due to their careful documentation. But expansion had another aspect in the work of great artists who found the sea, with or without ships, newly inspiring as an element. The variations and subtleties of light, space, colour, and movement were freshly studied without recourse to the conventions of the past. Turner, a marine epoch in himself, affords the supreme instance of one for whom the sea at every stage of his career was a vital complement to his view of the terrestrial scene.

The 'discovery' of the sea, as it may be called in the range of pictorial suggestion that opened up, is signalized also by the works of artists from Constable to Whistler in which atmospheric effect was beautifully rendered. Even so, the various ways of interpreting the sea in pictures were not exhausted. The Romantic mood, as in the work of Caspar David Friedrich, made it the vehicle of mystery and philosophic contemplation. In terms of critical appreciation, a discovery of modern times is the quality of the 'naïve' painter, not professionally skilled and often anonymous. Many pictures of ships and the sea by artists of this primitive order are astonishing in their vividness of line and colour.

The twentieth century has differences of direction to be taken into account. The official commissions of the two world wars encouraged the production of many

paintings and drawings of specifically naval interest. Otherwise, the tendency of modern art towards free personal expression or some purely aesthetic or abstract concern might be thought to have eliminated the marine genre like other objective types of painting. Yet there are many modern masters whom it would be absurd to classify as marine painters who have given us splendid visions of the sea and its ships, incidental to other aims, that add a wide variety of treatment.

It has seemed desirable also to include some account and illustration of marine art in the Far East and especially as practised by Japanese masters. In this genre, realized in the form of both painting and colour print, they display all the verve and decorative sense that in the later years of the nineteenth century came as a revelation to Europe.

I

From ancient times to the sixteenth century

It is not surprising that the earliest examples of marine painting come from the centre of ancient civilization, the Mediterranean. A picture forms in the imagination of the busy traffic of the inland sea in that long stretch of time from the fourth millennium B.C., when a sail made its first appearance on a prehistoric Egyptian vase, to the period, about the beginning of the Christian era, when scenes from the *Odyssey* were a fashionable form of Roman mural decoration. Characteristic types of warship and merchantman can be distinguished. The beauty of shape that at all times seems to belong to the ship as an object carefully adapted to its purpose is reflected in the linear elegance of both Egyptian and Greek art.

The artists of Egypt, always concerned with the familiar objects believed to retain their use in the hereafter, mainly portrayed the graceful river-boats of the Nile. Their pictures of sea-going vessels were fewer, but there is a like grace in representations of the slender ships with lotus-bud ends and broad papyrus sails such as Queen Hatshepsut despatched along the Red Sea, *c.*1500 B.C., to open trade with the regions of East Africa.

As a form of decoration and illustration combined, war craft and merchantmen were motifs that the Greek artist-potters frequently made use of in the ornamentation of vases and bowls. In the period of geometric art, about the ninth to eighth centuries B.C., they painted, in simplified outline, slender warships as light in weight, it may be assumed, as those the Homeric heroes, with no great exertion, had been able to heave onto the shore. They added the later feature of warship design: the beaked projection that enabled a swift vessel to ram its opponent. The black-figured vases of the sixth century B.C. contrast the purposeful litheness of the warship with the heavier build of the merchant ship designed to transport cargoes of wine, grain, pottery, and weighty loads of stone and marble as well as to carry passengers. The decoration of a sixth-century bowl in the British Museum dramatically shows a pirate craft overhauling one such 'broad-beamed, black-hulled merchantman' as Homer had long before described.

A masterpiece of the Attic black-figure style, *c.*535 B.C., is the celebrated 'Dionysos' cup, signed by Exekias (Museum für Antike Kleinkunst, Munich). Exekias was both potter and painter and one of the most distinguished of those known to us by name. As a potter, he signed a number of vases and his signature on two, one in Berlin and the other in the Vatican, attests that he decorated as well as fashioned them. The design of 'Dionysos sailing' on the inner red-glazed surface of the cup is a superb example of his ability to animate a delicate linear style. The vine that wreathes round the mast is a decorative feature emblematic of the wine-god with no relation otherwise to his voyage afloat. But though Exekias makes no effort to include even a conventional rendering of water, he conveys the sensation of sea in a subtle way. The boat with the long curve that aptly sums up the elegance of the ancient galley seems actually to sail. The dolphins around, with a grace of

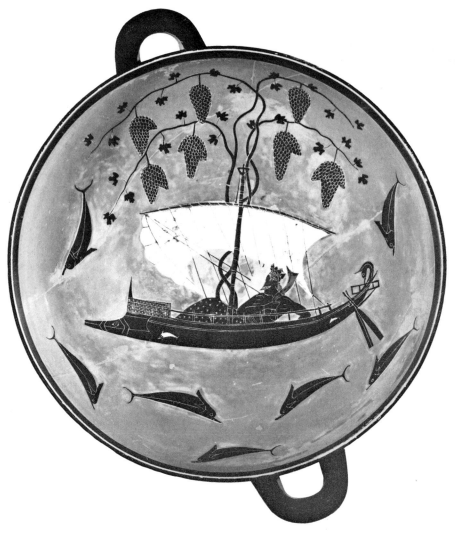

form matching that of the boat, seem to leap and frolic in a sea that is invisibly present.

The Greeks, always more interested in the sea and ships as a motif in art than such other maritime peoples as the Phoenicians and Cretans, would appear to have turned, in the Hellenistic period, to paintings of a more elaborate kind than the artist-potter's silhouettes. Compositions of figures, harbours, ships, and marine backgrounds recalling the wanderings of Odysseus probably set a style and provided models for the mural painters to copy in the period of Roman ascendancy. Works of this kind frequently adorned the public buildings and the villas of wealthy Romans in the first century A.D. Artists portrayed in comparatively realistic fashion the Roman biremes or triremes with their rhythmically working banks of oars. They painted ships at anchorage against a background of palaces, temples, and monuments in free and decorative style already curiously resembling the fanciful scenes that Guardi was to paint in the eighteenth century.

The series of scenes from the *Odyssey*, preserved at Rome in the Vatican Library, is remarkable in the suggestion of three dimensions, equally so in the sense of strange adventure. In an age of primitive navigation, to leave the familiar coastal routes for the open sea where nothing but sky and water was to be seen and without the guide of compass and chart, was to journey into the unknown. Such

islands as eventually hove into view were objects of mystery, readily credited with magical associations. The painter was able to convey mystery and wonder by the very bleakness of the rocks of fantastic form beneath which the Homeric galley moored. The encounters of Odysseus with the supernatural in various forms were fit subjects for the artist, none more so than the well-planned escape from the lure of the sirens' liquid song by Odysseus bound to the mast and his oarsmen deaf to enchantment through the wax plugged in their ears.

In the medieval art of northern Europe, ships and the sea sometimes appeared in the record of contemporaneous events, sometimes in illustration of Biblical episodes. The Channel crossing had its significant part in the tense drama unfolded in the Bayeux Tapestry, probably made in England for Bishop Odo of Bayeux towards the end of the eleventh century when the events that led up to the Norman Conquest were still fresh in memory. The style of the great period of Anglo-Saxon art was used with a Norman bias in the effort to demonstrate that Harold of England was in the wrong, a traitor in fact to his feudal obligations to Duke William of Normandy. The naval scenes include Harold's embarkation at Bosham *en route* for Normandy; his return to England after, as the Norman version had it, taking the oath of allegiance to Duke William; the building of the invasion fleet; and the arrival of the Conqueror at Pevensey prior to the Battle of Hastings. The ships so vividly and decoratively portrayed, with raised stern and dragon-head prow, adhered to the pattern of those in which the Norsemen had travelled far and wide. The rendering of the sea was by arbitrarily curving lines but even these had the expressive vigour belonging to the unique work as a whole.

The monastic painter of the early Middle Ages, remote in his studio-cell from the material world and little inclined or fitted to represent it realistically, had his own naïve way of solving the problem set by a subject such as that of Jonah swallowed by the 'great fish' (usually assumed to have been a whale). An instance is the version of the subject in a twelfth-century bestiary preserved in the Bodleian Library at Oxford. There is none of the secular keenness of observation that the designer or

3 *Egyptian mural painting. The Vice-Regal Barge. Detail from tomb of Huy, Thebes. c.1360 B.C. Copy by Mrs N. de G. Davies, London, British Museum. The boats used on the Nile were also adapted with mast and sail to coastal expeditions.*

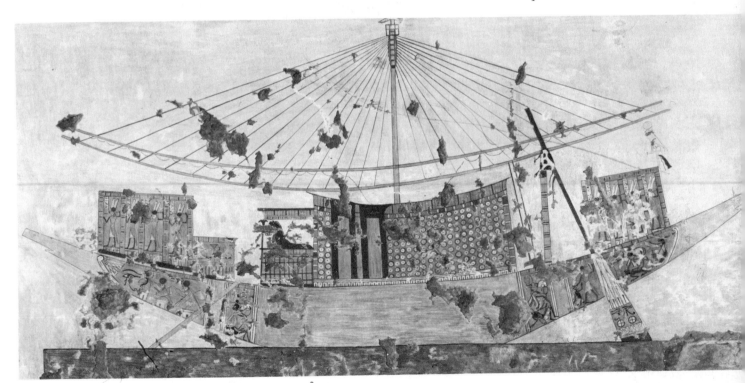

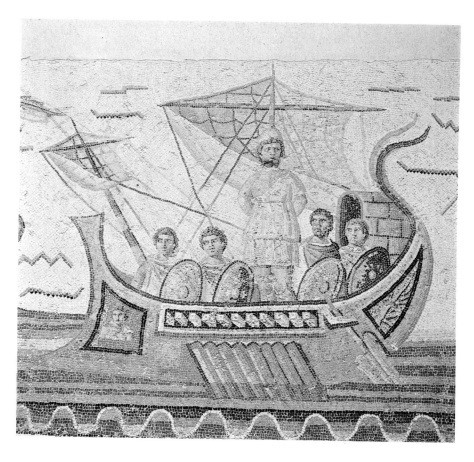

4 *Ulysses tied to the mast. Detail of Roman mosaic from North Africa. Tunis, Bardo Museum. The* Odyssey *was a prime source of subjects for artists in the ancient world, making for such varied interpretations as that of the Greek vase-painter (p.14) and the Roman mosaicist's more phlegmatically realistic approach.*

designers of the Bayeux Tapestry had shown (secular even though the tapestry had hung during the Middle Ages in Bayeux Cathedral). Instead, the artist had a very rudimentary notion of a ship, a still more abstract conception of sea. In the reduction of the material world to an abstract system, there was an element of the spiritually-orientated doctrine that Islamic art also displays. A likeness may be found in the summary pattern doing duty for sea in a fourteenth-century manuscript (Edinburgh University) which illustrated the story of Jonah.

The development of the secular manuscript in the later medieval period brought with it new richness of colour, a keener observation of material things, and pictorial comment on the growth of sea-borne trade and the spirit of geographical discovery. A warship depicted in a fifteenth-century manuscript of the Chronicles of Froissart (British Museum) gains beauty from its heraldic brightness of colour. A view of Venice with its shipping in an English manuscript of *c.*1400 of Marco Polo's *Livre du Grand Caam* (Bodleian Library, Oxford) has much to tell of the already great centre of relations by sea between West and East. The artist conjures up the scene as it might have been more than a century earlier when Marco Polo, with his father and uncle, embarked on the first stage of their journey to the land of Kublai Khan. Quaintness of perspective and sumptuous colour enhance the fairy-tale vision of gothic palaces; ships with their raised poop and stern and castle-like crows-nest are carefully detailed; there seems an effort to distinguish between the sinuous ripple of canals and the waves of more open water.

In a number of fifteenth-century miniatures the ship, as it might have been seen from the battlemented walls of a Flemish city such as Bruges long dependent

16

Scenes from the Odyssey. Roman mural
paintings of the first century B.C. **5** (above)
The Lestrygonians attack the ships of
Odysseus. **6** (below) The Visit to the Under-
world. Rome, Vatican Library.

7 *The Expedition of the Duc de Bourbon to Barbary. Painting in a French MS. of the* Chronicles of Froissart. *Late fifteenth century. London, British Museum (MS. Harley 4379 fo. 60ᵛ).*

on maritime trade, is a distant emblem of the source of civic wealth. Thus ships appear in a delightful detail of a miniature by Simon Marmion in a manuscript of *Fleur des Histoires*, a fifteenth-century collection of stories of ancient and sacred history written for the Duke of Burgundy by Jean Mansel (Brussels, Bibliothèque Royale). Though the scene is imaginary and subsidiary to a religious theme, vessels and walled city clearly enough evoke a Netherlandish reality. The delicacy of style is typical of the artist, Simon Marmion born at Amiens, active at Valenciennes between 1458 and 1489, and celebrated as 'the prince of illuminators'.

The painters of frescoes and panels, whose main function was to deal with religious themes, had less opportunity than the miniaturist of including the extra detail that made a pleasant pictorial 'aside' on the manuscript page. Unity of effect was more important even in a highly finished work. Yet there were subjects in which, far from interfering with this unity, ships and the sea had a principal and necessary part. The artists of the late medieval and early Renaissance periods saw them with an innocent eye but an eye alert at the same time for decorative effect.

8 *The Port of Classis. Detail of Byzantine mosaic. Sixth century A.D. Ravenna, S. Apollinare Nuovo.*

19

9 *Etruscan fishing. Detail of Etruscan mural painting from a tomb at Tarquinia.* c.520–510 B.C.

A delightfully naïve example of the late-gothic, North-German school is a painting made for the altar of the former Convent of St John at Rostock by an unknown master, *c.*1420, of the return journey of the Three Kings, by boat (Rostock Municipal Museum). One of the first German works to include landscape and seascape it is child-like in its odd perspective and proportions but the ships are drawn with a precise and determined hand and the waves, resembling miniature mountain peaks, communicate the intensity of the artist's effort to render their foamy crests and rise and fall.

In Italy, the early Renaissance painters seem to have enjoyed interpreting legends of St Nicholas, the patron saint of sailors as well as of merchants, scholars, and children (for whom he was later converted into the benevolent figure of Santa Claus). The Bishop of Myra in Lycia, St Nicholas, is said to have been persecuted and imprisoned under Diocletian, but released in the reign of Constantine. It was not until the eleventh century, however, when the remains of the saint were transported to Bari on the Italian coast that legends concerning his life and tales of miracles became numerous. Three hundred years later they were well enough remembered to be a subject for the Sienese painter Ambrogio Lorenzetti (active 1319–48). In one of the scenes from the 'Legend of St Nicholas' (Uffizi Gallery, Florence) ships and sea are painted with the beautiful refinement of the Sienese style. Not uncritical, generally speaking, of the artist brothers Ambrogio and Pietro Lorenzetti, the connoisseur, Bernard Berenson, could exclaim with enthusi-

asm for this work, 'where is there more magic than in that most precious panel of the Uffizi in which Nicholas of Myra, standing by the rock-bound sea, fronts the setting sun?'

Versions of storm at sea, rebuked and stayed by the miraculous intervention of St Nicholas, were the fascinating later products of the Florentines, Bicci di Lorenzo (1373–1452) and the Sienese Giovanni di Paolo (c.1403–82), both treating the theme in a gothically naïve manner but with much imagination. Bicci's version, painted as part of an altar-piece for the Church of S. Niccolo in Caffagio, Florence (destroyed in the eighteenth century) gives full value to the lines of the ship, its sails rent by the storm and a feeling of liquidity to the water. He makes a dramatic contrast between the star-spangled firmament across which the saint sails through the air and the dark cloud retreating before him (Ashmolean Museum, Oxford). The same subject from a dispersed altar-piece by Giovanni di Paolo (the fragment being now in the Philadelphia Museum of Art, Johnson Collection) is treated in a more bizarre fashion but is no less striking in imaginative quality. The waves are stylized into green cones, the rigging torn from the masts floats above in mid-air, the result is splendidly unreal and at the same time symbolically pregnant with reality.

Tendencies observable in the fifteenth to sixteenth century were the growing importance of the background in ostensibly religious subjects and the contemporary aspect given to legendary themes. The work of the Flemish painter Joachim Patinir or Patenier (c.1480–1524) marks the rise of landscape as a main theme, often setting land and water in a panoramic relation. This artist worked at Antwerp and his popularity may be gauged from the number of pictures attributed to him, many of which were possibly by pupils or imitators. A characteristic subject, it is true, was river rather than ocean, rocky shores and broad streams often suggesting the region of the Meuse from which he probably came. At the same time, the greenish-blue translucence of waters stretching to an infinite distance in his 'Charon crossing the Styx' (Prado, Madrid), is decidedly marine.

A contemporary outlook is evident in the versions of the Legend of St Ursula

10 *Duke William's fleet coming to Pevensey. Section of the Bayeux Tapestry. Late eleventh century. Bayeux, Calvados, Anglo-Saxon in syle. Embroidered on linen with woollen threads, the total dimension is* c.231 ft×19½ in., *made up of several pieces of different lengths.*

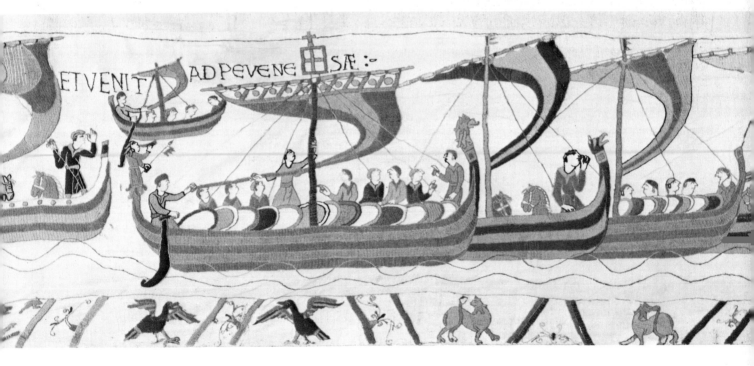

11 *Jonah and the Whale. Manuscript painting from an English bestiary. Late twelfth century. Oxford, Bodleian Library (Ashmole 1511 fo. 86ᵛ). Conventional treatment of sea and fish link this with an Eastern version of the subject (see below).*

12 *Jonah and the Whale. Islamic manuscript painting from* The Universal History of Rashid al-Din. *Edinburgh, University Library (MS 20 fo. 23ᵛ).*

22

by two such masters as Hans Memlinc and Vittore Carpaccio. It would have been impossible to picture with any historical accuracy events so vague in date and improbable in circumstance as St Ursula's lengthy sea journey in the supposed company of 11,000 virgins, ending with the massacre of them all by the Huns at Cologne. Memlinc at Bruges and Carpaccio at Venice settled the visual problem simply by translating dress, the saint's ports of call, and the ships in harbour into terms of their own day. Memlinc (c.1430–94), an artist probably of German origin, had a long association with Bruges where he settled when about 30. Though most products of his prosperous career were altar-pieces with many figures and portraits executed with great refinement of colour and detail he produced a masterpiece of a unique kind in the Reliquary of St Ursula (Hospital of St John, Bruges). A dazzling combination of handicraft and painting, the reliquary, shaped like a Gothic chapel in miniature, was embellished with his rendering of the Ursula legend including Flemish ships of the type he was familiar with at Bruges and figures in the luxurious apparel of the time, the fate of the female company being almost lost from view in the brilliance of colour.

Carpaccio (c.1455–1526) at Venice, was much occupied with the narrative cycles that the fraternities of Venice required for the decoration of their halls, or *scuole*. The most celebrated of these paintings in series are the nine works in which he detailed the story of St Ursula as related in the *Golden Legend* of Jacopo Voragine. The cycle, painted 1490–5 for the Scuola di Sant'Orsola, now in the Accademia, Venice, reflects Venetian life just as Memlinc reflects that of Bruges. Carpaccio's detail evokes the city's appearance with great precision after the manner of the brothers Gentile and Giovanni Bellini. The Basin of St Mark and its shipping

13 *Joachim Patenir. Charon crossing the Styx. Wood panel,* 25¼×40½ *in. Madrid, Prado.*

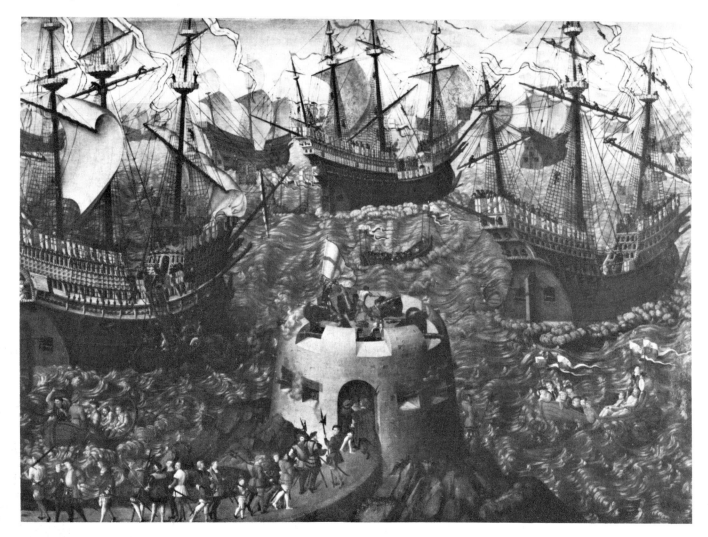

14 *Embarkation of Henry VIII at Dover. Detail of the anonymous painting, c.1550. Canvas, 66½×135¾ in. Royal Collection, reproduced by gracious permission of Her Majesty the Queen.*

is portrayed in one scene with all a patriotic Venetian's affection.

Great artists later in the sixteenth century made the sea the vehicle of emotional expression or even of philosophic thought. A vivid sensation of storm is given in 'St Mark, St George and St Nicholas save Venice from the Hurricane' (Accademia, Venice). The picture was first attributed by Vasari to the great innovator Giorgione, though its authorship has been the subject of debate. It may have been an idea of Giogione's worked out by other Venetians or possibly, as some experts have suggested, the result of collaboration between Paris Bordone and Palma Vecchio, both of whom were influenced in style by Giogione. Beyond doubt is the force imparted to its surge of movement. Though the demonic powers threatening saints and city are personified, the conflicts of light and dark in sky and sea are still more impressive.

Philosophic calm and furious intensity are both to be found in those great works by Pieter Bruegel the Elder where the sea appears. They represent only one phase of the comprehensive view of nature that makes him the greatest of the Netherlandish artists of his time, but contribute memorably to the total effect of his work. Born, it is assumed, in the village of Bruegel in north Brabant, at some date between 1520 and 1530, he spent his apprentice years at Antwerp in the house of the painter

and decorative designer Pieter Coecke van Aelst. He paid the customary visit to
Italy on coming of age, going as far as Sicily, though more interested it would
seem by the scenery on his way than in the paintings of the Italian masters.

On his return to Antwerp, Bruegel worked for Jerome Cock, painter, engraver,
print-seller, and picture-dealer, much of his prosperity deriving from the sale
of prints suited to the popular taste of the time. Many of Bruegel's designs catered
for the liking for satire and allegory in which he adopted the fantastic style of
Hieronymus Bosch, but his engravings included a number illustrating different

15 *Defeat of the Spanish Armada. Anonymous design for tapestry, 44×56½ in. Greenwich, National Maritime Museum.*

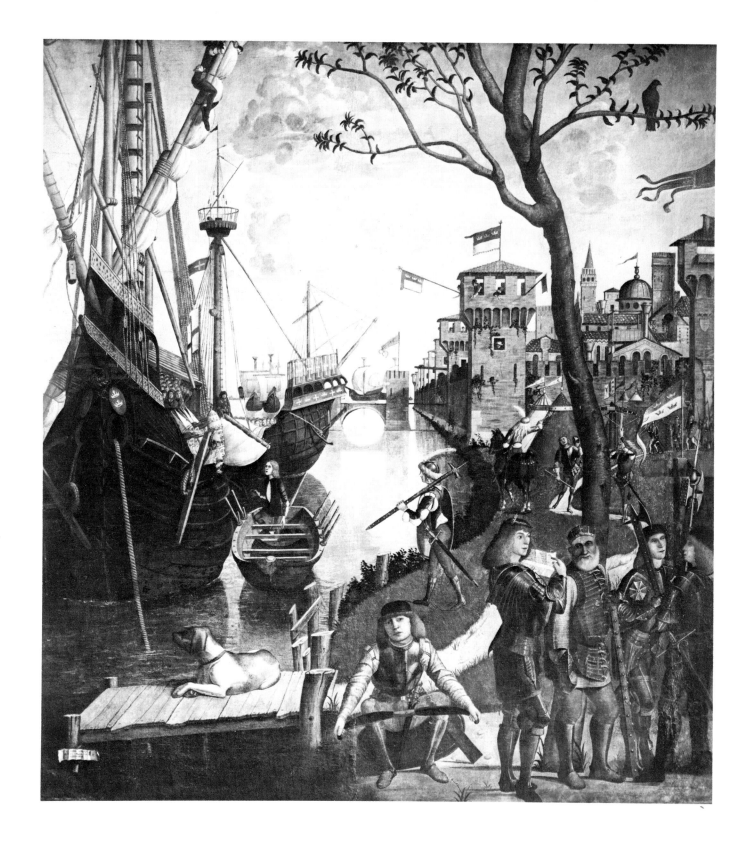

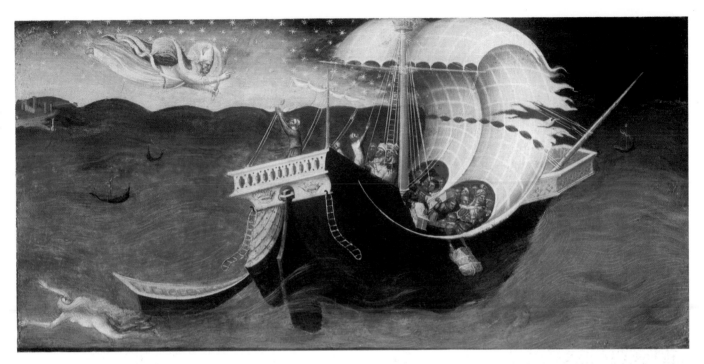

17 *Bicci di Lorenzo. St Nicholas Rebuking the Tempest. 1433. Panel from altar-piece, 11x23 $\frac{5}{16}$ in. Oxford, Ashmolean Museum.*

(facing)
16 *Vittore Carpaccio. Scene from the Legend of St Ursula Cycle. 1490–5. The arrival of St Ursula and her company of virgins at Cologne is pictured by the Venetian artist in terms of his own time, including the carefully observed ships. Venice, Accademia.*

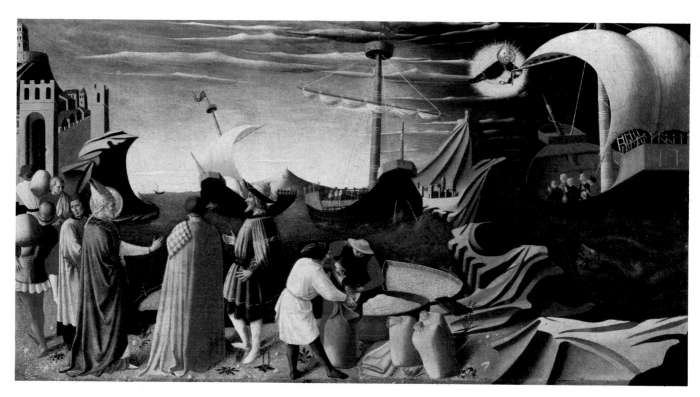

18 *Fra Angelico. The Bringing of grain to Myra. From the series of the Miracles of St Nicholas. 1437. Panel, 13×23⅘ in. Rome, Vatican Picture Gallery.*

19 *Vittore Carpaccio. The Legend of St Ursula. Detail of ships from The Wedding. 1490–6. Oil on canvas. Venice, Accademia.*

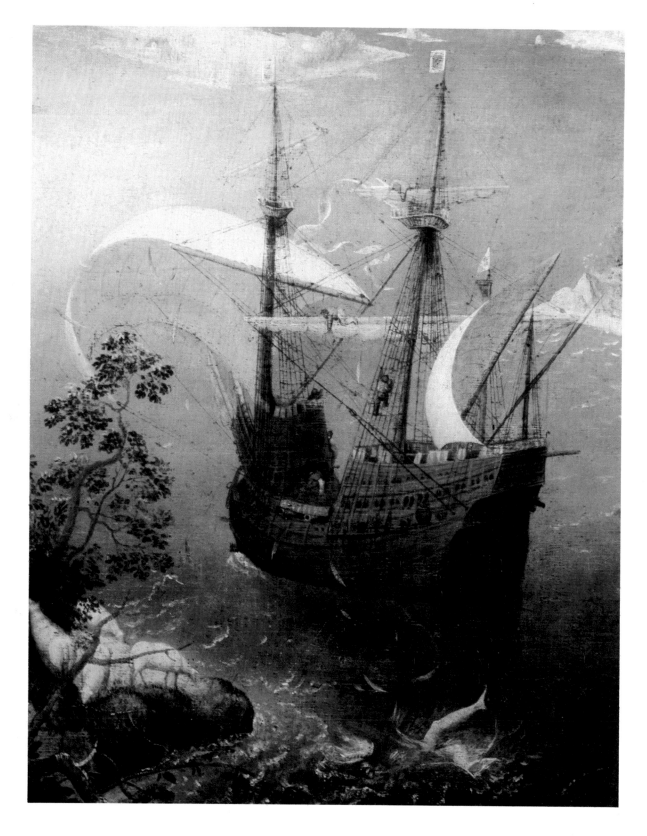

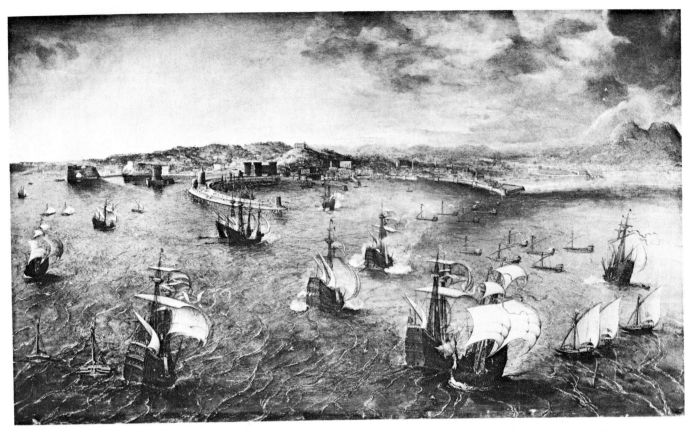

21 Pieter Bruegel the Elder. *View of the Harbour at Naples. Mid sixteenth century. Oil on wood panel, 16x27½ in. Rome, Doria Gallery. Possibly painted in Italy or after Bruegel's return from his Italian visit. The gunsmoke that can be seen suggests a naval battle in progress.*

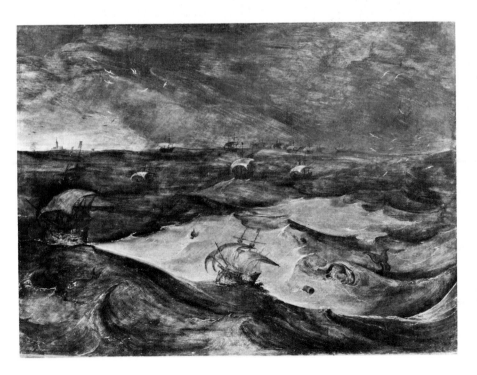

(*facing*)
20 Pieter Bruegel the Elder. *The Fall of Icarus (detail). c.1558. Oil on canvas, 29x44 in. (total size). Brussels, Musées Royaux des Beaux-Arts.*

22 Pieter Bruegel the Elder. *Storm at Sea. Oil on wood panel, 27½x37¾ in. Vienna, Kunsthistorisches Museum. Generally considered to be one of Bruegel's last works, this painting may have some symbolic content in the barrel and whale represented but can be appreciated simply as a magnificent rendering of storm.*

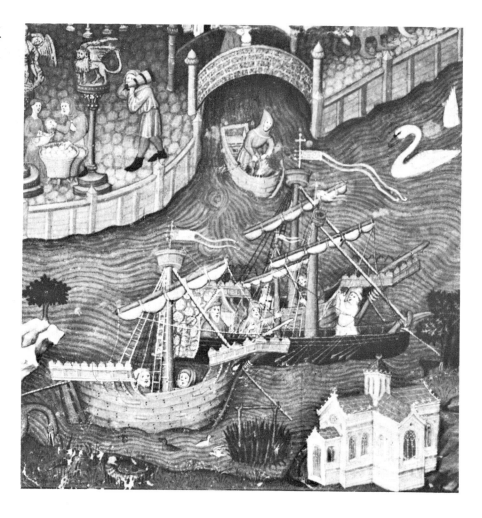

types of ship. It was natural that the citizens of the port, now rising towards the height of prosperity, should have this taste for prints of shipping. A few early paintings attributed to him suggest he had gathered impressions at Italian ports, for example a painting of a fleet in the harbour of Naples (Rome, Doria Gallery), but Antwerp must have provided all he needed for the engravings. They were precise in all their details of masts, sails, rigging, and cannon, but a more poetic conception of the ship as part of the general scheme of things was added to the accuracy of delineation he had acquired in his first great painting of 1558, 'The Fall of Icarus' (Brussels, Musées Royaux des Beaux-Arts).

The story, taken from Ovid's *Metamorphoses* of the too-ambitious aeronaut, the wax of whose wings melted in the heat of the sun, causing his plunge into the sea, may seem at first to have an insignificant place in the picture. A raised leg alone tells of Icarus's fate. Yet the vast placidity of the work otherwise may be taken to have a philosophic implication. Life goes on, on sea as on land, the ploughman, shepherd, fisherman, and distant sailors swarming up the rigging of the beautiful ship with its billowing sail all assure us. The tragedy of overweening ambition is only one small incident. Worthier of note is the worker's normal industry. This at least is a possible moral, apart from which this cosmic panorama of land and sea can be appreciated in visual terms simply.

From time to time ships continued to make their incidental appearance in his work though such other subjects engaged him as the wonderfully painted scenes of

32

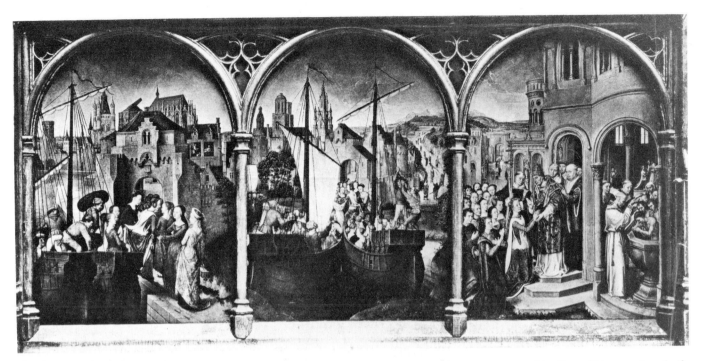

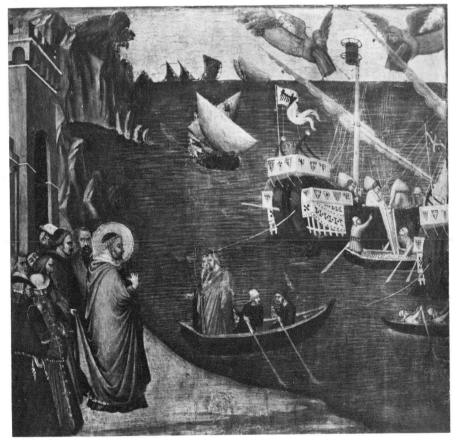

24 Hans Memlinc. Side panels of the Reliquary of St Ursula, depicting episodes of the St Ursula legend. 1489. 14¾×10 in. Bruges, Hospital of St John.

25 Ambrogio Lorenzetti. Scene from the Legend of St Nicholas of Bari. Panel, 7⅜×7⅛ in. Florence, Uffizi Gallery. The fourteenth-century Sienese master shows corn being generously provided by cargo-ships for the famine-stricken city of Myra, their stores at the same time being miraculously replenished by the angels whose aid the saint has invoked.

peasant life, the round of the seasons, and the religious narrative compositions that seemed to have a covert reference to Spanish persecution in the Netherlands. Bruegel delighted to introduce a picturesque fleet moored beneath his skyscraper vision of the Tower of Babel (Vienna, Kunsthistorisches Museum). Other works, it is very likely, have a more or less cryptic allusion to the trials the Netherlands were undergoing in his time. The 'Chained Monkeys' (Staatliche Museen, Berlin) with a background of the Scheldt and its ships and the skyline of Antwerp perhaps symbolize the servitude of the Flemish provinces under alien rule. The sinking ships and distant flames of 'The Triumph of Death' (Madrid, Prado) are more grimly dramatic and no less relevant. Probably one of his last masterpieces, assigned to 1568, the year before his death, was 'Storm at Sea' (Vienna, Kunsthistorisches Museum). The rent and racing sky, the tremendous surge of waters place the painting among the first great seascapes, though an underlying moral or symbolic idea may again have been intended. It is a possible assumption that the ship stands for humanity's course through the dangers of life and that the jettisoning of material possessions as represented by the barrel thrown overboard symbolizes a means of salvation. But the work can be understood as a painting without regard to these hypotheses. The contrast of light and dark that throws a spearhead of movement across the surface, the tossing ships, the gulls wheeling against the dense clouds, convey the effect of tempestuous reality. In the view of man at odds with the greater force of nature Bruegel gives in his own way an anticipation of Turner's dramatic seapieces.

2

The seventeenth century, North and South

The Dutch painters of the seventeenth century were the first to develop fully a distinct and specialized school of marine painting. A reason for this may be found, as for the development of Dutch art in general, in the enthusiasm and newly-created sense of national pride that followed the long struggle of the northern provinces against Spanish rule, and their final attainment of independence. Artists in various genres contributed to what could be summarized in total as a 'portrait' of Holland, comprising its people, their cities, domestic interiors, and personal possessions and the landscape that had well-defined characteristics of its own.

The waterways that threaded the flat lands, the sea that gave them a long and indeterminate boundary, had their necessary part in the composite image. The rise of marine painting was closely linked with that of landscape as a whole. Jakob van Ruisdael, to take a great example, showed equal mastery in the panoramic view of low-lying country, the marshy woodland with its ancient oaks, and his paintings of stretches of sea.

The Dutch were naturally proud of the ships that had not only been a means of liberation and a form of defence, but the vehicle of expanding trade and a source of wealth. This accounts for the fact that the united provinces of the northern Nether-lands were able to emerge from the conflict with Spain without exhaustion, on the contrary, with every sign of confidence and well-being. Inevitably, ship portraits and the record of maritime events were numerous and popular. They had a large share in the making of a specialized tradition, but they are not the whole story of Dutch marine painting.

In a broad survey, it is possible to recognize three separate phases. At the begin-ning of the seventeenth century, the urge was strongly felt to set down on canvas the course of maritime events from which the northern provinces had emerged triumphant: the sea battles, famous ships, the comings and goings of distinguished persons on State business, the arrival and departure of merchant fleets bound for or returning from the Far East or the New World of the Americas. In the breathing-space that followed, a calm after storm, an altered mood prevailed. Artists began to take more note of atmospheric effect, of the nuances of greys of the northern climate, of sea and sky as possessing their own pictorial value. Thus marine painting became less specialized and the ship an incidental feature rather than the main object of attention.

The renewal of war in the second half of the century, this time with England as the rival for overseas trade and possessions, brought with it a third phase. A revival of the battle picture was a consequence, though subjects were more realis-tically painted than when the century began. Documentation was not the only motive, however. Dutch painters gained impressions from abroad that influenced their style and approach to the maritime theme. The glowing light of Italy and its translation into art were a new impulse. At the other extreme was the picturesque

wildness of Scandinavia. This too was not without its influence.

A representative painter of the first phase who may be regarded as the founder of the Dutch marine school was Hendrick Cornelisz Vroom (1566–1640) who portrayed with nicety of detail the full-rigged ships with heavy, square stern and beak-head bow, such as were used by the navy and the Dutch East and West Indies companies. Vroom was the son and pupil of the potter and sculptor Cornelis Vroom. He was first trained in the making of faience, but took to painting after a period of extensive travel in Europe, in the course of which he visited Germany, Italy, Spain, and Portugal. Something of Bruegel's Flemish precision remains in his portrayal of ships, usually seen broadside on, in the small marine paintings in which he specialized on his return to Haarlem. Characteristic dark tones of brown and blue-green were relieved by touches of bright local colour and in the shoreward scenes by the presence of many small figures. Vroom was prolific, widely known, and is said to have become a rich man. In 1616 he became a member of the Guild in Antwerp and among his commissions were panels executed for the regents of the southern Netherlands after the cessation of hostilities, the Archduke Albert and his wife the Infanta Isabella. He was also commissioned by Lord Nottingham to make designs for tapestries of the Spanish Armada. The tapestries

26 *Hendrick Cornelisz Vroom. The Battle of Gibraltar.* 1607. *Oil, 54×74 in. Amsterdam, Rijksmuseum. A composition that gains pictorially from the vivid pattern formed by the debris of battle.*

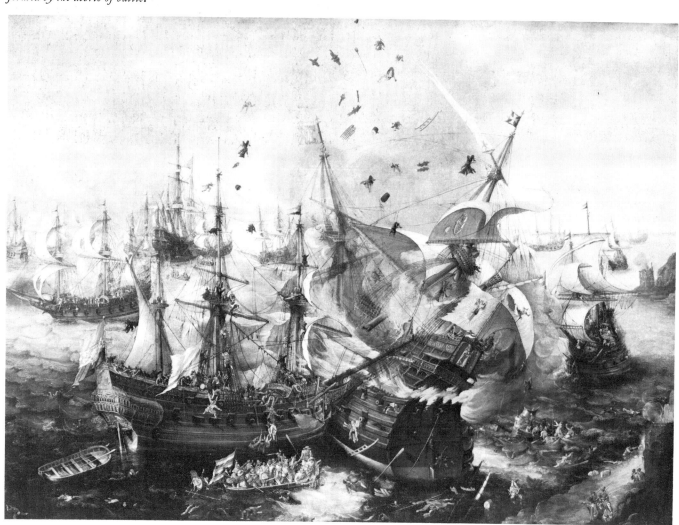

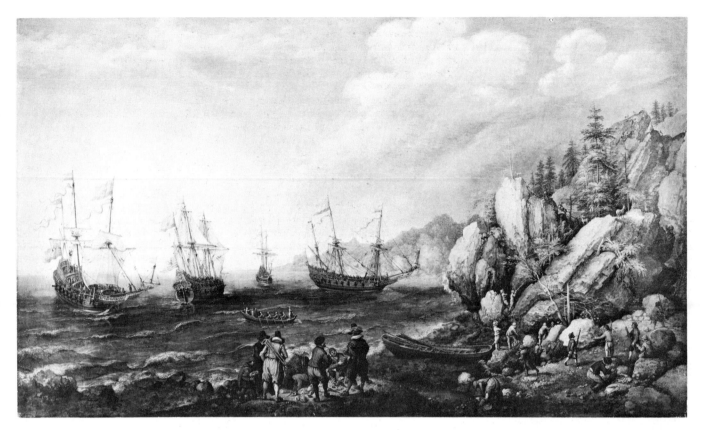

hung in the old House of Lords until destroyed in the fire that burnt down the Houses of Parliament early in the nineteenth century.

A likeness to his competent workmanship and style of composition is to be traced in the marines of Adam Willaerts (1577–1669), with some reminiscence of Bruegel also. Born in Antwerp, Willaerts settled in Utrecht as a painter of both landscape and seascape. Other minor artists of the first phase of Dutch marine painting were Cornelis Claesz Wieringen (*d.*1643) a pupil of H. C. Vroom whom he followed in style, Abraham Willaerts (1603–69) son of Adam Willaerts, who like his father painted sea fights and shipwreck scenes, and such painters as Aart van Antum and Andries van Ertvelt who worked in the style of Vroom. It is probable that pictures of events such as they produced were specially commissioned as records. But after this phase many pictures were painted of beach, estuary, and open sea with shipping that were in no sense documents, but answered to a taste for the typical everyday spectacle that was shared by artists and a picture-buying public.

Such works, evoking the atmosphere of home waters, without reliance on a story, or an element of the unusual, make an illuminating contrast with the landscapes of painters in the southern Netherlands after the break between north and south. Rome was the goal of many Flemish artists, and the rocky heights and winding river valleys encountered on the way left impressions that became fantastic in memory and in their pictures. For the Dutch painter, familiar reality excluded this kind of invented scene, though realism was also an innovation. That fresh breezes blew along the northern littoral, that large rolling clouds moved with solemn dignity in atmospheric accord with the sea below, were conditions of nature that required a new interpretation in paint. They were main factors in pictures where ships of any sort, from the fishing smack to the trading *fluitschip* and the large *pinas*, were incidental details of composition, like the cottage or other architectural feature that might enliven a rural scene.

37

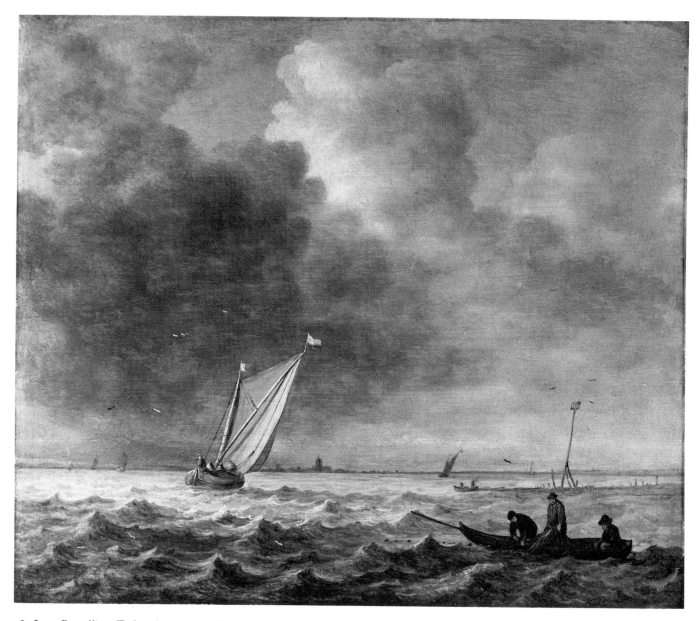

28 *Jan Porcellis. Fishing-boats. Panel, 8½×7 in. Berlin-Dahlem, Gemälde Galerie. Freshness of atmosphere and simplicity of subject contrast in the marine painting of Porcellis with the elaborate ship portraiture of other Dutch artists.*

Realism of atmosphere, as in the Impressionist art of a later age, could be achieved without recourse to an imposing subject-matter. John Constable, a discerning critic as well as a great artist, pointed out the positive advantage that Dutch painting gained in this respect. Discussing a seascape by Ruisdael in one of his lectures at the Royal Institution, Constable remarked that the subject, the mouth of a Dutch river, was 'without a single feature of grandeur in the scenery; but the stormy sky, the grouping of the vessels and the breaking of the sea, make the picture one of the most impressive ever painted'.

Tone, that is to say the gradation of light and shade as distinct from colour, was a technical means of conveying atmosphere developed by the generation of marine painters that followed the early pioneers. The delicate greys that represented light in the open air, the unity of effect and sense of space that came to dis-

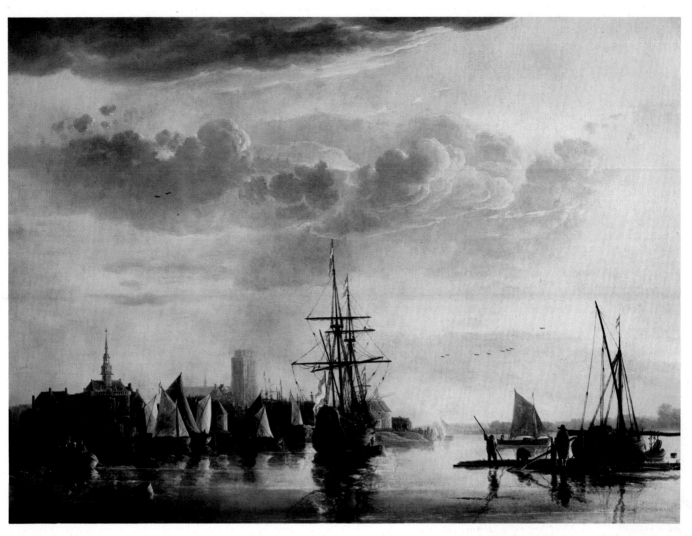

29 *Aelbert Cuyp. View of Dordrecht. c.1655. Oil on canvas, 38½×54¼ in. Kenwood, Iveagh Bequest.*

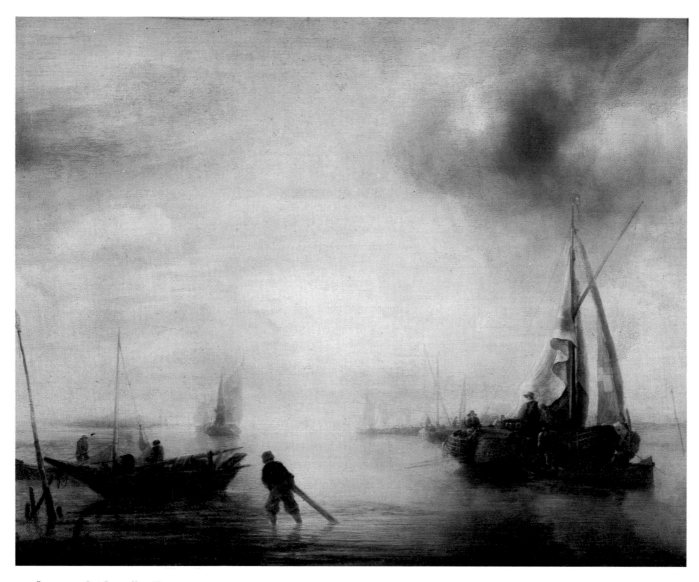

30 *Jan van de Cappelle. Evening Calm.*
c.1655. Panel, 18½x23 in. Cologne, Wall-
raf Richartz Museum.

tinguish pictures of sea, seashore, and river mouth in the first half of the seventeenth century, formed a tradition that owed much to the work and influence of Jan Porcellis (1585–1632).

Admiringly termed 'the Raphael of marine painting' by Samuel van Hoogstraten, a Dutch painter of a succeeding generation, Porcellis was an early and influential exponent of the tonal seascape. Born in Ghent, he became the pupil of Hendrick Cornelisz Vroom at Haarlem, but his originality can be appreciated in the striking contrast his paintings present to those of his master. Instead of the stately close-ups of important ships, he would paint any small vessel or row boat that fitted into a scheme of composition; instead of a heavily coloured, immobile sea, the sparkle of light on waves in lively movement. His small paintings executed in grey tones are remarkable in the feeling of animation and freshness they give.

Porcellis was a member of the Guild at Antwerp in 1617 but worked mainly in the Dutch cities, at Rotterdam, Haarlem, Amsterdam, and finally at Soutermonde near Leiden, where he died. His son Julius Porcellis painted in his manner and made copies of his works. The influence of Jan Porcellis is marked otherwise in the paintings of two such outstanding artists as Simon de Vlieger and Jan van de Cappelle, who studied him to good advantage. Simon Jacob de Vlieger (c.1606–53) is a key figure in the aesthetic tradition that stemmed from Porcellis, and in turn an inspiring force on others. Born in Rotterdam, De Vlieger first worked as a painter in that city, but in 1634 became a member of the Guild of St Luke at Delft and subsequently lived at Amsterdam. In 1650 he settled at Weesp, some 10 miles from Amsterdam, where he died in 1653. His mature style seems to have been formed in

31 *Simon de Vlieger. A Calm Sea. Oil on canvas, 29×39 in. Rotterdam, Boymans-van-Beuningen Museum. The effect of calm is heightened by the horizontal lines of the foreground.*

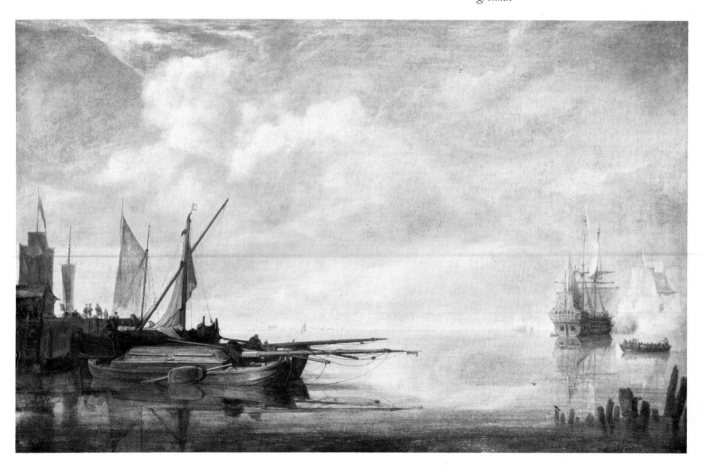

the 1630s through his acquaintance with the work of Porcellis, and he developed still further the majestic effect of sky above a low horizon. His subjects were varied, including landscape of duneland and forest and animal and figure subjects, but he is best known by pictures of beach and sea as wonderfully spacious as the 'Beach near Scheveningen' of 1633 (National Maritime Museum, Greenwich) and entirely marine subjects in which masts and sails served to emphasize the effect of space.

De Vlieger had a number of followers who profited by his example, among them Jan van de Cappelle, Hendrick Dubbels, and Willem van de Velde the Younger. Jan van de Cappelle (c.1623/5–79), painter of sea, river views, and winter landscapes, was born in Amsterdam, where his father was the owner of a dyeing and weaving concern. He went into the business and became a wealthy man and art patron as

32 *Jacob van Ruisdael. A Rough Sea. c.1660. Oil on canvas, 42½×49⅛ in. Boston, Museum of Fine Arts, Dutch-William Warden Fund.*

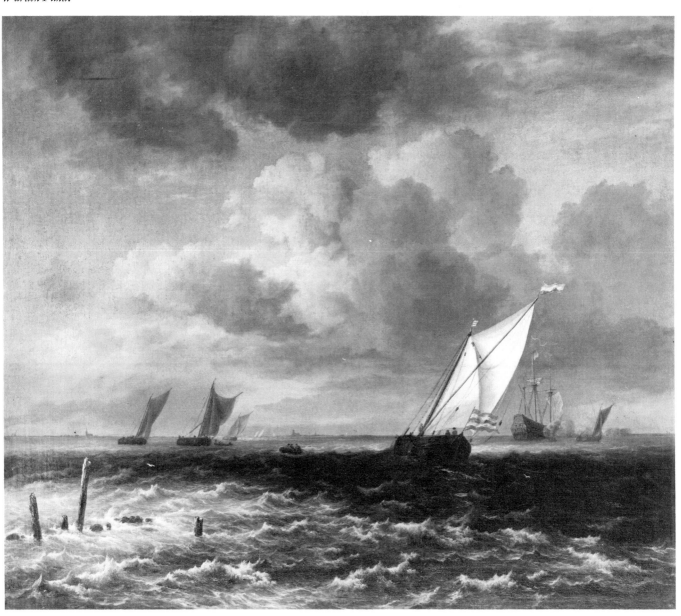

well as painter. He was a friend of Rembrandt, who painted his portrait. As a con-
noisseur he amassed a large collection of paintings and drawings by his Dutch
contemporaries (500 drawings by Rembrandt alone). Though he is said to have
been self-taught, his collection was an education in itself. It is significant that he
owned nine paintings and as many as 1,300 drawings by De Vlieger, as well as
sixteen paintings by Porcellis. Copies of works by both, made by Van de Cappelle,
were mentioned in the 1680 inventory of his collection. As a painter he was not
prolific, but outstanding in the quality that can be appreciated in such a serenely
luminous painting as 'Evening Calm' of c.1655 (Wallraf-Richartz Museum,
Cologne). In this work he ventured beyond the silvery greys in which he had
earlier followed De Vlieger to a fine rendering of the warm glow of sunlight made
the more impressive by the foreground silhouettes of boats and figure.

A kindred development of realism is to be found in the work of Jan van Goyen
(1596–1656). His cultivation of a near-monochrome and the low horizon that gave
full value to the spaciousness of sky bring De Vlieger and Van de Cappelle to
mind, the trenchant design of his 'Fisherman laying a Net' (National Gallery, Lon-
don) being much in Van de Cappelle's vein. But on the whole his evolution was
separate from theirs. He was born at Leiden and his early efforts seem to have
been guided by Leiden painters. After a visit to France when about 19, he spent a

34 *Allart van Everdingen. Snow Storm at Sea. Oil on canvas, 38⅘×48⅖ in. Chantilly, Musée Condée. The artist brings to one of his rare seascapes the romantic force of his Scandinavian mountain views.*

(opposite)
35 *Jan van Goyen. A River Scene with Fishermen laying a Net. 1638. Oil on oak panel, 12¼×10 3⁄16 in. London, National Gallery.*

year at Haarlem as the pupil of the landscape and genre painter Esaias van de Velde (c.1590–1630). For some years he painted in the style of this master with bright colour and elaborate detail but after about 1626 and the age of 30 he took to the simplification and limited range of colour that had become characteristic of the Haarlem style.

Because he painted many seascapes, he is to be numbered among the marine painters, though he was rarely out of sight of land and there are many works in which he was out of sight of the sea. The stretches of river with their shores variegated by the picturesqueness of towns, villages, and foliage are the subject of many typical works. Yet the wide river spaces he painted were seldom without the boats that gave their reminder of nearness to open water, conveyed especially in his numerous views of Dordrecht.

The style of Van Goyen may be compared with that of Salomon van Ruysdael (c.1600–70), the uncle of the great Jacob van Ruisdael. Born at Naarden, he settled at Haarlem where he was a member of the Guild of St Luke. He is mainly of note

44

for his delightful river landscapes, though in some marines he seems to have taken Porcellis as his model. Like Van Goyen he followed Esaias van de Velde in his early work, but later adopted the monochrome style of Van Goyen, though showing greater interest in detail, and after he reached middle age again making a more positive use of colour.

The river scenes of these two painters contributed to form the early style of the versatile Aelbert Cuyp (1620–91). He was always more varied than they in subject and was destined to make an impressive departure from the Dutch tradition in renderings of the warm glow of sunlight that led to his being called 'the Dutch Claude'. Cuyp was born at Dordrecht, the son and pupil of the portrait painter, Jacob Gerritsz Cuyp (1594–1651/2). His varied output included some portraits, as well as placid landscapes with cattle and horses, seapieces and still-lifes, his originality being particularly evident in what J. M. W. Turner described as his ability 'to blend minutiae in all the golden colour of ambient vapour'.

Cuyp's life was uneventful, its calm round apparently undisturbed by the nation's wars. He acquired an estate, Dordwijck, near Dordrecht, and as a landed

36 *Aelbert Cuyp. Boats by a Rocky Shore. 1655+. Oil on panel, 10×13⅛ in. Custodia Foundation (Coll. F. Lugt). Paris, Institut Néerlandais. Realist and fanciful elements are both found in Cuyp's paintings as appears in the contrast here shown.*

46

37 *Aelbert Cuyp. The Passage Boat. c.1650. Oil on canvas, 49×56¾ in. Royal Collection, reproduced by gracious permission of H.M. The Queen.*

proprietor had a seat in the High Court of Justice of the province. Dordrecht was a centre from which he made sketching excursions. The ancient estuary port on its island at the meeting-point of the Maas and Waal was itself a satisfying subject, a picturesque background for boats of every kind. He could paint the scene with all the fidelity that distinguishes the well-known 'View of Dordrecht', sometimes referred to as 'the Iveagh Sea-Piece' (Iveagh Bequest, Kenwood). The large expanse of sky and the mellow warmth of tone blend, as Turner remarked, with what he called the 'minutiae' of architecture and shipping.

Cuyp's golden light, so much in contrast with the cool greys of other painters of Dutch landscape and seascape, suggests an Italian source. It does not appear that

38 *Hendrick Dubbels. A Dutch Yacht be-calmed with other Vessel, near the Shore. Oil on canvas, 19×18 15/16 in. London, National Gallery. The expanse of sky over a low horizon contributes powerfully to the effect of this picture and Van de Cappelle's river view (opposite page).*

he ever visited Italy, but was able to add his own poetry of vision to the reminiscence of a sunnier climate and a foreign school brought back to the Netherlands by Dutch artists who had gone to Rome. In particular he seems to have been influenced by Jan Both (c.1618–52), one of the Utrecht painters who looked to Italy for inspiration. After some years in Rome, Both returned to Utrecht, glowing skies painted in the manner of Claude Lorrain being a feature of his Italian views. To call

48

Cuyp 'the Dutch Claude' was not an empty compliment but points to a resemblance of aim transmitted through Both as intermediary. Light became the dominant theme in Cuyp's later works, for example the 'Rocky Shore' (Custodia Foundation, Coll. F. Lugt, Institut Néerlandais, Paris) in which the shore is merely fanciful and secondary to the atmosphere that bathes sky and sea.

In contrast to this idyllic and southern-inspired warmth was the effect of contact with Norway and Sweden. Their wild and rugged landscape, so different from the flatness of Holland, appealed strongly to the Dutch painter Allart van Everdingen (1621–75). He visited Scandinavia as a young man and on his return worked at Haarlem and Amsterdam on landscapes of forests, waterfalls, and mountain streams with a feeling for the drama and force of nature new to Dutch art. It was a romantic feeling, sombre and intense, rather than an interest in topography that Van Everdingen also evinced in his few but remarkable marine paintings. Instead of the habitual calm of the Dutch seapiece, he conveyed the sensation of untamed force in one of his most impressive works, 'Snow Storm at Sea' (Musée Condé, Chantilly). The romantic mood of Van Everdingen found a response in one of the greatest of European landscape painters, Jacob van Ruisdael.

Ruisdael was born at Haarlem, the son of a picture-dealer and frame-maker

39 *Jan van de Cappelle. View on the Scheldt.* c.1650–5. *Oil on canvas,* 24¼×33⅛ *in. Toledo, Ohio, Toledo Museum of Art (Gift of Edward Drummond Libbey).*

49

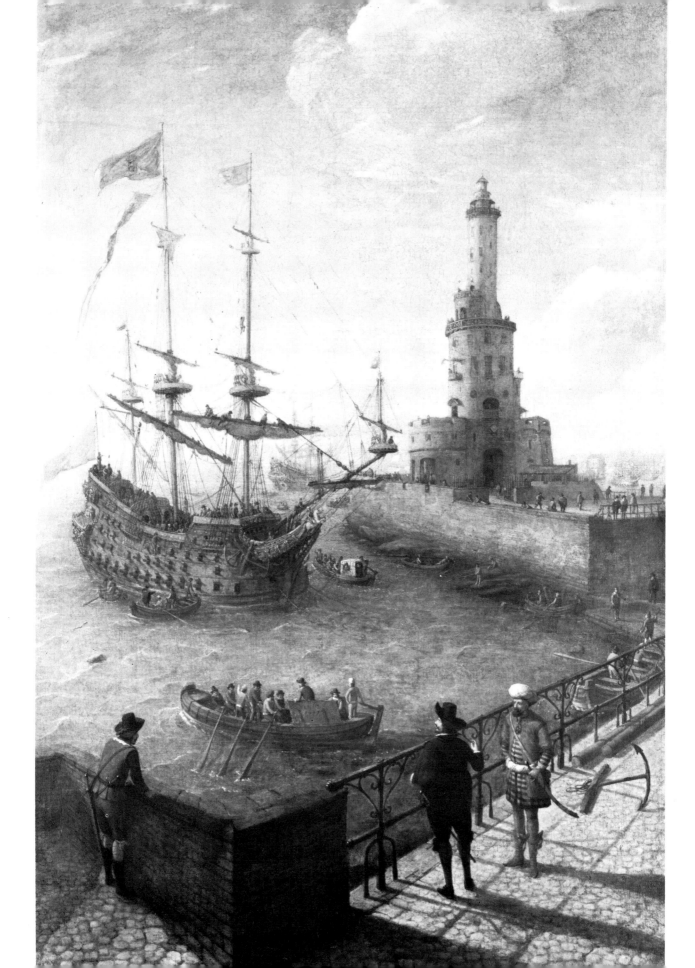

who was also a painter, Isaack van Ruisdael, from whom he may have had his first lessons in art. He probably studied under his uncle Salomon van Ruysdael and became a member of the Haarlem Guild in 1648. He travelled in the eastern parts of Holland and in west Germany, in this period developing an increased depth and force of light and shade. That in middle age he took a degree in medicine in France at Caen (1676) and was registered as a physician at Amsterdam seems a comment on the need to supplement the income derived from painting that many seventeenth-century Dutch artists experienced.

His was a broad and unspecialized outlook. The sand dunes and stretches of water in the undrained Haarlem Lakes provided him with many subjects but his prolific output was very varied, including panoramic views of the Netherlandish plain, forest scenes, winter scenes, imagined Scandinavian landscapes inspired by the fir-crowned heights and waterfalls of Van Everdingen, and numerous seascapes. His art was fed from various sources – the river pictures of his uncle Salomon, the woodland pictures of Cornelis Vroom, son of the marine painter, H. C. Vroom, and the sea pictures of the Haarlem School. It is estimated that he painted some forty to fifty seascapes, mainly of rough seas and storm. They had a force of expression no doubt stimulated by Van Everdingen's example but personal to Ruisdael. The subjective mood of his 'Stormy Sea' (National Museum, Stockholm) with its towering masses of cloud, leaning sails, and sharp opposition of light and dark reflects the strong individuality that was to cast its spell over artists in France and England after a long interval of time. There was a grandeur in his approach to nature as represented by the sea that Constable esteemed as 'going far beyond Van de Velde', a romantic melancholy in his woodlands that was to re-appear in the work of the Barbizon School in France.

A separate development was that of the night scene with effects of moonlight or combinations of natural and artificial light. This was a genre popularized by the work of the German landscape painter Adam Elsheimer (1578–1610) whose small pictures ('The Shipwreck of St Paul' in the National Gallery, London is a good example) were made widely known through engravings. The night effect was mainly used by a number of painters in the Netherlands to heighten the drama of action and episode, scenes of battle, conflagrations, nocturnal marauding. Exceptional was the work of Aert van der Neer (1603/4–77), who might be said to have invented the marine nocturne as a poetic conception. He stands out singly as the painter of estuaries and sea with ships that acquired a mysterious beauty from the light in which they were seen. After painting some skating scenes of the type so often produced by the minor Dutch masters, Van der Neer began to paint his moonlight pictures when about 40 years of age. He worked at Amsterdam where he kept an inn for a number of years though presumably in the unpractical fashion that caused him to become bankrupt in 1662. He gave up painting for a long time afterwards, returning to it in his later years though in a coarser style than that of the 1640s. 'Fishing by Moonlight' (Kunsthistorisches Museum, Vienna) is a work that shows him at his poetical best.

Paintings of imaginary southern harbours were a product of the growing practice of spending some time in Italy, causing some artists to diverge from their native realism and produce a fanciful vision of architecture and sea. Nicolaes Berchem (1620–85), celebrated mainly for his Italian pastorals, also painted a number of these harbour scenes. Memories of three years in Italy stirred his imagination when he returned to Haarlem and Amsterdam. Other Dutch painters who were similarly influenced were Jan Asselijn (1610–52), Jan Baptist Weenix (1621–60), Jan Beerstraaten (1622–66), and Adam Pijnacker (1621–73). But a more significant feature of marine painting from the 1650s onwards, apart from such artificial by-products, was the return to prominence of its documentary side.

The ship again became a main theme instead of an incidental item of composition. The pace of shipbuilding quickened with the extension of overseas trade and equally with the struggle to hold the mastery of the seas that England also claimed. The heavy warships of the time, carrying up to eighty guns, were portrayed in pictures that served as both record and propaganda. The naval wars with England, in 1652–4 and again from 1664 onwards, until the marriage of William of Orange

(facing)
40 Abraham Willaerts. Spanish Three-Decker Lying at Naples. 1671. Oil on canvas, 34x21½ in. Greenwich, National Maritime Museum.

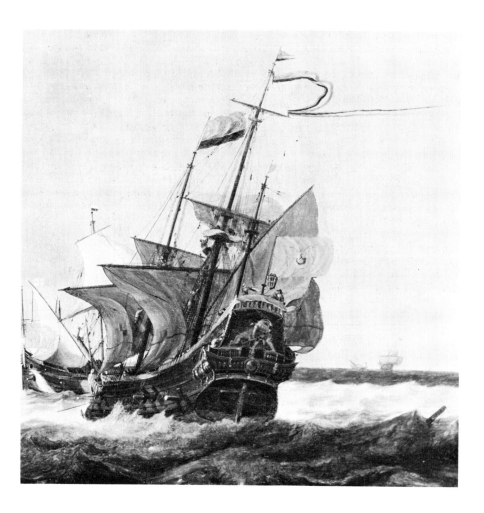

with Mary, daughter of James, Duke of York, in 1677 reconciled the two countries, called for chronicles of battle. It is easy to understand why the concern with the interpretation of nature in its marine aspect gave way in this era of conflict to paintings emblematic of naval power and prestige.

The members of the Van de Velde family, Willem the Elder (c.1611–93), Willem the Younger (1633–1707), and the latter's younger brother, Adriaen (1636–72), all made their mark in this period in their various ways. The father, son of a sea-captain, inherited a sailor's interest in the men-of-war and naval engagements of the time. He was virtually an official war artist, sketching from a galley on occasion when a battle was in progress. Concerned with accuracy of record rather than with painting as an art of colour he elaborated his sketches in pen and indian ink on a prepared white ground, the effect being somewhere between that of a line engraving and the form of monochrome painting known as grisaille. It may be noted that he had a follower in this method in Adriaen Salm (c.1663–1720) who used it in capable fashion for pictures of naval vessels and battles as well as of whaling and the Dutch herring fishery.

Willem van de Velde the Younger, born like his father at Leiden, may well have had some early parental instruction in drawing, but he had the advantage of training as a painter with Simon de Vlieger. The latter's refinement of style and command of tone and spatial composition is reflected in Van de Velde's early works of a non-documentary character. He showed a preference in a number of excellent paintings for scenes of evening calm with ships at anchor mirrored in the placid

waters. He worked at Amsterdam until 1671, evidently in close association with his father. They both went over to England for economic reasons at the critical time when the Dutch faced French invasion as well as English attack by sea and were understandably diverted from picture buying. The Van de Veldes were settled in London in 1672 and worked together. Willem the Elder's function was the 'taking and making of Draughts of seafights' and of his son 'putting the said Draughts into Colours' in the wording of the warrant of appointment when they were taken into the service of Charles II in 1674. Each was allotted a salary of a hundred pounds per annum. They had a studio in the Queen's House at Greenwich that Inigo Jones had originally designed for Queen Anne of Denmark and finished for Queen Henrietta Maria some forty years earlier. In the handsome building, appropriately near to the ships on the Thames, and now part of the National Maritime Musem, they remained industrious in the production of sea pictures until 1692, when they moved to Westminster. When Willem the Younger died in 1707 he was buried at St James's church, Piccadilly.

It is a comment on the detachment of artists at that period from political and patriotic causes that the Van de Veldes could so easily change sides. At Amsterdam, Willem the Younger had painted Dutch victories such as the great Four-Day Battle of 1666 in which the Admirals De Ruyter and Cornelis Tromp defeated the English Fleet under the Duke of Albemarle and Prince Rupert off the North

42 *Willem van de Velde the Elder. The Four Days Battle.* 1666. *Grisaille*, $46\frac{5}{8} \times 72\frac{1}{4}$ in. *Amsterdam, Rijksmuseum. The artist depicts the fiercely contested engagement between the Dutch under De Ruyter and the English under Monck that resulted in a narrow victory for the Dutch.*

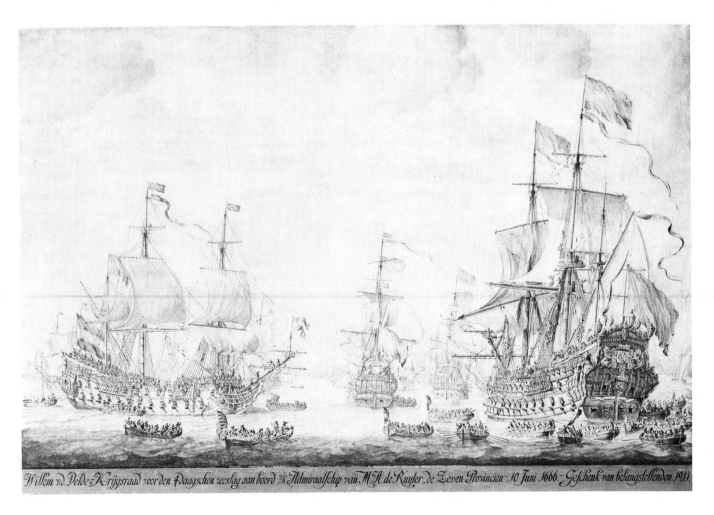

Willem v.d. Velde. Krijgsraad voor den 4daagschen zeeslag aan boord 't Admiraalschip van M.A. de Ruyter de Zeven Provincien 10 Juni 1666. Geschenk van belangstellenden 1911

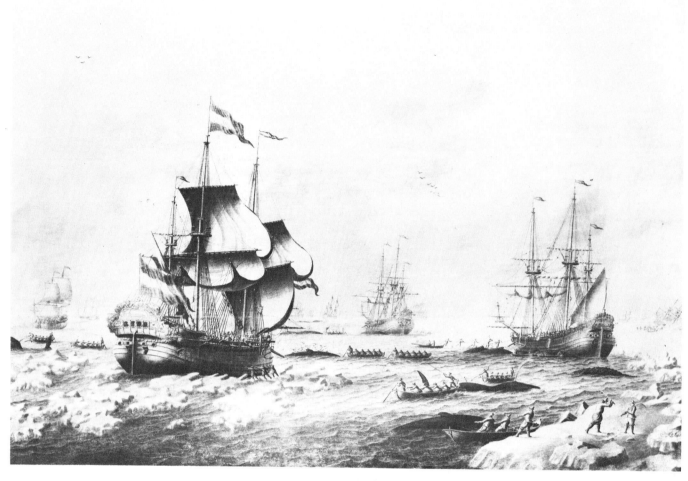

43 *Adriaan van Salm. A Whaling Scene.*
Grisaille, 28×40 in. Greenwich, National
Maritime Museum.

(*facing*)
44 *Willem van de Velde the Younger.*
H.M.S. Resolution *in a Gale. c.1670. Oil*
on canvas, 47×40 in. Greenwich, National
Maritime Museum.

Foreland. An eye-witness of the action, the artist painted the captured English ships in the picture now in the Rijksmuseum, Amsterdam. But he and his father were equally ready to celebrate English victory at the Battle of the Texel. Spectacular scenes of battle and paintings of English warships increasingly occupied Willem the Younger at Greenwich.

More than 600 works have been attributed to him. He gained the unstinted admiration of Horace Walpole who declared him 'the greatest man that has appeared in this branch of painting; the palm is not less disputed with Raphael for history than with Vandervelde [*sic*] for sea-pieces.' There is no doubt of the great influence he exerted on English marine painters in the eighteenth century. 'The Cannon Shot' (Rijksmuseum, Amsterdam), a memorable work in colour and composition, set a style that many followed. 'The Resolution in a Gale' (National Maritime Museum, Greenwich), an instance of his skill in combining the detailed portrayal of a particular ship with the impression of a strong wind and choppy sea was another influential type of composition. He was not without the limitation to which the specialist is liable, especially a tendency to mechanical repetition. Nor does he seem so altogether unrivalled an artist as Walpole affirmed if one thinks of him in comparison with Jan van de Cappelle and Jacob van Ruisdael. As an artist he was in some ways surpassed by his brother Adriaen who was less tied to a specialized genre. Adriaen van de Velde produced a variety of landscapes, excelling in beach scenes that

54

sensitively conveyed the attraction of the sea as seen from the shore. But Willem the Younger is justly admired for such early seascapes as the delightful 'Dutch vessels close inshore at Low-Tide and Men Bathing', 1661 (National Gallery, London) as well as respected for the vast amount of maritime information he provides in pictorial form.

He surpasses his successor in the Dutch marine tradition in Holland, Ludolf Bakhuizen (1631–1708), though some of Bakhuizen's paintings of men-of-war runing before the wind are like enough to Van de Velde's characteristic style as to give a possible attribution to either artist.

Bakhuizen, who signed his name with the variant spellings of Bakhuisen, Backhuysen, and Backhuyzen, born at Emden, East Friesland, came to Amsterdam *c*.1650 as a merchant's clerk and writing-master. Beginning by making pen drawnings of ships, subsequently he took to painting. He was a pupil of Van Everdingen and also studied the work of Hendrick Dubbels (*c*.1621–76). Dubbels, born at Amsterdam, was a painter of sea and river scenes and some winter landscapes and a follower of the younger Willem van de Velde in style. An attractive example of his work is 'A Dutch Yacht becalmed with other Vessels near the Shore' (National Gallery, London), in which he was evidently influenced by Van de Velde, though the picture was once mistakenly ascribed to Van de Cappelle.

Bakhuizen thus had a link at a remove with Van de Velde, supplemented by direct acquaintance with his work at Amsterdam. After the Van de Veldes, father and son, migrated to England he was regarded as the chief of Dutch marine painters. He had eminent patrons from abroad, including Peter the Great of Russia, who had lessons in painting from him. The majority of his paintings were of men-of-war in stormy seas. The continuity of style and subject in the second half of the seventeenth century can be traced in the paintings of a number of minor artists who specialized for the most part in sea fights, primarily of interest as historical records. They included Abraham Storck (1644–1704 +), who shortened his name from Sturckenburg and worked at Amsterdam, painting men-of-war and Dutch harbour scenes in the manner of Bakhuizen. Jacobus Storck (1641–87), marine and landscape painter whose harbour scenes were crowded with detail, was probably Abraham Storck's brother. Lieve Verschuier (*c*.1630–86), born at Rotterdam, was a marine painter said to have been the pupil of De Vlieger, though he followed Cuyp in his use of warm tones. The aspects of nature represented by clouds, space, and the placid ripples of the Meuse, which he rendered in an interesting fashion, were over-shadowed in his work by the commissioned pictures of naval ceremony and war. Reynier Nooms (known as Zeeman (*c*.1623–6?) was another painter of sea fights as well as of Dutch and Mediterranean harbours. Jan Beerstraaten, already referred to as the painter of imaginary harbours, also produced pictures of the actuality of naval warfare.

The Dutch painters of ships were in many instances liable to criticisms such as Ruskin was later to voice. There was a tendency to regard the sea as a 'level-seeking consistent thing with a smooth surface . . . in which ships were scientifically to be embedded . . .' The critic was perhaps too sweeping in remark on the conventional waves '*en papillote* and peruke-like puffs of farinaceous foam which were the delight of Backhuysen and his compeers', but he made the valid point that the specialist was apt to resort to conventions that limited his view and study of nature. In the play of light and atmosphere that overrode convention Jan van de Cappelle had the advantage of Van de Velde. Freshness of view was a precious quality sometimes attained by the unspecialized, or the artist specialized in other ways. Thus Emanuel de Witte (1615/17–1691/2), though mainly known for his paintings of church interiors and market scenes, could produce so vivid a work of a different kind as his 'Harbour at Sunset' (Rijksmuseum, Amsterdam).

The Dutch school of sea and river painting was a unique product of the seventeenth century without its like elsewhere in Europe. There was nothing of the kind in France where artists were given more encouragement to produce the classical subject compositions deemed appropriate to the magnificence of Louis XIV's reign. This is not to say that the king and his advisers were unaware of the value of a navy to establish parity with Holland and England, to pursue colonial enterprise, and

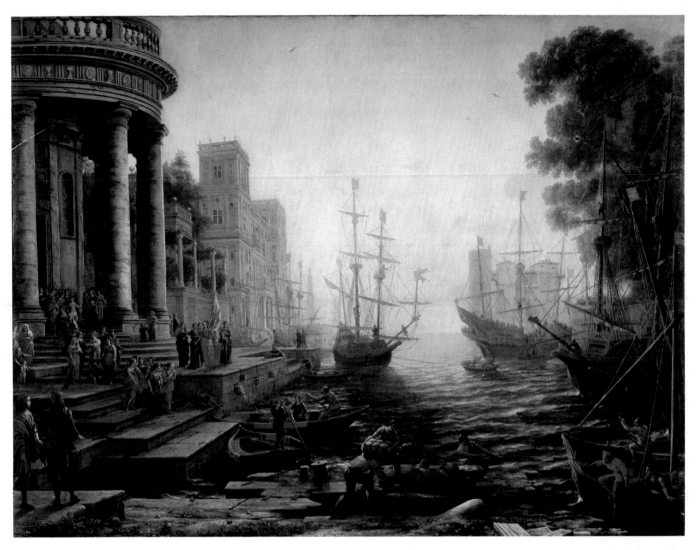

45 *Claude Lorrain. The Embarkation of St Ursula (detail).* 1641. *Oil on canvas,* 44½× 58½ *in. (total size). London, National Gallery.*

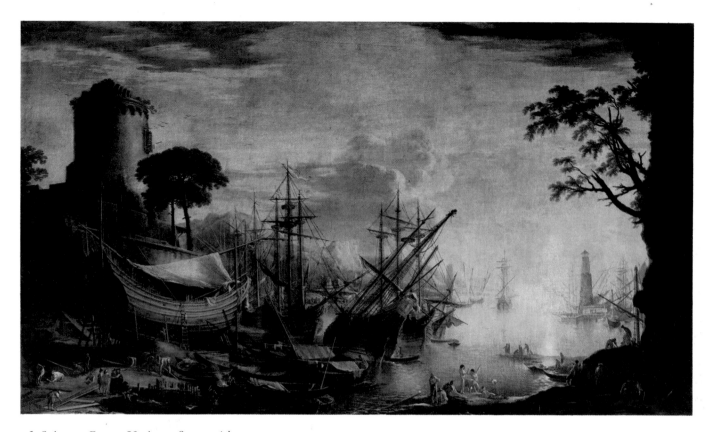

46 *Salvator Rosa. Harbour Scene with Tower. Oil on canvas,* $41\frac{1}{5} \times 51\frac{1}{5}$ *in. Florence, Palatina Gallery.*

(facing)
47 *Willem van de Velde the Younger. The Cannon Shot. Oil on canvas,* $30\frac{3}{4} \times 26\frac{1}{4}$ *in. Amsterdam, Rijksmuseum.*

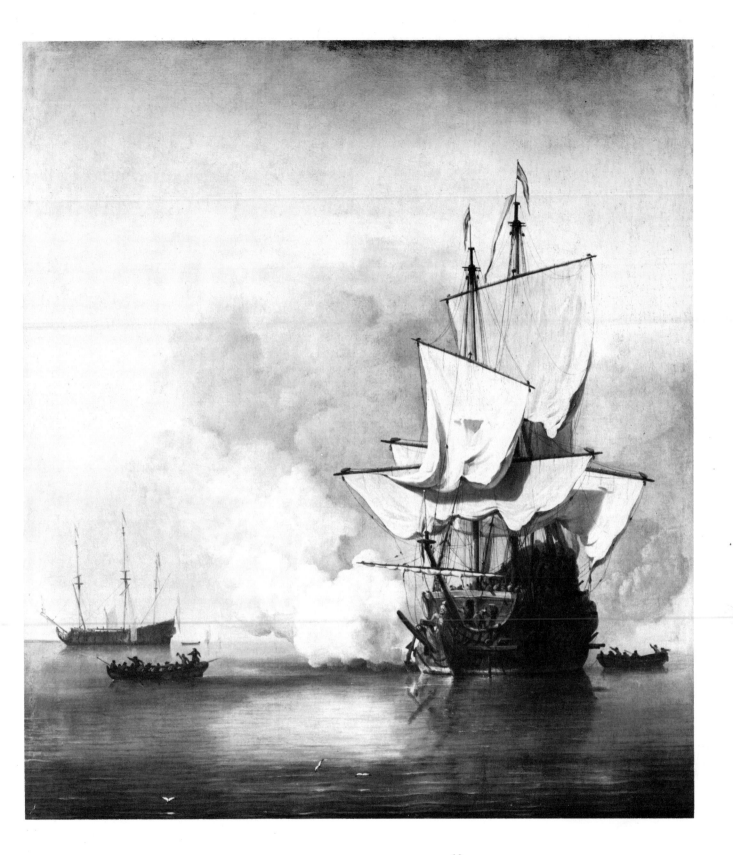

59

police the pirate-infested Mediterranean. The century was one of intensive ship-building. After having only the scantiest rudiments of a fleet in 1660, France in the latter half of the century could boast of more than 200 well-equipped warships.

The vessels were works of art in themselves rather than subjects for the picture painter. The Dutch ship-builders allowed some baroque luxury of ornament in the carved and gilded stern of a man-of-war, but this was little to be compared with the richness of material and design that the sculptor Antoine Coysevox (1640–1720) lavished on *Le Roi Soleil*, turning this 104-gun man-of-war into a floating palace. A lofty 'castle' aft and a load of oak-carving made such ships top-heavy and cumbrous to manoeuvre. It was one of Colbert's reforms to slim them down for the sake of efficiency.

Pierre Puget (1620–94), sculptor, painter, and architect, was one of the ship decorators who has left some record of the French warships in graphic form, though Colbert's ban on superfluous ornament caused him to turn to fresh employment as sculptor at Versailles. In a different ambience altogether was the great French painter who chose to live in Italy, Claude Lorrain (1600–82). The coasts,

48 *Lieve Verschuier. Rippling Water. Oil on oak panel, 14⅝×19¼ in. Amsterdam, Rijksmuseum.*

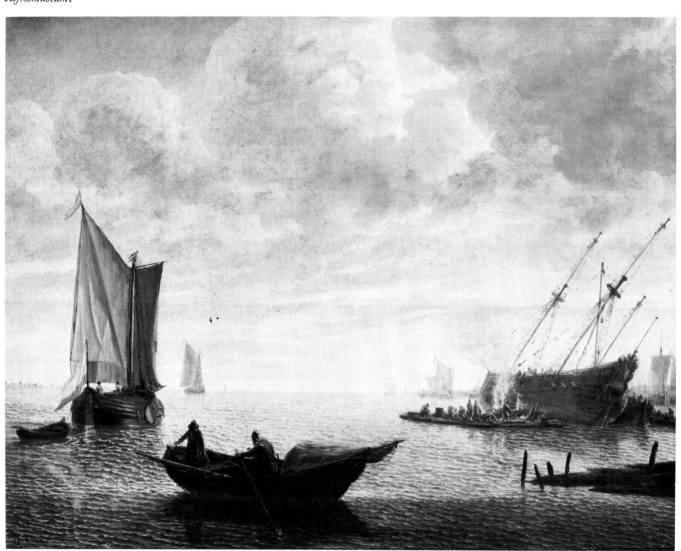

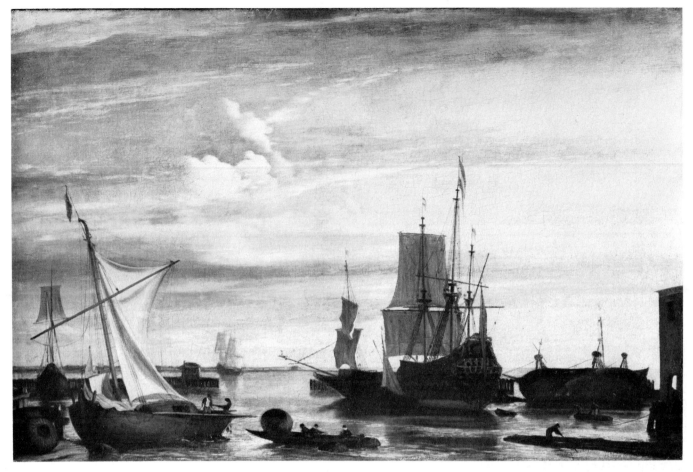

harbours, and ships of the Mediterranean were sources of inspiration even though he would be inappropriately described simply as a 'marine painter'. His great 'seaport' and 'embarkation' pictures were, in one aspect, dreams of an imagined idyllic past with a fanciful reconstruction of its buildings derived from the ruins and Renaissance examples of classical architecture in Italy. But there was another side to his art, a naturalism in the treatment of space and light, sky and sea, that revealed his close observation of the visible and existing world.

Only an outline of the life of Claude remains, the impression of a contented, industrious, and prosperous career. He was born at the village of Chamagne in the Vosges, then part of the Duchy of Lorraine. After a vague beginning as a pastry-cook, he somehow found his way to Italy at the age of 19. He began to paint as the pupil of Agostino Tassi, a painter of decorative architecture whose work, it is significant to note, included harbour scenes. For a year or two he worked with a pupil of Tassi, Goffredo Waals, at Naples and afterwards at Rome as Tassi's assistant. After a brief return to Lorraine he settled in Rome when still in his 20s and remained there for the rest of his life. He gained rich and influential patrons. In his 30s, the leading landscape painter in Italy, he began his *Liber Veritatis* or 'Book of Truth', an annotated volume of drawings after his works (Chatsworth) that is a principal record of his paintings and patrons.

In paintings of rustic landscape, it can be seen that Claude was influenced by Domenichino, though his originality is always evident. Like other artists in seventeenth-century Rome he was exposed to a variety of impressions and influences,

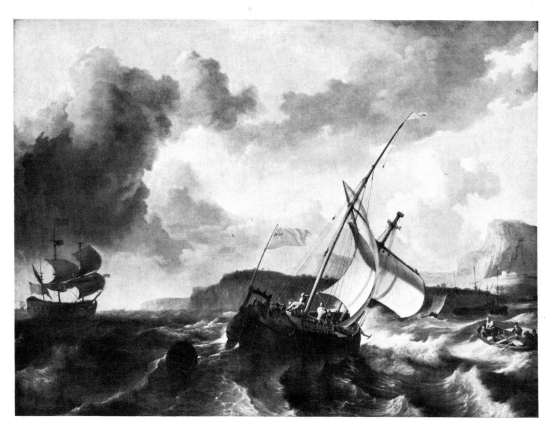

50 *Ludolf Bakhuizen. An English Vessel
and a Man-of-War in a Rough Sea off a
Coast with Tall Cliffs.* c.1680. *Oil,* $38\frac{3}{4}\times$
*52 in. London, National Gallery. Bakhuizen
followed the younger Van de Velde in stormy
marine views of this kind. The background of
coast seems to have been imaginary.*

51 *Adam Pynacker. Estuary Scene with
Barges and Mountains. Oil,* $17\frac{1}{4}\times23\frac{1}{8}$ *in.
Hartford, Connecticut, Wadsworth Athen-
eum. An idyllic combinaton of landscape and
marine elements of which Pynacker produced
a number of variants.*

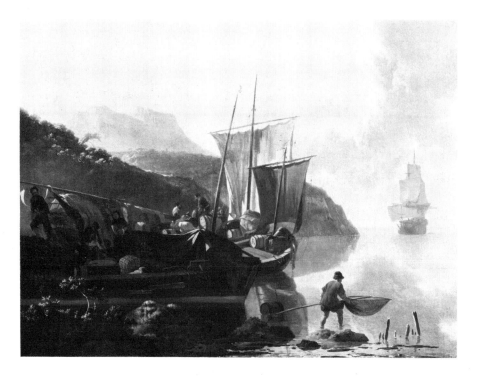

derived from the northerners as well as Italians. There is some connection in Claude's work with the landscape tradition created by the Flemish painter Paul Brill (1554–1626) and the German-born Adam Elsheimer (1578–1610). There are indications that Claude's style of drawing in pen and wash was influenced by the Dutch artist, Bartholomeus Breenbergh (1598/1600–57), with whom he was most probably acquainted personally. A variety of currents can be traced in the evolution of the 'classical' landscape of Claude and of his friend Nicolas Poussin. But Claude's study of nature had a special importance. His friend and first biographer, Joachim Sandrart, speaks of the time he spent in the open, observing 'the changing phases of dawn and the rising and setting sun'. He made sketches of boats on the coast with the freedom and vigour that he also applied to his drawings of the Roman Campagna.

52 *Pierre Puget. Design for the Decoration of a Ship.* c.1688/9. *Pen, brown ink and wash, 20¾×24⅞ in. New York, Metropolitan Museum of Art. The seventeenth-century French designer and sculptor, as in this beautiful drawing, was apt to conceive the ship as an elaborate piece of ornamental art at the expense of practicality.*

53 *Claude Lorrain. Study for a Seaport. Pen and bistre, 7⅝×10¼ in. London, British Museum. Claude's powers as a draughtsman and method of planning a painted composition are both illustrated here. The delicate tracery of rigging in the finished 'Port at Sunset' is envisaged in the sketch. See opposite.*

Claude's imagined harbours thus had the reality of sky and sea. He had at least one thing in common with the painters of Holland, that in painting the sea he discovered the sky, though a sky very different from theirs, a radiance reflected in the mirror-like surface of calm waters, conducted and intensified throughout a picture by the glowing perspective of Mediterranean wavelets. The many 'seaports' are widely distributed in public galleries, splendid and typical being 'The Embarkation of St Ursula' (National Gallery, London). There is the inimitable radiance that no other painter could quite achieve, heightened, if anything, in effect by the fanciful detail of the setting and the ships of intricate silhouette. In the later works, where Italian influence was stronger, Claude's style increased in refinement. The impression he might sometimes give of a seventeenth-century masquerade by the shore was replaced by a feeling of closer kinship with the ancient Mediterranean world. Virgilian in spirit, for example, were two of his greatest works, the 'Altieri Claudes', now in the Fairhaven Collection, Anglesey Abbey. The theme of one, the arrival of Aeneas at Pallantaeum, was painted to the requirements of Prince Gasparo Altieri, who claimed descent from Aeneas, the legendary founder of Rome. The elongated figures in the picture were like mysterious phantoms of the past. The galley conveying Aeneas to the site on which Rome was to be built was pictured

with some effort at a plausibly antique design. The total effect was truly and not theatrically 'classical'.

Equal in a long-term influence but in extreme contrast to Claude in character and aim was his contemporary, the Neapolitan painter Salvator Rosa (1615–73). The contrast between them is as distinct as James Thomson suggested in the celebrated reference to:

> whate'er Lorraine light-touched with softening hue,
> Or savage Rosa dash'd or learned Poussin drew.

They had an attachment in common to the southern Italian coasts, but their differences of temperament were as clearly marked in their pictures of sea and shore as in the far distance between Claude's pastoral landscapes with their fertile and well-wooded prospects and Salvator's views of a rugged and barren Calabria. The coast that for Claude became a sumptuous dream wrapped in sunlit peace was an area in which Salvator sought out such coastal caverns and grottoes as might be imagined a refuge or headquarters for the presumedly lawless characters he so often painted.

54 Claude Lorrain. Seaport at Sunset. 1639. Oil, 29⅜×40 in. Paris, Louvre.

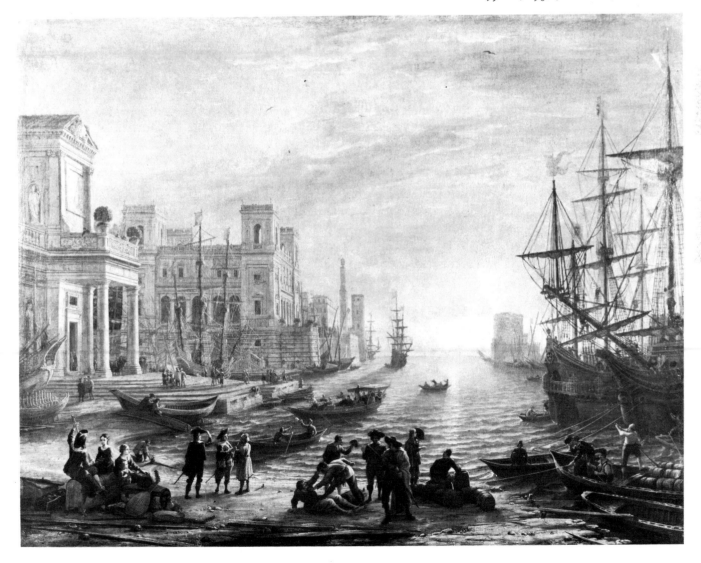

65

Rosa was less influenced by the international currents of the Roman art world than by the sombreness of the Neapolitan School on which the Spanish painter, Jusepe de Ribera, left his stamp. Born in the region of Naples, Salvator Rosa worked in youth in the studio of Francesco Fracanzano, a follower of Ribera, whose sister Salvator married. Though he worked mainly at Rome and Florence with only a brief return to Naples, the sombre Neapolitan influence was always present in his scenes of martyrdom, torture and witchcraft, battle scenes and landscapes. It is assumed that during his stay at Naples as a young man he painted sketches from nature that were the basis of his coast scenes.

These contributed to his success in Rome where he made a dramatic and successful appearance as a painter, poet, actor, and Stoic philosopher. Salvator can be appreciated as an early Romantic in his large ambitions. The two poles of Romanticism are exemplified in Claude's nostalgia for an idyllic past and Salvator's feeling for the violent and sinister. His coast had this menacing air and even ships in harbour took on the air of a pirate fleet in its stronghold. The impression of menace was heightened by a characteristic colour scheme concentrating on depth of shadow in the areas of light, and a livid coldness rather than an enlivening touch of positive colour. Such paintings appealed strongly enough to artists of a later age as to give rise to many variants. Alessandro Magnasco (1667–1749) pushed Salvator's violence to a further extreme. This Genoese painter delighted in the wildness of foam round rocky headlands as in the 'Ships on a Rocky Coast' (Pinacoteca, Bologna) and in the stabbing touches of the brush that churn up the waters in his picture of St Anthony preaching to the birds and fishes (Beit Collection). His influence, combined with that of Salvator, is traceable in the work of the Venetian painter, Marco Ricci (1676–1729/30) who, however, modified tension of style and theme to more decorative purpose. The long continuance of the Salvator Rosa tradition in the later eighteenth century as well as the later influence of Claude, belong to a following chapter of history.

The Dutch painters of the seventeenth century who joined in the pilgrimage of artists to Rome were early in appreciation of Claude's 'seaports' with their tranquil glow of sun and seaside picturesqueness. By what means Cuyp shared in their discovery of sunlight has already been discussed. How the realistic outlook of the Dutch painters who went to Italy and studied Claude's work at first hand was changed in consequence has a good example in Adam Pijnacker's 'Estuary scene with barges and mountains' (Wadsworth Atheneum, Hartford, Connecticut) with its peaceful sense of a Mediterranean existence inseparable from the past and continuing a placid history.

3

The eighteenth century – Britain, France, and Italy

It was not until the eighteenth century that what might be called a British School of marine painting came into existence. Since Tudor times it had been a usual practice to look to Continental Europe for skilled painters, for portraiture in particular; a main interest of court and artistocracy. When some maritime event called for record, the same thing applied, the special skills of Netherlandish artists were sought. The anonymous painter of 'The Embarkation of Henry VIII from Dover, May 31, 1519' (Hampton Court) was probably Flemish. The Duke of Nottingham employed Hendrick Vroom for the design of 'The Defeat of the Armada' to be worked out in tapestry.

Such occasions were rare enough. Although the importance of a fleet and the ships that explored the world was well understood, the idea of pictorial record was in its infancy. Only as an allegory of danger overcome did Hans Eworth, anglicized Fleming, make the unusual addition of a ship in a storm to his portrait of Sir John Luttrell, 1550 (Luttrell Collection, Dunster Castle). The ship models of a later age, reconstructed from plans and the probabilities of appearance, are often the only record of ships traditionally famous. The aspect of Henry VIII's *Henri Grace à Dieu*, the *Great Harry*, of which 'the like had never been seen in England', vividly presented in the model in the Science Museum, South Kensington, was based on a drawing in a navy roll of 1546 preserved in the Pepys MS. at Magdalene College, Cambridge.

No contemporary picture (or model) exists of the *Golden Hind* in which Sir Francis Drake circumnavigated the globe or of the *Mayflower* of the Pilgrim Fathers. In the first half of the seventeenth century one would look in vain for pictures of ships or of such a development as was going forward in the Netherlands where marine painting had its part in the general progress of the art of landscape. It was probably an artist from the Netherlands, though his name is not known, who painted the portrait of Phineas Pett (1570–1647), the naval architect who was appointed commissioner of the navy in 1630. He is seen with the great ship in the background which he built for Charles I, the *Sovereign of the Seas* (National Maritime Museum, Greenwich). An expert hand did justice in the picture to the carved and gilded decoration of the stern, designed by Van Dyck and executed by the King's master-carver, Gerard Christmas.

The recurrent wars with Holland in the second half of the seventeenth century made it seem desirable to follow the Dutch lead in paintings of individual warships and the panoramas of naval engagements. A number of paintings in a somewhat cumbrous version of the Dutch style have been attributed to one Isaac Sailmaker (?1633–?1721) but little is known of him beyond his interesting name. Horace Walpole in his *Anecdotes of Painting* described Sailmaker as 'a Fleming' and an apprentice of the Antwerp-born George Geldorp who lived in London and had some responsibility for looking after the king's pictures. Walpole added that

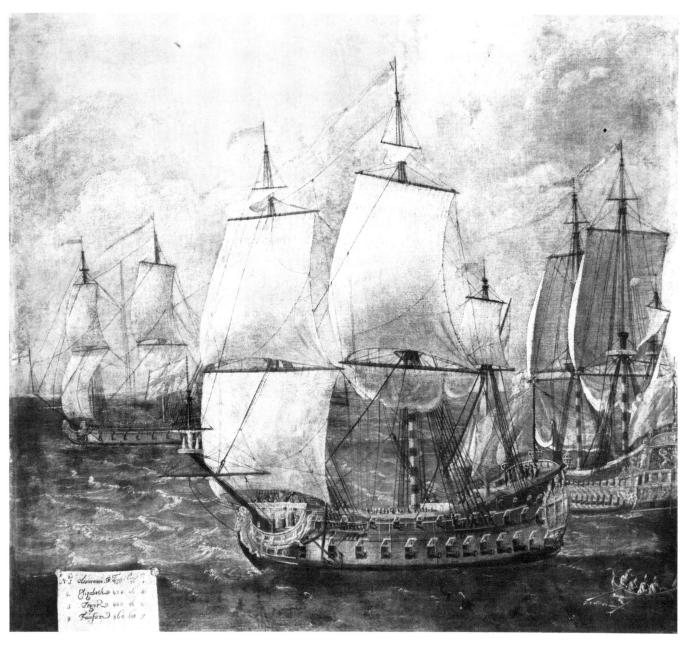

56 *Isaac Sailmaker* (?) *The* Fairfax, Assurance, Tiger *and* Elizabeth. *Oil on canvas,* 39½×37 *in. Greenwich, National Maritime Museum.*

Sailmaker was employed by Cromwell 'to take a view of the fleet before Mardyke', was still active at the beginning of the eighteenth century, and was 88 years of age when he died in 1721.

The beginning of the British School, and its later course in the eighteenth century, is better dated from the advent of the Van de Veldes, father and son, who came to London in what may have been a temporary lull in hostilities and were thereafter fully employed in painting British instead of Dutch victories. They enjoyed an unquestioned eminence in this respect for over thirty years. Their many commissions included a constant demand for replicas of pictures of the Battle of the Texel, the Battle of Solebay, and other naval events. It can be understood that

the principal partner, Willem van de Velde the Younger, had little time or scope for variety of style or type of theme but his specialization had the advantage for his English followers of offering the guidance of a well-defined and reliable recipe.

A close follower of Van de Velde in style was Peter Monamy (*c*.1670–1749) who painted ship portraits, scenes of action, and some marine compositions of a more general kind. Monamy was born in Jersey, but went to London at an early age and worked for a sign- and house-painter on old London Bridge. Horace Walpole, allowing himself some poetic license, remarked that 'the shallow waves that rolled under his window taught young Monamy what his master could not teach him and fitted him to imitate the turbulence of the ocean'. More typical in fact than 'tur-

57 *Artist unknown. Peter Pett with the Sovereign of the Seas. Oil on canvas, 55×61 in. Greenwich, National Maritime Museum.*

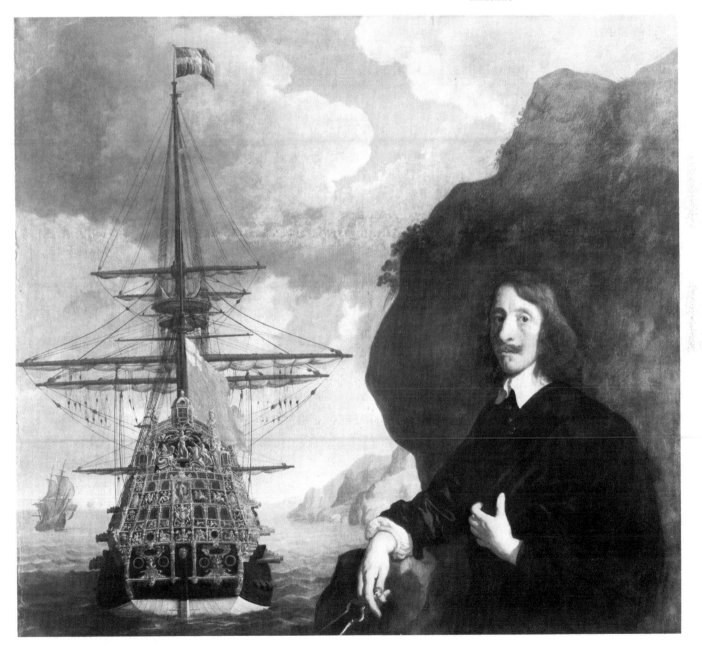

69

58 *Peter Monamy*. The Royal William *Firing a Salute* (detail). Oil on canvas, 17½×26 in. D. M. McDonald Collection.

bulence' were the calm seas he painted with ships riding at anchor, after Van de Velde's manner. The precept of pictorial composition that a large object should be balanced by a small one was consistently applied in such works by the contrasting proportions of a tall ship and a yacht or barge nearby. Monamy had a special liking also for the ceremonial moments when a man-of-war fired a gun at sundown or on other occasions as a form of salute, a favourite Van de Velde subject that the English painter treated in much the same manner.

Monamy was the most distinguished of the immediate followers of Willem van de Velde the Younger. Others who relied on Dutch example were Robert Woodcock (c.1691–1728) who made copies of Van de Velde's works, and Francis Swaine (d.1782) who continued the established Dutch manner of painting ships becalmed and ships in stormy seas. By degrees, the Dutch influence was modified as the numbers of marine painters in Britain increased, and such original talent appeared as that of Samuel Scott (c.1701/3–72) and Charles Brooking (c.1723–59).

Samuel Scott was born in London at a date approximately fixed by the date of

his death, 12 October 1772 and the statement of his pupil, William Marlow, that he was then 70. Details of his early life and training are lacking though he is said to have first taken to painting as an amusement. He married early, had a daughter, Anne Sophia, who was baptized at St Paul's, Covent Garden in 1724, and began to produce sea pieces in that decade, the earliest known example being signed and dated 1726. An appointment as Accomptant in the Stamp Office, 1727–55, left Scott time enough to paint, naval engagements and ships at sea being his main subjects until the 1740s. They gained him the somewhat misleading title of 'the English van de Velde'. For the works commissioned by such patrons as Admiral Edward Vernon and Admiral Lord Anson, commemorating their naval exploits, Scott naturally enough consulted the existing mode of representing sea fights.

It would seem that Scott's only sea voyage was to Holland about 1748 on one of the yachts under Anson's command deputed to escort George II back to England after a visit to Hanover. His voyage along the Medway in 1732 in the company of William Hogarth and three other friends was no more than a humorous diversion described and illustrated in the *Five Days Peregrination* as a mock-heroic account of adventure afloat. Yet on the Thames there were ships of every kind for serious study. After collaboration with the landscape painter George Lambert in six pictures of the East India Company's coastal settlements, for which Scott provided the shipping, he turned in the 1740s to the views of ships in the Thames against the London background that are among his principal productions. They include such masterly works as the 'View of the Thames at Deptford' (Tate Gallery, London), the 'View on the Thames at Wapping', c.1746 (private collection), and 'View of the Tower of London', 1755 (private collection), all characterized by an unmistakeably English atmosphere and exquisite qualities of design and detail. His style in these years was greatly changed from that of the invented battle compositions in which

59 *Francis Holman. Shore Scene with Shipping. 1778. Oil on canvas, 38×50 in. D. M. McDonald Collection.*

the smoke-wreathed vessels were formal symbols of victory to the exercise of a truthful and sensitive observation.

It has been debated whether the influence of Canaletto, who visited London in 1746, was responsible for Scott's change of style and theme. Now that 'the English van de Velde' had become clearly inapposite, Scott had the misfortune to be saddled with the title 'the English Canaletto'.

Some apparent similarities result from the choice of like subjects or an almost identical viewpoint as in 'The Arch of Westminster Bridge' that both painted. Yet a difference appears in this instance between their respective handling of structure and incidental detail. There is an obvious difference also in the divergence of their interests. Canaletto came to paint a palatial London. Scott is distinct in the equal attention he gave to the varied picturesqueness of riverside warehouses, wharves, and barges. He was the intimate of the river and its craft from Green-

wich to Twickenham where he lived for some time. His later years at Ludlow and Bath where he died in 1772 were productive of little but by 1762 he had done enough for Walpole justly to acclaim him as 'one whose works will charm in every age'.

The Thames was as natural a base for marine painters in England as the system of Netherlandish waterways for the Dutch. A maritime nerve-centre was Deptford on the south bank near Greenwich. The shipyard founded there by Henry VIII was vastly increased in importance in the eighteenth century when a new period of overseas expansion followed the end of conflict with the Dutch and a new phase of rivalry with France began. Deptford was the birth-place and its shipyards the inspiration of the Cleveley family, three members of which were active as marine painters for the greater part of the century.

John Cleveley the Elder (*c.*1711–77) specialized in paintings of the river and dock-yards, the ceremony of launching in the presence of royalty being one of his themes. As an artist he was the most distinguished of the family. There are some indications that he studied the compositions of Canaletto with benefit. In his views of Deptford, with the massive hulls of men-of-war in the background, he sought to give an air of pageantry and animation to the river by the variety of barges, row-boats, and sailing ships he introduced. The incidental figures he introduced did not lack a certain eighteenth-century elegance.

His twin sons, John Cleveley the Younger (1747–86) and Robert Cleveley (1747–1809), were also marine painters. They worked in both oil and water-colour,

63 *Samuel Scott. Shipping on the Thames with a view of the Tower of London. 1755. Oil on canvas, 40×73⅝ in. Private Collection.*

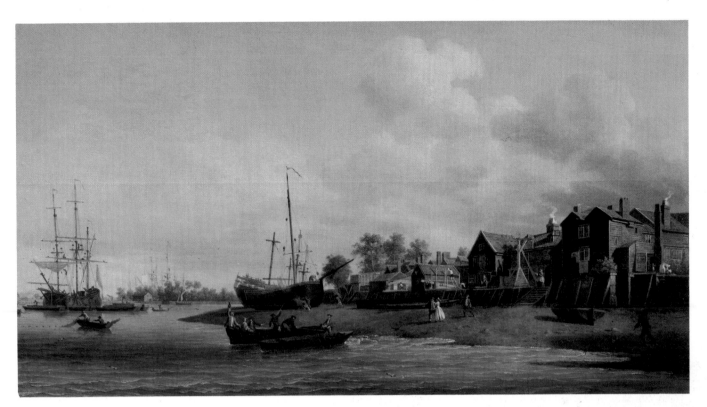

64 *Samuel Scott. A Morning with a view of Cuckold's Point. c.1760. Oil on canvas, 20½×37¼ in. London, Tate Gallery. The location is established by the inclusion of a post surmounted by horns, responsible for the name of this dock, timber-yard and ferry on the Thames.*

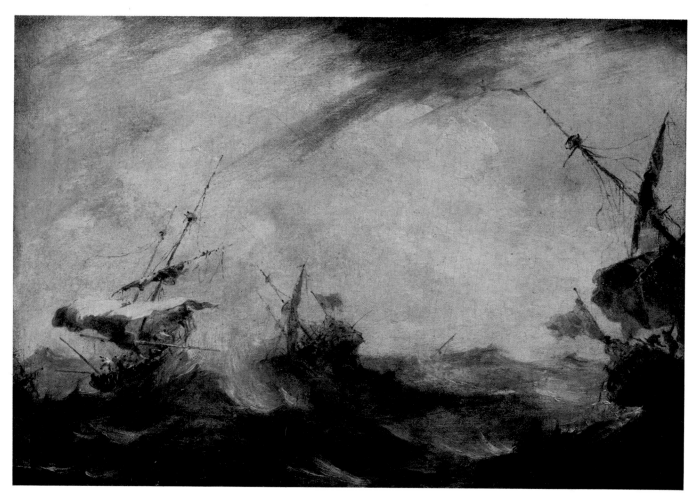

65 *Francesco Guardi. Storm at Sea. Oil on canvas, 13×17½ in. Milan, Castello Sforzesco.*

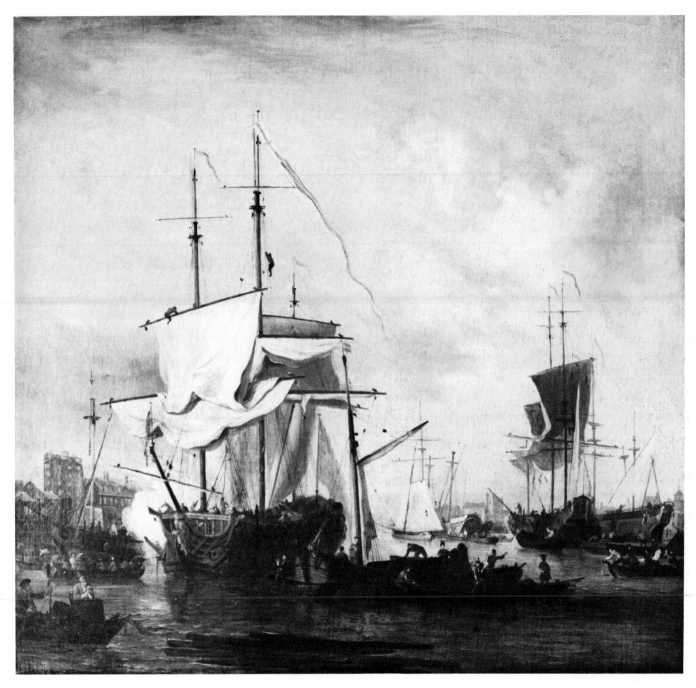

66 *Samuel Scott. Shipping on the Thames at Wapping. Mid eighteenth century. Oil on canvas, 25¼×25¼ in. Private Collection.*

John the Younger being instructed in water-colour by Paul Sandby when the latter was drawing-master at Woolwich. He exhibited paintings at the Royal Academy from 1770 and became the chosen artist on two voyages of scientific discovery. He accompanied Sir Joseph Banks to Iceland in 1772 after the celebrated naturalist's return from his voyage round the world with Captain Cook. He was again draughtsman to Captain Phipps (afterwards the second Baron Mulgrave) on his polar expedition in 1774 (in which Nelson served as midshipman). Cleveley

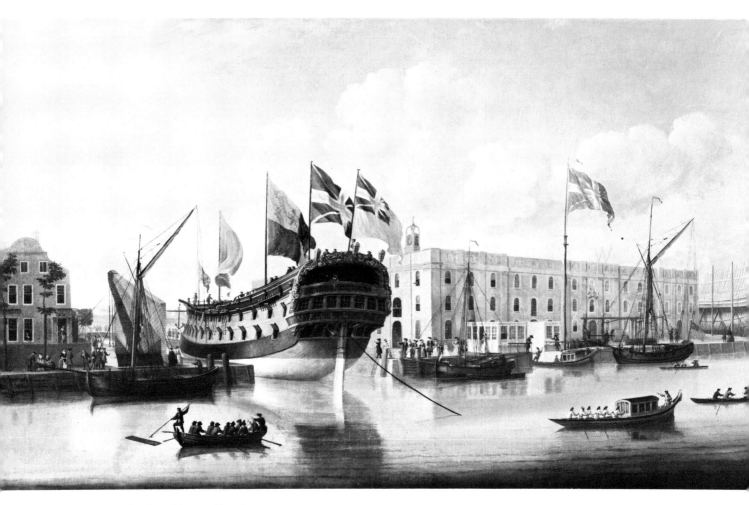

67 *John Cleveley the Elder. A Ship floated out at Deptford. 1747. Oil on canvas, 36x62 in. Greenwich, National Maritime Museum.*

made a spirited picture of the ships embedded in the ice (Victoria and Albert Museum, London). Robert Cleveley painted marine views and sea fights and exhibited at the Royal Academy from 1780 to 1803. The war with revolutionary France provided him with a number of subjects and as marine painter to the Prince of Wales and draughtsman to the Duke of Clarence he depicted such occasions as the royal greeting for Lord Howe at Spithead on his triumphant return from the Battle of the Glorious First of June. Robert Cleveley was killed in 1809 by a fall from the cliffs at Dover.

The most outstanding of the painters especially associated with Deptford was Charles Brooking (1723–59). Some hundred extant seapieces assign him prominence though he died when only 36. Whether he was born at Deptford is not known. He was possibly the son of a Charles Brooking, employed as painter and decorator at Greenwich Hospital. Edward Edwardes in his *Anecdotes of Painters* (1808) refers to his having 'been bred in some department of the dockyard at Deptford', implying at least that he had worked there. Brooking's younger contemporary, the sporting painter Sawrey Gilpin, remarked that 'he had been much at sea', leaving one to speculate whether, how often, and in what regions he had actually sailed. He could, of course, have gained his considerable knowledge of ships from his Thames-side vantage point. It is likely that he began as a painter by copying Dutch paintings or engravings from them. Mr Basil Taylor in his study of Brooking mentions a picture in the Dutch style in a private American collection signed

'C. Brooking pinxit, aged 17 years'. Simon de Vlieger and Willem van de Velde the Younger are both recognizable influences in his work, but it is evident that he was drawn more sympathetically towards the atmospheric phase of Dutch marine painting than the official record of naval architecture and battles at sea. He painted some naval actions, for instance the exploits of the 'Royal Family' privateers against the French during the Seven Years War (engraved by Boydell in 1753) but it is the freshness of his seapieces of a more general kind that singles him out as an artist. The beautifully-related movement of sky, sea, and ships, the renderings of breezy days that seem to blow a marine air across the canvas, the strong feeling for nature, are qualities to be appreciated in many works. Nor was he wanting in a sense of drama such as appears in his 'Two-decked ship on fire at night' (Mellon Collection), an anticipation of Turner's dramatic union of air, water, and fire.

Brooking seems to have been fairly well-known in his own time though without conspicuous material success. In 1752 he was invited to illustrate a work on the plant-like marine parasite the Corallines by the naturalist John Ellis. In 1754 he followed the example of Hogarth and others in presenting a work to the Foundling Hospital, an outsize canvas, 6 × 10 ft, of naval vessels and, like other donors of their paintings, was appointed a governor of the hospital. But he seems to have died in poor circumstances in a street off Leicester Square leaving wife and children in need. Many of his paintings were sold, it is said, through the shops of print-

68 *John Cleveley the Younger. Lord Mulgrave's Ships in the Ice in the Polar Regions. 1774. Water-colour, 14×18 in. London, Victoria and Albert Museum.*

69 *William Hodges. The* Resolution *and the* Adventure *at Tahiti.* 1777. *Oil on canvas,* 53½×76 *in. Greenwich, National Maritime Museum.*

sellers and frame-makers who often concealed the identity of the painter. As with so many artists of great merit it has been left to posterity to give him due appraisal.

In the second half of the eighteenth century, the number of marine painters steadily increased as Britain established her command of the sea and extended her trade, influence, and possessions all over the world. National concern with the struggles and triumphs of the time fostered a growing public taste for paintings of ships and the sea or engravings taken from them as well as a need for officially commissioned works of record. The vogue accounts for the success of Dominic Serres (1722–93), the surprising outcome of an adventurous career. French by birth, born at Auch in Gascony, Serres was intended for the priesthood by the family wish but rebelled and ran away from home. Reaching Spain, he was taken on as one of the crew on a ship bound for South America. Eventually he became master of a French ship trading with the West Indies. The vessel was the prize of an English frigate off Havana during the Seven Years War and Serres was brought to London as a prisoner and lodged in the Marshalsea Gaol. It may be assumed he was in his 30s when set free but found as little difficulty as the Van de Veldes in settling among the enemies of his native land. He married in London, decided to become a marine

painter, and is said to have had lessons in technique from Charles Brooking. This must have been at some date prior to 1759 as Brooking died early in that year. He quickly became proficient in painting and drawing and by 1761 was exhibiting at the Incorporated Society of Artists and the Free Society that preceded the foundation of the Royal Academy. He won success with surprising ease. The Gascon ex-sailor was one of the founder members of the Academy in 1768. He exhibited works there until the year of his death, 1793. A series of paintings of the royal visit to the fleet at Portsmouth (Buckingham Palace) gained him the honorary appointment of marine painter to George III. Lord Hawke, victor in the Battle of Quiberon Bay, and other naval commanders commissioned records of their successes from him. Paintings such as his view of Lord Howe's defeat of the French and Spanish fleets off Gibraltar in 1782 were popular in engravings.

Dominic Serres can be appreciated as a capable illustrator of naval history. His son, John Thomas Serres (1759–1825) adopted the same career. He exhibited sea-pieces at the Royal Academy, was for a time drawing master at the Chelsea Naval School, and followed his father as marine painter to the King, being also appointed draughtsman to the Admiralty. But success turned to disaster through his marriage to a Miss Wilmot who claimed the title of 'Princess of Cumberland' and involved him in legal complications and expenses that caused his financial ruin. He died 'within the Rules of the King's Bench', i.e. an undischarged debtor. As an artist he had an eye for the picturesque and was not exclusively occupied with sea fights. A painting of shipping at Limehouse in 1790 (Kensington Palace) is an

70 *Dominic Serres. Royal Visit to the Fleet. 1775. Oil on canvas, 60x96½ in. Royal Collection, reproduced by gracious permission of H.M. The Queen.*

instance agreeably combining the serried masts and sails of full-rigged ships with the stir of local activity in the small boats on the river and the picturesque back‑ground of Limehouse itself.

A Thames-side painter in the later years of the century was Francis Holman (fl. 1760–90), most of whose life was spent in the maritime atmosphere of Shadwell and Wapping. He exhibited at the Royal Academy from 1774 to 1784 and was noted for his paintings of East Indiamen, well conveying their elegance of line and for views of the Thames dockyards. In one especially interesting work, 'Shore Scene with Shipping' (D. M. McDonald Collection) he gave an epitome of the maritime character of the 1770s, skilfully bringing into a unified composition a fleet at an‑chor offshore and an assorted group of naval officers, fishermen, and fishwives in the foreground. He had a pupil in Thomas Luny (1758–1837) who became one of the best-known and most prolific of the marine specialists. Luny served in the Navy until 1810 and in later life lived at Teignmouth. His activity as a painter extended over more than a half-century. From 1777 to 1835 he turned out ship portraits, pictures of naval actions, and seapieces of a more general kind with unflagging vigour.

In contrast and in a separate category were the artists who accompanied Captain Cook on his voyages round the world, William Hodges (1744–97) and John Webber (c.1750–93). They may be called incidentally marine painters though their main function was to depict the landscape of regions hitherto unknown to the European. Hodges, trained in the studio of Richard Wilson, had produced topo‑

71 *John Thomas Serres. Shipping on the Thames at Limehouse. Oil on canvas, 42×60½ in. Royal Collection, reproduced by gracious permission of H.M. The Queen.*

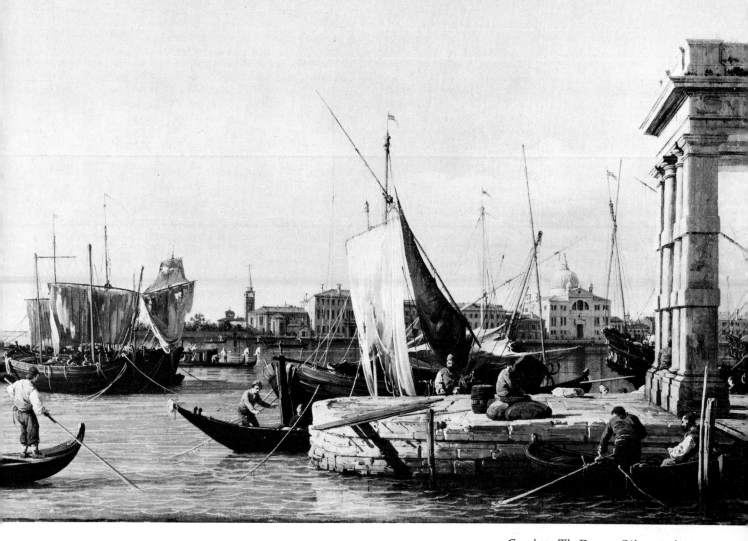

72 *Canaletto. The Dogana. Oil on panel, 18x 24½ in. Vienna, Kunsthistorisches Museum.*

graphical views that recommended him as draughtsman on Cook's second expedition in 1772, the same year in which John Cleveley went with Sir Joseph Banks to the northern seas. Hodges produced views of South Sea islands with the breadth of style he had learned from Wilson. He painted the expedition's ships *Adventure* and *Resolution* at Tahiti. Webber as a young artist fresh from the Royal Academy Schools went with Cook on his third and final voyage in 1776. He was present when the explorer met his death at the hands of natives in Hawaii. His drawing of the event was engraved by Bartolozzi. Both he and Hodges disappear thereafter from the maritime scene though their sea voyages seem to have instilled a liking for distant travel. Hodges went to India where he benefited by the patronage of Warren Hastings and acquired wealth. Prior to the loss of his fortune, an ill-conceived effort to start a bank, the failure of which hastened his death, he travelled extensively in Europe as Webber did also. Both exhibited landscapes for many years at the Royal Academy and became R.A.s, Hodges in 1787, Webber in 1791. Memories of Tahiti, the New Hebrides, New Zealand, the volcanic island of Krakatoa, and other island views, in paintings and drawings executed for the

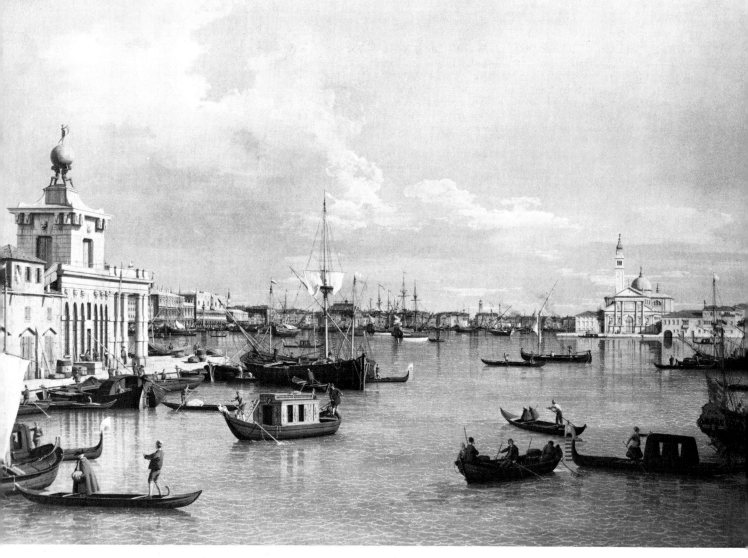

73 *Canaletto. The Basin of St Mark's from the Guidecca.* c.1735–40. *Oil on canvas, 51½×74¾ in. London, Wallace Collection, by permission of the Trustees.*

Admiralty, were the main results of their marine experience.

The continent of Europe in the eighteenth century provides a more complex study of art in marine aspect than that of the mainly Dutch-inspired English painters. In Italy there were contrasting traditions, the one stemming from the violent art of Salvator Rosa, the other the tranquil progress of view painting at Venice. The outstanding Venetian painters of *vedute*, Canaletto (Antonio Canale) (1697–1768) and Francesco Guardi (1712–93) give their reminder in many works that Venice itself was a marine phenomenon, 'wedded', as civic ceremony emphasized, to the sea. The ships of many nations moored in the Basin of St Mark's were for the painter as much a part of the magnificent spectacle the city presented as its palaces, churches, and network of canals.

There was a practical reason for view-painting in the fact that eighteenth-century Venice was a climactic point of the Grand Tour, attracting a host of wealthy visitors by its beauty, entertainments, and great works of art. Their demand for pictorial souvenirs helps to account for the vast number of works that came from Canaletto's workshop.

Canaletto, son of a designer for the theatre, took to view-painting after working in the studio of an earlier practitioner of the genre, Luca Carlevaris. He became versed in architectural perspective by a stay in Rome as a young man when he

84

studied with the painter of architecture and classical ruin, Giovanni Pannini. Thus equipped he returned to Venice and quickly became celebrated for the clarity of his colour and composition and mastery of detail. He painted a variety of craft with a skill and care equal to that he lavished on architecture. Boats of every kind lent animation to his work and enabled him to make many variants of composition. Naturally he exploited the picturesqueness of the gondola. Several times he painted, as Guardi also did, the water pageant around the *Bucentaur*, the ornate ship of state on which the Doge sailed each Ascension Day to perform the ceremony of wedding the city to the Adriatic. Of particular interest in a marine respect were his several versions of the harbour of St Mark's of which there are fine examples in the Museum of Fine Arts, Boston, the Wallace Collection in London, and the National Museum of Wales, Cardiff. 'The Harbour of St Mark's towards the East', 1735–40, at Boston is a masterpiece in which the city is a distant setting for the wide stretch of calm water alive with shipping from the towering hulks of visiting warships on peaceful missions to the local fishing boats and the ever-present silhouettes of the darting gondolas. The masts of the ships, as affectionately detailed as any nicety of Venetian architecture, are a foreground symphony of line. The distant view of buildings across a space of water variegated by shipping was always a motif in which he excelled. Apart from the purely architectural views of London painted on his two visits in 1746 and 1751, the superb river composition with Greenwich Hospital seen from across the Thames, 1747–50 (now in the National Maritime Museum, Greenwich) stands out as a masterpiece.

Francesco Guardi was in several ways unlike Canaletto as an artist even though he painted many of the same Venetian subjects. He was less confined by topographical limits, was lighter in style and more receptive to imaginative suggestion.

74 *Francesco Guardi. The Doge of Venice embarking on the* Bucentaur. *Oil on canvas, 26¼×38 11/16 in. Paris, Louvre. One of a series of twelve paintings by Guardi, commemorating Venetian festivals.*

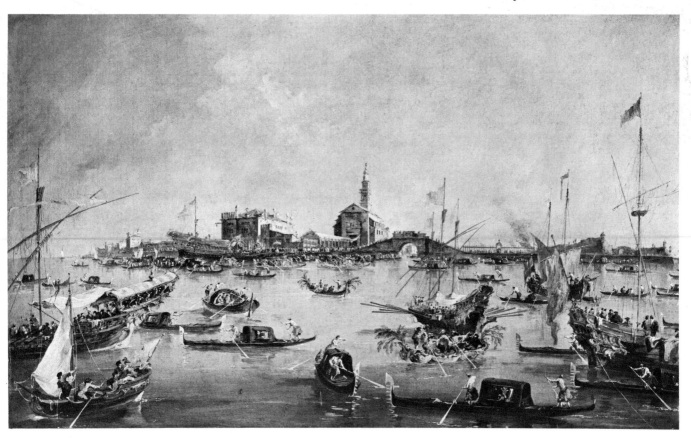

85

His work included figure compositions, portraits, invented scenes (*capricci*), and seapieces as well as views of Venice. Guardi was born in Venice, the son of a minor painter, Domenico Guardi. He was a figure painter for many years, collaborating with his brother Gian Antonio, and developing his version of the rococo style, the luminous colour and sparkle of touch that his brother-in-law, Giovanni Battista Tiepolo, handled with brilliant effect.

There was an element of fantasy in his outlook fostered in all probability by the example of Marco Ricci and Magnasco. A painting of the sea in its rage and ships in wild confusion, Guardi's 'The Storm' (Castello Sforzesco, Milan) brings to mind Ricci's theatrical exaggeration of fanciful headlands and foaming torrents, the feverish intensity Magnasco imparted to a vision of shipwreck on a rocky shore. The lagoon, after a different fashion, was equally a stimulus to fantasy. His rococo style was well adapted to convey the sparkle of the tranquil waters. The island quiet of the spits of land that dotted the surface provided him with fascinating voyages of discovery. His imagination was stirred by the marooned churches, derelict ships of faith; the grandiose ruined arches beneath which a few poor inhabitants eked out their existence. Such contrasts made it a short step from the lagoon of actuality into an aqueous dreamland. They alternate with the views of Venice itself to which it is assumed he turned about the year 1760 when he was well over 40. Many years of prolific output then remained to him in which he was assisted by his son Giacomo (1764–1835) who also produced his own small and brightly-

75 *Francesco Guardi. Capriccio. Oil on canvas, 11⅘×20⅘ in. Florence, Uffizi*

coloured gouaches of Venice.

In his own time Guardi was regarded as no more than a minor though worthy follower of Canaletto. Later assessment has seen him as the greater of the two. Both had their superlative qualities, Canaletto an unerring manual skill, Guardi a different eminence, even when they painted the same subjects, in the originality of style at once vivacious and imaginative. The end of the Venetian School that so well fused land and sea in harmony, came with the end of the century. The productive flow ceased with the advent of the Napoleonic age and alien rule, as also the flow of wealthy visitors. It was to be a long time before a new generation of artists and writers from other countries came to reinterpret the beauty of place and setting that remained impervious to decline.

Meanwhile a taste for the 'picturesque' first stimulated by Salvator Rosa was

77 *Alessandro Magnasco. Ships on a Rocky Coast. Oil on canvas. Bologna, Pinacoteca.*

growing. English and French connoisseurs in particular took pleasure not only in the topographical souvenirs of the Grand Tour, but in the wildness of nature in which they equated the 'picturesque' with the 'sublime'. The irregular conformations of rocky coasts and gnarled trees, picturesque in their variety of shape, were considered especially suited to pictorial treatment. The taste was symptomatic of a growing impatience at a cultured and theoretic level with the formal order of the urban culture of the century. Eventually the reaction became a powerful ingredient in the Romantic movement. The French painter, Claude Joseph Vernet (1714–89) illustrates in his many marine pictures a stage in this development. They were still somewhat artificially stylized in the eighteenth-century manner and not yet thoroughgoing in Romantic violence of feeling, but nicely adapted to the requirements of his patrons in a way that made him extremely popular.

Vernet, one of a family dynasty of artists, was born at Avignon, the son of a decorative coach painter, Antoine Vernet. He was first apprenticed to his father, but the favourable notice and support of two noblemen enabled him to set out for Rome in study in 1734 when he was 20. He went by sea, and the voyage was broken at Marseilles where his first view of a seaport was a revelation deciding him to

become a marine painter. In Rome he felt the influence of Claude, reflected in early harbour scenes and various renderings of sunrise and sunset, but a number of pictures of storm and shipwreck show how much he was impressed by Salvator's view of nature's savage splendour. He remained in Italy from 1734 to 1753. He visited Naples in 1737 and was a member of the Academy of St Luke in Rome in 1743. Vernet got on well with other artists and pleased a large circle of patrons. His relations with English artists and the English colony in Rome were cordial. He encouraged Richard Wilson to devote himself to landscape. He married the daughter of the Irish naval officer, Captain Parker, who commanded the papal squadron. The names and requirements of English patrons figure prominently in

78 *Claude-Joseph Vernet. Night with Moonlight Effect.* 1765. *Oil on canvas,* $43\frac{1}{8} \times 57\frac{5}{8}$ *in. Paris, Louvre.*

79 *Claude-Joseph Vernet. Entry to the Port of Marseilles (detail). 1754. Oil on canvas, size of whole, 64⅝×103 in. Paris, Louvre.*

Vernet's account and memorandum books, his *Livre de Raison*. It is evident from their requests that they shared the pleasure he took in the magic of a moonlit sea, the exhilaration of storm. On board ship in a real storm, so the story goes, he had himself lashed to the mast, to study the mountainous waves, exclaiming 'Give me my brushes so that I may paint these superb effects before I die'! Such effects on canvas were sought by a Mr Bouverie who ordered among other seapieces a tempest 'of the most horrible description', a Mr Tilson who specified his wish at various times for a fog at sea, a frightful tempest, and a calm. A contemporary writer on the state of French painting in 1746 gave the highest praise to the way Vernet painted an expanse of sea 'on which no person of sensibility could bestow even a glance without being seized by mute admiration'.

After twenty years of this success in Italy Vernet was diverted to a commission of a different kind. Madame de Pompadour persuaded Louis XV that a series of paintings of the ports of France with their ships and fortifications would give a suitable indication of his and the nation's maritime resources. Marquis de Marigny, brother of Mme de Pompadour and the king's Minister of Works, commissioned

Vernet, the obvious choice as the leading marine painter of the time. Marigny worked out an itinerary and a list of ports to be painted. Vernet began with Marseilles in 1753.

This and the other port views he completed were carefully descriptive as such an official commission required but were certainly 'picturesque' in diversity of form and incident. The elaborate compositions added to the detail of architecture and the intricate outline of big ships, a lively concourse on the water-front including, besides workers loading and unloading bales of goods, a parade of elegant strollers in the height of eighteenth-century finery. The series, intended to number twenty-four paintings, was never completed but the thirteen now preserved in the Musée de la Marine, Paris, including his views of Marseilles, Toulon, Bordeaux, La Rochelle, and Dieppe, are an achievement in the amount of information they convey if excelled as works of art by the products of his free invention. After settling in Paris in 1762 he continued to paint in his earlier vein with undiminished facility. After his death seven paintings were added to the Ports of France series (three in the Musée de la Marine, of St Malo, Le Havre, and Brest) by Jean François Hué (1751–1823) with some approximation to Vernet's style.

Vernet was the most distinguished of French landscape painters to follow chronologically after Claude and Poussin though landscape painters were few in eighteenth-century France. His principal follower was Charles-François Lacroix,

80 *Charles-François Lacroix* (*Lacroix de Marseille*). *Seaport.* 1750. *Oil on canvas, 37¼×65¾ in. Toledo, Ohio, Toledo Museum of Art.* (*Gift of Edward Drummond Libbey.*)

known as Lacroix of Marseilles (*c*.1700–82). He made copies of Vernet's harbour and moonlight scenes and painted imaginary Mediterranean seaports with fanciful complication of architecture and figures in the graceful manner of the period. But Vernet was alone among painters in France in the trend towards Romantic expression of which Salvator Rosa may be accounted a forerunner. The development of Romanticism as it applied to paintings of the sea and ships needs to be considered in a wider perspective and in various facets.

81 *Canaletto. The Harbour of St. Mark's towards the East.* c.1735–40. *Oil on canvas,* 48 15/16 × 79 15/16 *in. Boston, Museum of Fine Arts, A. Laurence, S. Sweetser and C. French Funds.*

82 *Caspar David Friedrich. Moonrise over the Sea.* 1820–6. *Oil on canvas,* 21 $\frac{9}{16}$ x27 $\frac{13}{16}$ *in. Berlin (West), Nationalgalerie, Staatliche Museen Preussischer Kulturbesitz.*

4

The romantic impulse

The nature of the Romantic impulse as manifested in art and literature has been
often and extensively studied and defined in general terms; its place in the history
of paintings of the sea merits more specific attention. It seems well established that
in art Romanticism was not a style but the expression of an attitude or state of mind,
conveying some intensity of mood and psychology. Such moods have been various
enough to include a vivid response to the phenomena of violence, a sense of what
was strange and mysterious, of what was either tragic or heroic or both in the
relation of man with his environment, a longing also for some condition different
from that of the material present.

How does this apply to marine painting? Surprisingly enough, if it should be
taken for granted that this branch of art is no more than a matter-of-fact record, it
has lent itself with striking effect to each form of Romantic motivation. The urge
to represent violent action and emotional crisis with a corresponding force of ex-
pression can be traced in many memorable paintings of storm and stress at sea. The
change of mood that showed itself in the later years of the eighteenth century is
apparent in renderings of naval warfare. It was a weakness of the conventional
battle scene of an earlier day that the ships statically placed in relation to one another
became simply parts of a diagram. Nor did the puffs of smoke that signalized the
firing of their guns convey the reality of battle. An effort to bring the human com-
batants to the fore and to picture the fury of an engagement was 'The Battle of La
Hogue' by Benjamin West, exhibited at the Royal Academy in 1780.

Benjamin West (1738–1820) had an important part in the development of Euro-
pean painting in his time. Member of an American Quaker family, born near
Philadelphia, he first earned a living there as a sign and portrait painter. He was
helped to go to Rome in 1759 and his first achievement of note was a history paint-
ing in the neo-classic style. When he visited London this won him the favour of
George III. Successful and famous in England where he settled, he made a sen-
sational new departure in his 'Death of General Wolfe', 1770, that introduced the
realism of contemporary dress and character into the picture of an historical oc-
casion. It was with a similar realism, but with the dramatic force which made him
a Romantic pioneer, that in 1780 he reconstructed an incident in the five-day battle
fought off Cape La Hogue near Cherbourg in 1692 between the French and the
combined Dutch and English fleets. West depicted the struggle round the burning
French ships with a regard for how the scene might have looked in actuality that
led him to visit the fleet at Spithead to study the effect of gun-smoke. An admiral
ordered several ships to manoeuvre and fire broadsides while West made notes,
later realized in the lurid contrasts of flame and sulphurous darkness around the
hand-to-hand encounter in the finished work.

Another American herald of the Romantic age in two remarkable works with
a marine motif was John Singleton Copley (1738–1816). Born in Boston of Irish

parents, he made a great reputation there as a portrait painter, but settled in England in 1775 and added to portraiture, historical painting. He adopted the manner of Benjamin West, though excelling him in artistic quality. A vigorous example is 'The Siege and Relief of Gibraltar' (Tate Gallery, London), that commemorated the final repulse of the combined French and Spanish fleets in 1783 after a prolonged struggle. As West had done, Copley brought the fighting men into the foreground and adroitly contrasted the confusion on the besiegers' side of torn sails, broken masts, floating debris, sinking boats, and drowning sailors with the order and steadfastness of Lord Heathfield's Gibraltar garrison.

Still more impressively Romantic was Copley's 'Brook Watson and the Shark' of which there are versions at Boston and in the National Gallery, Washington. This picture, exhibited at the Royal Academy in 1778, depicting a shark's attack on a midshipman who had gone swimming in the sea off Havana raised emotional intensity to its most acute point. The despairing movements of the intended victim at the moment before his rescue, and the macabre portrayal of the shark's jaws,

83 *Eugène Delacroix. The Barque of Don Juan. 1840. Oil on canvas, 53×77 in. Paris, Louvre.*

84 *Richard Wright. The Fishery. Oil on canvas,* 19½×26½ *in. Liverpool, Walker Art Gallery.*

gave a sensation of horror in which the artist seems to anticipate the agony of Théodore Géricault's Romantic masterpiece, 'The Raft of the *Medusa*' that was to follow many years later.

The atmosphere of violence inevitably belonged to the period of revolution and Napoleonic war. A series of paintings illustrated the struggle at sea with the dramatic heightening of reality initiated by West and Copley. In this manner, Philip James de Loutherbourg (1740–1812) produced some remarkable works. A prolific and versatile painter of landscapes, battle-pieces, and coastal views as well as an influential designer for the theatre, he was born at Strasburg, worked for some time in Paris where he became a member of the Académie in 1767, and in 1771 settled in London. He made stage designs for Garrick and later invented the miniature stage of his own with changing effects of colour and light which he called *Eidophusikon,* an invention much admired by artists, Gainsborough among them, and generally popular. He painted many shipwrecks, a theme very much in the spirit of the time (even a painter of mild rural subjects, George Morland (1763–1804) diverged from rural calm to scenes of storm and wreck after a stay on the coast of the Isle of Wight). De Loutherbourg took Vernet as his model though with more feeling for the tumult of the elements. In the dramatic 'Shipwreck' in the

85 *Benjamin West. The Battle of La Hogue.*
1778. Oil on canvas, 64½×96 in. Washing-
ton D.C., National Gallery of Art, A. W.
Mellon Fund.

Southampton Art Gallery, he added to the violence of nature that of man in the
attack on the survivors by lawless characters of the shore seeking plunder. With
a memory of Salvator Rosa shared by such other painters in England as J. H.
Mortimer and Wright of Derby who romantically idealised the bandit, he called
his outlaws *banditti*.

He began his paintings of the naval war with 'Lord Howe's Victory on the
Glorious 1st of June', 1794 (National Maritime Museum, Greenwich). The boats
of wrecked men-of-war and the sailors struggling in the sea gave added emotional
significance to the portrayal of big ships locked in action. The popularity of the
work in engraving encouraged him to paint more sea fights. In 'The Battle of Cam-
perdown, 1799' and 'The Battle of the Nile, 1800' (Tate Gallery, London) skies had
their importance in evoking the fury of action. The orange cloud caused by the
explosion of *L'Orient* in 'The Battle of the Nile' was tremendously theatrical.

86 *John Singleton Copley. The Siege and Relief of Gibraltar (detail).* 1783. *Oil on canvas,* 214×297 *in. London, Tate Gallery.*

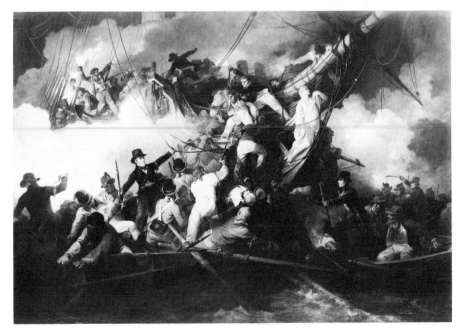

87 *Philip James de Loutherbourg. The Cutting Out of the French Corvette* La Chevrette. 1802. *Oil on canvas,* 42×59½ *in. Bristol, City Art Gallery.*

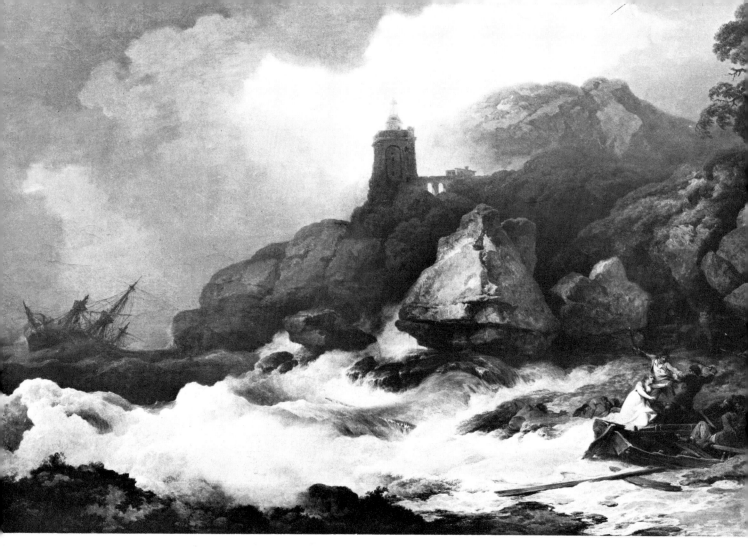

88 *Philip James de Loutherbourg. The Shipwreck. 1793. Oil on canvas, 43½×63 in. Southampton, City Art Gallery.*

Pictures of actual warfare however give only an incidental illustration of the Romantic mood. We have to reckon with the work of artists for whom the sea had a value as an incitement to personal expression of a subjective kind or a more profound view of life and nature. The great artists, Géricault and Delacroix in France, Caspar David Friedrich in Germany, and Turner in England, for whom the fate and trials of man were an essential theme, found in the sea a symbol of the forces with which humanity contended.

Géricault (1791–1824), though variously interested in military, sporting, and classic themes added one masterpiece to the pictorial annals of the sea, in the tragedy of real life he depicted in 'The Raft of the *Medusa*', 1819 (Louvre, Paris). The French frigate *La Méduse* foundered in mid-ocean in 1816 and the crew took to boats and a raft. The raft drifted helplessly for twelve days before a rescue ship arrived. By that time fifteen crazed survivors were left from the 140 that had first crowded its frail support. It is clear that Géricault intended more than an illustration of the occurrence. The 'Raft' was an expression of his belief that, as he said, 'Suffering alone is real, pleasure imaginary'. In the figures delirious and near to death, there seems a sublimation of his own troubles of mind: he exorcized horror with horror.

The 'passion for the sea' to which Delacroix confessed was also fused with the

Romantic sense of tragedy. Delacroix (1798–1863) in his vast range of emotional expression included the sea in its relevance to a feeling of loneliness and human insignificance. The despair of the castaway in the empty space of the universe is realized in his great picture of 1840, 'The Shipwreck of Don Juan' (Louvre, Paris). Like other paintings of the great Romantic it was inspired by Byron in the second canto of *Don Juan* with its grim description of the survivors of the storm who 'filled their boat with nothing but the sky for a greatcoat'. The sinister atmosphere reflects that of the poem which describes how their plight became a macabre struggle among themselves for survival.

The sea as a setting for tragedy links, in stupendous succession, Géricault's 'Raft', Delacroix's 'Barque of Don Juan', and Turner's 'Slave Ship' (Museum of Fine Arts, Boston) with its grim picture of the dead and dying slaves ruthlessly thrown overboard. Very different, though also Romantic in character, was the work of the great German contemporary of Delacroix and Turner, Caspar David Friedrich. In him the phase of introspection, melancholy, and the contemplation of mystery comes uppermost. In this respect he was without rival among his German contemporaries and his work, little known for a long time outside Germany, assigns him a European eminence.

Friedrich (1774–1840) was born in the Pomeranian harbour town of Greifswald. His early life was spent on the Baltic shore. He studied art at the Copenhagen

89 *Théodore Géricault. The Raft of the Medusa. 1819. Oil on canvas, 192⅜×280½ in. Paris, Louvre.*

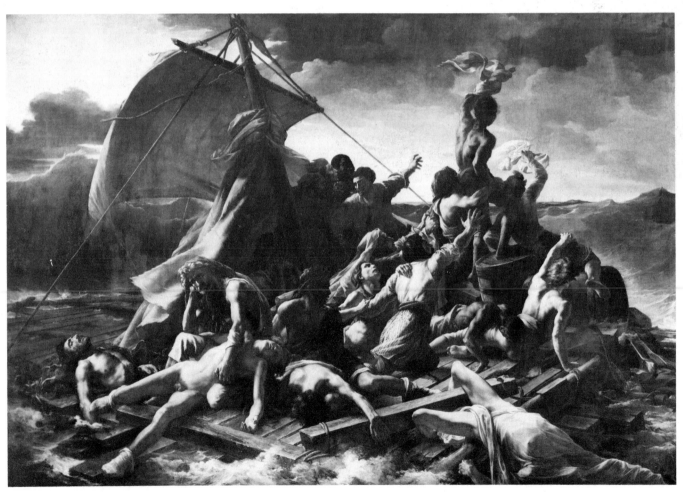

(facing)
91 *Eugène Isabey. The Wreck. 1854. Oil on canvas, 38×30 in. Detroit, Detroit Institute of Arts.*

90 *John Singleton Copley. Brook Watson and the Shark. 1778. Oil on canvas, 71¾× 90½ in. Washington, D.C., National Gallery of Art, Berlin Fund.*

Academy and in 1798 settled at Dresden, remaining there for the rest of his life except for tours in central Germany and periodic visits to Greifswald. Paintings of the sea and ships alternated with his visions of mountain heights and Gothic ruins, but he was far from being topographical. His impressions of reality were absorbed and transformed in the current of his thought. He set himself and seems to invite the spectator likewise to ponder the mysteries of life and space. This was already the effect of his early paintings in oil, a medium he began to use in 1807. Figures on the shore in the seapieces of this period seem to meditate on the immensity of ocean, a striking example being the 'Monk by the Sea', 1809 (Schloss Charlottenburg, Berlin). Contemporaries were startled by the loneliness of the small figure faced with what seemed infinity. It became usual with him to suggest meditation by such means. One of the most moving of the paintings in which the sea takes on a symbolic import is 'Moonrise over the Sea', 1820–26 (National Galerie, Berlin West). The figures looking seaward have their backs turned so that the spectator's eye turns in the same direction, to muse like them on the message of the

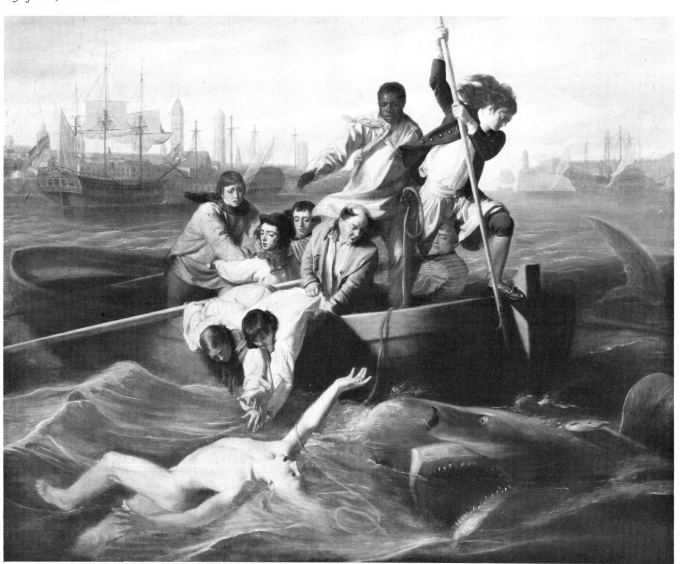

92 *George Morland. Shipwreck. Oil, 36x28 in. Private Collection.*

ghostly ships approaching the shore. Possibly, it has been suggested, they bring a message of Christian consolation in face of death, the rocks are symbols of faith and the strange blue-violet of the sky in contrast with the warm tones of the shore has some associated symbolic meaning.

A similar method of interpretation has been applied to a principal work of his later years, 'The Stages of Life', 1835 (Museum der Bildenden Kunste, Leipzig). The five ships, large and small, may be taken as emblems of the course through life of the five figures on the shore, the largest ship being assumed a premonition of the artist's approaching end, he being represented by the figure with his back turned. Such explanations can be carried too far. Haunting mystery is part of the beauty of Friedrich's work. Whatever Christian symbolism his sea pictures contain, they call also for appreciation of the elegance of masts and sails and the poetry of the Baltic scene. Such a work as the 'View of a Harbour', 1816 (Potsdam, Sanssouci) has its reminiscence of the harbours of Claude. But there can be little doubt that ships and the sea for Friedrich were means of expressing his view of the transience of life and the spirit of resignation, melancholy but not without hope in which external appearance stood for something more profound.

(*facing*)
93 *Caspar David Friedrich. View of a Harbour. 1815. Oil on canvas, 35¼x27⅞ in. Potsdam, Sanssouci.*

The northern seascape had its inspiration to give to others, including Friedrich's close friend, Johan Christian Claussen Dahl (1788–1857). Dahl, like Friedrich, studied art at Copenhagen and afterwards went to Dresden where the two artists met. Their friendship was lifelong and for a time they lived in the same house, Dahl being much influenced by Friedrich in his early work though later differences of aim became manifest. Dahl, unlike his friend, was interested in the sea as an aspect of nature in a material sense. Visits to his native Norway led to his being noted for paintings of stormy coasts, shipwrecks, and the stern beauty of the fjords.

Norway could inspire the painting of a scene as dramatic in its loneliness as the 'Liensfjord Lake' (Victoria and Albert Museum, London), by Francis Danby (1793–1861). This Irish painter, born near Wexford, who studied art in Dublin and worked in Bristol and London, represents both the dramatic and lyrical side of the Romantic impulse. He is best known for his version of that 'universal inundation', the Deluge, which also engaged the talents of John Martin (1789–1854)

94 *Caspar David Friedrich. The Wreck of the* Hope. *1824. Oil on canvas, 38⅘x80⅘ in. Hamburg, Kunsthalle.*

95 *Caspar David Friedrich. The Stages of Life.* c.1835. *Oil on canvas,* 28⅜×36⅞ *in. Leipzig, Museum der Bildenden Kunste.*

96 *Johan Christian Dahl. Fjord Landscape in Moonlight. Oil, 21½x28 in. Karl-Marx-Stadt, Städtische Kunstsammlungen.*

and Washington Allston (1779–1843). The sea became a colossal force in what Martin called his 'imaginings of the Antediluvian World'. Martin, the author of many apocalyptic scenes, excelled in this imaginative distension of the seapiece. The American painter, Washington Allston, who worked both in America and London, has his own version of oceanic might. In such a painting as his 'Rising Thunderstorm at Sea' (Museum of Fine Arts, Boston) he gave a lead to artists in the United States. The potentialities of the seapiece and the inference to be drawn from it have their supreme illustration in the works of J. M. W. Turner.

5

Turner, Constable, and their contemporaries

The two great English masters of landscape, Joseph Mallord William Turner (1775–1851) and John Constable (1776–1837), different as they were from one another in outlook and achievement, both produced superb sea pictures. If Turner never fails to astonish by the number and variety of those he painted, Constable displays all his rare quality in comparatively few. Their unlikeness in many ways was what might be expected between Turner, the barber's son, born in London in Maiden Lane, and Constable, the miller's son, born at East Bergholt in Suffolk; between Turner the unwearying traveller about Europe and Constable who never wished to leave his native land; between Turner as one with philosophic ideas about the fate of man, pitted against greater forces, and Constable with his clear-cut notion of the purpose of painting independent of any such concern.

Yet their devotion to nature links them as representatives of the Romantic era. They shared also a discriminating view of the course of landscape in the past and seem much of the same mind as to the painters they most admired.

Both had great respect for the Dutch School of the seventeenth century, including the marine painters. Turner was a grateful student of Willem van de Velde the Younger. Looking again, after many years, at a print of a Van de Velde 'Ships in a storm', he is said to have declared 'This made me a painter'. He reproved someone who praised him as being far superior to Van de Velde with a shake of the head and the words 'I can't paint like him'. Though Constable with critical impartiality placed Ruisdael above Van de Velde, his respect for the latter is evident. He delighted in Ruisdael, Cuyp, and others who showed 'how much interest the art, when in perfection, can give to the most ordinary subjects'. There is a remark with a bearing on his own practice in one of his lectures, at the Royal Institution, that 'the Dutch painters were a *stay-at-home people* – hence their originality'. But both he and Turner concurred in their veneration for Claude, a painter, said Constable, 'whose works had given unalloyed pleasure for two centuries', whose 'Embarkation of St Ursula' in the National Gallery he regarded as 'probably the finest picture of *middle tint* in the world'. It is easy to understand the discomfort Turner felt at Ruskin's disparaging criticisms of Van de Velde and Claude in *Modern Painters*. made in order to assert Turner's superiority.

The sea had some part in each of the clearly-marked stages of Turner's art. His start as a topographical draughtsman and water-colourist in the picturesque style that accorded with the taste of the time entailed frequent journeys around Britain in search of material. The sketch-books in the Turner Bequest preserved in the British Museum include numerous studies of boats and sea dating from these early expeditions. They took him before he was 20 to the coast, in South Wales, Kent, Sussex, and the Isle of Wight. For Margate and Brighton in particular he acquired a lifelong affection. His intent observation of the sea appears in the coloured drawings of what is known as the 'Wilson Sketchbook' made about the time of his first

97 *J. M. W. Turner. Dordrecht: The Dort Packet-Boat from Rotterdam Becalmed. 1818. Oil on canvas, 62×92 in. From the Collection of Mr and Mrs Paul Mellon.*

98 *J. M. W. Turner. A First-Rate taking in Stores. 1818. Water-colour and pencil, $11\frac{1}{4} \times 15\frac{5}{8}$ in. Bedford, Cecil Higgins Art Gallery.*

99 *Francis Danby. Liensfjord Lake, Norway. Exhibited R.A. 1841. Oil on canvas, 32½×46 in. London, Victoria and Albert Museum.*

100 *Philip James de Loutherbourg. The Battle of Camperdown.* 1799. *Oil on canvas,* 60x84¼ *in. London, Tate Gallery.*

101 J. M. W. Turner. *Fire at Sea*. c.1835.
Oil on canvas, 68½x88 in. London, Tate
Gallery.

102 *J. M. W. Turner. Yacht approaching
the Coast. c.1842. Oil on canvas, 40½×56 in.
London, Tate Gallery.*

known oil painting 'Fishermen at Sea' (Tate Gallery, London), a night view off the Isle of Wight, hung in the Academy of 1796 and already remarkable for its dramatic power.

103 *J. M. W. Turner. Guardship at the Great Nore. 1810. Collection of Major General E. H. Goulburn.*

Turner was then 22. From that time on he was to produce both oil paintings and water-colours with equal command and originality. 'Fishermen at Sea' was followed by 'Moonlight. A Study at Millbank' (Tate Gallery, London), a calm river night scene in which he seems to have taken Van der Neer's 'Moonlights' as his model. His early masterpiece 'Calais Pier' (National Gallery, London) exhibited in 1803, which followed his first visit to the Continent when the Treaty of Amiens made it possible in 1802, had a vigour without precedent. He may have had a storm by Van de Velde in mind but there is little to recall the Dutch master in the actual treatment of the composition. The Dover packet seen arriving at Calais in rough weather represents the vessel in which Turner himself crossed the Channel, the turbulent seas are those in which it nearly overturned. There is the feeling of actual experience in the surge of the waves. A few excited scribbles in white chalk on the tinted leaves of a sketch-book, made when he landed, were enough to recreate the instant impression in Turner's astonishing memory.

104 *J. M. W. Turner. Helvoetsluys:* The City of Utrecht 64 *going to Sea. 1832. Oil on canvas, 37×47 in. Bloomington, Indiana, Indiana University Art Museum.*

TURNER
IMPORTANT

His seas were to become ever wilder in later pictures of shipwreck and storm Ruskin well describes Turner's 'image' of the sea, in *The Harbours of England,* as 'a very incalculable and unhorizontal thing, setting its watermark sometimes on the highest heavens as well as on sides of ships . . . half of a wave separable from the other half . . . not in any wise limiting itself to a state of apparent liquidity but now striking like a steel gauntlet and now becoming a cloud and vanishing, no eye could tell whither; one moment a flint cave, the next a marble pillar, the next a mere white fleece thickening the thundery rain'.

The Romantic mood intensified by the violence of a world at war, the feeling of tragedy and fatality weighing on the observation of natural phenomena, was manifest in a whole series of paintings in which the cruel sea was an emblem of nature's triumph over the aims and puny constructions of man. These came at intervals and alternated with works of another kind in a way that makes Turner's evolution a complex study. Tremendous seas battered the wrecks and swept around and over the struggling survivors in 'The Shipwreck' (Tate Gallery, London), 1805, and the 'Wreck of a Transport Ship' (Gulbenkian Foundation, Lisbon), 1810.

116

But in the meantime, between these two dates, he was employed on the more or-thodox patriotic battle piece 'The Battle of Trafalgar as seen from the Mizen Shroud of the *Victory*' (Tate Gallery, London), 1806–08. For that purpose he visited the *Victory* on the Medway, talked with the crew, and made drawings of the ship.

He would perhaps have given a measure of approval to Ruskin's dictum that 'take it all in all, a Ship of the Line is the most honourable thing that man as a gregarious animal has ever produced'. He seems to have learned by heart every detail of the men-of-war of the Napoleonic years. His memory and mastery of water-colour are alike remarkable in 'A First-Rate taking in Stores' (Cecil Higgins Art Gallery, Bedford) which he painted in a morning at Farnley Hall in Yorkshire, the home of his patron, Walter Marsden Fawkes, where he was always made wel-come. The purpose was to give an idea of the size of such a vessel. The son of the house, Francis Hawksworth Fawkes then aged 15, was given the exceptional privilege of watching Turner at work. He was later to describe his wonder at the way the ship emerged on the water-saturated paper, while Turner swiftly rubbed in colour and scratched out highlights 'in a kind of frenzy'.

105 *J. M. W. Turner. Van Tromp Going About to please his Masters, Ships at Sea, Getting a Good Wetting.* 1844. *Oil on canvas,* $37\frac{5}{8} \times 47\frac{3}{4}$ *in. Surrey, Royal Holloway College.*

106 *J. M. W. Turner. Ulysses deriding*
Polyphemus. 1829. *Oil on canvas,* $52\frac{1}{4} \times 80\frac{1}{2}$
in. London, National Gallery.

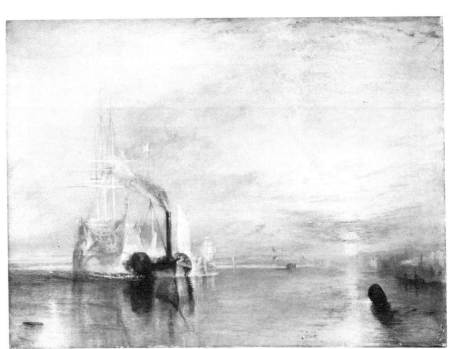

107 *J. M. W. Turner. The* Fighting
Téméraire *Tugged To Her Last Berth To*
Be Broken Up. 1838. *Oil on canvas,* $35\frac{3}{4} \times 48$
in. London, National Gallery.

It may be that Turner's visit to the Louvre in 1802, when he made copious notes of the pictures he saw, may have first given him the idea of painting in the manner of the masters he admired, not with the wish to do better than they, but to complete his education as an oil-painter by the more intimate acquaintance thus to be gained. He examined in this way the methods and styles of Claude, Cuyp, and others. It was a form of study spread over a number of years. His effort to achieve a radiance of light comparable to that of Claude's 'seaports' was made in 'Dido building Carthage' (National Gallery, London) exhibited in 1815. It was later his wish that the painting should be hung near Claude's 'Embarkation of St Ursula' though the full revelation of the sun and its glow had to await the visits of Turner to Italy that began in 1819.

The most successful of his paintings 'in the manner of' was the serene 'Dordrecht: The Dort Packet-Boat from Rotterdam becalmed' (Mellon Collection, New Haven). This picture may have been inspired partly by his visit to Holland in 1817 and by a picture, already by then in an English collection, the view of Dordrecht by Cuyp now in the Iveagh Bequest, Kenwood. The sympathy between the two artists appears not in any obvious descriptive detail but in the mellow warmth of colour, the sense of space, what Turner described in Cuyp's picture as

108 *J. M. W. Turner. Keelmen Heaving in Coals by Moonlight. 1835. Oil on canvas, 36¼×48¼ in. Washington, D.C., National Gallery of Art, Widener Collection.*

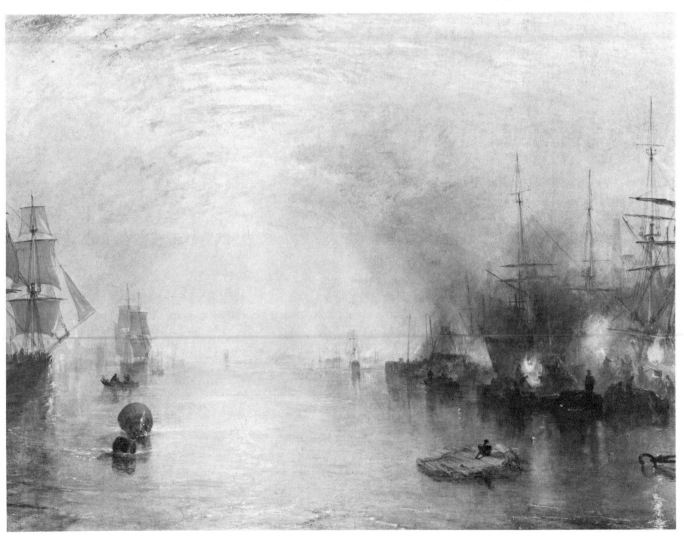

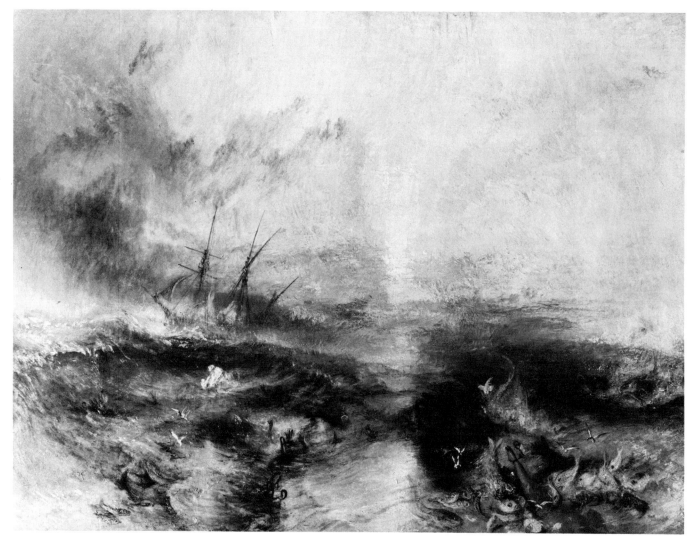

109 *J. M. W. Turner. Slavers Throwing Overboard the Dead and Dying. Typhoon Coming On.* 1840. *Oil on canvas,* 35¾×48 *in. Boston, Museum of Fine Arts, H. L. Pierce Fund.*

'the golden colour of ambient vapour'. Constable thought Turner's 'Dort' 'the most complete work of genius he ever saw'. It is certainly one of the marine masterpieces.

Variety in Turner's seapieces was constantly displayed in the different terms of his two media. Luminous water-colours of Venice shine with delicate notes of sunrise or sunset in contrast with the operatic splendour of colour in 'Ulysses and Polyphemus' (National Gallery, London). The variations of mood are marked in the paintings of the sea that Turner continued to produce until the last few years of his life. In the 1830s Dutch art and Dutch maritime history were much in his thoughts. He seems to have had Van de Velde in mind in the cool tones and style of composition of 'Helvoetsluys', 1832 (Indiana University Art Museum, USA). This was the picture he heightened in effect on the Academy varnishing day by the addition of a single patch of red which he shaped into a buoy. The purpose was to offset the neighbouring brilliance of Constable's 'Opening of Waterloo Bridge'. 'He has been here and fired a gun' was Constable's comment.

The manoeuvres of the Dutch admiral Tromp were the theme of several paintings and as late as *c.*1844 he depicted with a characteristically informative title,

and the dynamic freedom of his later years, 'Van Tromp, Going about to Please his Masters, Ships at sea getting a good wetting' (Royal Holloway College, Surrey). When he chose, Turner could be gently poetic as in the tranquility of sky and sea after storm of 'The Evening Star' (National Gallery, London), 1830–35, or the calm of moored boats and delicate distance of 'The Old Chain Pier, Brighton' (Tate Gallery, London) *c.*1830–31. Tranquility and a sunset appropriate to the melancholy of the occasion distinguish what is perhaps the most famous of all marine paintings, 'The Fighting Téméraire Tugged To Her Last Berth To Be Broken Up, 1838' (National Gallery, London), 1839. Named from a captured French ship, the *Téméraire* became known as the 'Fighting' *Téméraire* after the Battle of Trafalgar in which the captain and crew had an active part. A stately phantom in the painting, the ship on the way from Sheerness to Rotherhithe signalizes the passing of the age of 'wooden walls', the steam tug towing it the advent of the age of steam. From the appearance of steamboats as a main feature in other paintings by Turner as well as the railway in 'Rain, Steam and Speed' it may be concluded that he had no such fastidious aversion from progress in this form as his great admirer Ruskin showed. For Ruskin the 'Téméraire' was the last perfect expression of Turner's genius

110 *J. M. W. Turner. Snowstorm: Steamboat off a Harbour's Mouth making Signals in Shallow Water and Going by the Lead. 1842. Oil on canvas, 36x48 in. London, Tate Gallery.*

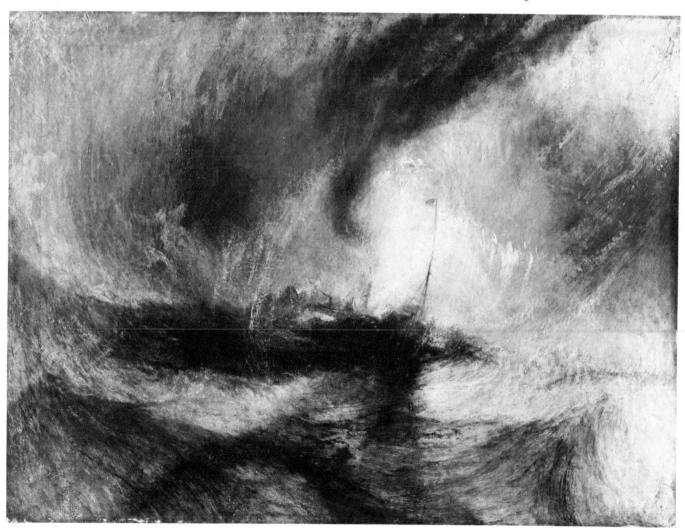

111 *J. M. W. Turner. Yarmouth Sands.*
Water-colour, 9¾×14¼ in. From the Collec-
tion of Mr and Mrs Paul Mellon.

112 *J. M. W. Turner. Wreck of a Trans-*
port Ship. c.1810. *Oil on canvas, 68⅛×96⅜*
in. Lisbon, Gulbenkian Foundation.

113 *John Constable. The Marine Parade and Old Chain Pier, Brighton.* 1826–7. *Oil on canvas,* 50×72¾ *in. London, Tate Gallery.*

though in fact there were great works still to come. The sense of fatality, a contrast with the tranquil scenes of the 1830s, had already reappeared in the stupendous 'Fire at Sea', *c*.1835 (Tate Gallery, London). There followed in 1840 the intense drama of 'The Slave Ship – Slavers Throwing Overboard the Dead and Dying. Typhoon Coming On' (Museum of Fine Arts, Boston). Mortality was again the theme in 'Peace. Burial at Sea', 1842 (Tate Gallery, London). What emotional value he could extract from the dark silhouettes of sails and ships is to be seen in this picture of the burial of Sir David Wilkie who was taken ill and died on board ship when returning from his journey to Palestine. It was an intended vehemence. Turner's reply to a criticism of the blackness of the sails was that he would have made them even blacker if he could.

It was in a final phase of Turner's art that sky and sea were brought into almost abstract relation. A comment by Ruskin in *Modern Painters* on the effect of a gale well applies to this ultimate development; 'you will understand that there is indeed no distinction left between the sea and air, that no object nor horizon, nor any landmark or natural evidence of position is left; that the heaven is all spray and the ocean all cloud and that you could see no farther in any direction than you could see through a cataract'.

'Snowstorm: Steamboat off a Harbour's Mouth making Signals in Shallow Water and going by the Lead' corresponds very nearly to this description. Sea and

116 *John Constable. Coast at Brighton.*
c.1824. From the Collection of Mr and Mrs
Paul Mellon.

sky together form a vortex of unbridled natural force. The painting was a memory of the storm Turner had himself experienced when on board the *Ariel* after leaving Harwich, as his note in the Academy catalogue of 1842 recorded. Like Vernet before him, he had himself lashed to the mast and for four hours watched the wildness of the elements! 'I did not expect to escape', he said 'but felt bound to record it.' The picture imparts an exhilaration that Turner may have felt in actuality during his vigil instead of the pessimism implicit in his earlier shipwrecks and scenes of peril at sea. Nor did he cultivate effects of storm only in this late period. There were also delicate harmonies of colour in paintings of the sea that dissolved forms into idyllic abstraction. 'Yacht approaching the Coast', *c.*1845 (Tate Gallery, London) is a fine example of this last phase.

There is no parallel to Turner's extraordinary evolution. That of Constable is in many ways different. He had a realist rather than romantic viewpoint, holding to the belief that the simplest subject could be made into a work of art and therefore that a journey in search of striking effects was unnecessary. Like the Impressionists after him he was content to paint wherever he happened to be, confident that light translated into colour and the sky that was a universal presence could lend interest to the least distinguished of landscapes in nature.

John Constable (1776–1837), born at East Bergholt, Suffolk, the son of a prosperous miller, took longer than Turner in getting into his stride as a painter. He was first destined for the family business and was employed in it for some little time. It was not until he was 24 that he became a student in the Royal Academy Schools, the connoisseur, Sir George Beaumont, to whom his mother gained him an introduction, having persuaded Constable's father that his son should be allowed to follow the bent, already made evident by his sketching expeditions in Suffolk and copies of old masters. His first acquaintance with the sea was a trip from

(*facing*)
114 *John Constable. Coast Scene with*
*Shipping in the Distance. c.*1824. *Oil on*
paper laid on canvas, 12⅓×19½ *in. London,*
Victoria and Albert Museum.

(*facing*)
115 *John Constable. Rough Sea, Weymouth*
(?) *c.*1816. *From the Collection of Mr and*
Mrs Paul Mellon.

London to Deal in 1803 in the *Coutts*, an East Indiaman, at the invitation of the captain, a friend of Constable's father. He was, he wrote from London to his friend at East Bergholt, Dunthorne, 'near a month on board and was much employed in making drawings of ships in all situations'. The drawings, which he lost for a time but later recovered, many of them now preserved in the Constable Collection at the Victoria and Albert Museum, were executed in a kind of graphic shorthand that suggests he had profited by study of the vivid outlines of the Van de Veldes. At Chatham he hired a boat to see the men-of-war and sketched the *Victory* from various angles. 'She looked very beautiful, fresh out of dock and newly painted.'

The drawings were material for his one excursion three years later into the battlepiece. This was his water-colour, made after the Battle of Trafalgar, of H.M.S. *Victory* between two French ships of the line (Victoria and Albert Museum, London). It was exhibited at the Academy in 1806. A Suffolk sailor from the *Victory* who took part in the action is said to have supplied him with details but not, it may be gathered from the picture, in a way to fire Constable's imagination. It is clear that the painting of dramatic events was not his *métier*. If Turner became somewhat confusedly melodramatic in his versions of Trafalgar, Constable went to the ·

120 *Richard Parkes Bonington. The Coast of Picardy. Oil on canvas,* 14⅜×20 *in. London, Wallace Collection, by permission of the Trustees.*

opposite extreme in bleakness of composition. A long time afterwards, the British Institution offered prizes for the best sketches and paintings of the Battles of the Nile and of Trafalgar, but this, Constable remarked, 'does not concern me very much'. By then (1824) he had produced many masterpieces inspired by the rural scene in eastern and southern England. 'The Hay Wain' painted in 1821 made its great impression in 1824 at the Paris Salon. Yet this was also a year in which he returned to the sea as a subject viewed from the shore, in some of the most brilliant of his small oil pictures.

Holiday occasions and considerations of health were motives for seaside excursion. In 1816 on his honeymoon in Dorset he had painted on the beach his first study (Victoria and Albert Museum, London) for 'Weymouth Bay', swiftly noting the transient gleams of light on sea and sky. His concern for Mrs Constable's health was a reason for later visits to Brighton. He disliked the town itself as 'the receptacle of fashion and off-scouring of London'. There was 'nothing here for a painter but the breakers and the sky which have been lovely indeed'. But these were sufficient for one who could 'make something out of nothing, in attempting which', said Constable, 'he must almost of necessity become poetical'.

The remark well applies to such a small masterpiece as the 'Brighton Beach:

Colliers', 1824, so spontaneous and simple in conception, so fresh and sparkling in marine atmosphere. There are others, perhaps less well known, in the Victoria and Albert Museum that are satisfying to the eye in a similar concentration on the space of sky and sea, subtly heightened in effect by the placing of a fishing boat or distant sail. Interesting in a different way but without the superlative freshness of the sketch is the view of the 'Marine Parade and Old Chain Pier, Brighton', 1827 (Tate Gallery, London). Like Turner, with whose version of the subject Constable's may be compared, he was interested in the slender lines of the iron pier reaching out seaward, though for once, rather than making 'something out of nothing' he introduced a great deal of picturesque detail, beached fishing boats, as well as boats afloat, an overturned dinghy, anchors, and various figures. On this occasion Turner had the advantage in the grander simplicity of his 'Chain Pier'. It is in the direct oil sketches of the sea, in quality comparable with his masterly oil sketches of rural landscape, that Constable's genius is evident in its uniqueness.

Among the contemporaries of Turner and Constable who excelled in the

121 *Richard Parkes Bonington. The Fishmarket, Boulogne. Oil on canvas, 14x20 in. From the Collection of Mr and Mrs Paul Mellon.*

129

122 *David Cox. Rhyl Sands. Water-colour,* $10\frac{5}{16} \times 14\frac{1}{4}$ *in. London, Victoria and Albert Museum.*

seascape, Richard Parkes Bonington (1801–28) stands out. Born at Arnold near Nottingham, Bonington was the son of a former Governor of Nottingham Gaol and amateur painter from whom he may have had his first lessons in art. In 1817 the family moved to Calais where Bonington's father became occupied in the lace industry. It was about the same time that the French water-colourist François-Louis Thomas Francia returned to Calais, his birthplace, after a long sojourn in England where he had exhibited regularly at the Royal Academy and been painter in water-colours to the Duchess of York. Bonington became his pupil in water-colour at Calais. Francia was noted for the accomplished style in which he painted fishing boats and harbour scenes and his young pupil quickly acquired a like facility, to the extent that some of his water-colours have been mistaken for Francia's or regarded as attributable to either artist.

After 1824, when his contributions to the famous Salon of that year gained French esteem along with those of Constable, he worked in Paris. He became the friend of Delacroix who was greatly interested in his water-colour, a medium then unfamiliar enough in France as to be known as '*l'art Anglais*'. But he also began to study oils under Baron Gros and by copying at the Louvre. A division of aim now began to appear between figure subjects in water-colour in the Romantic taste

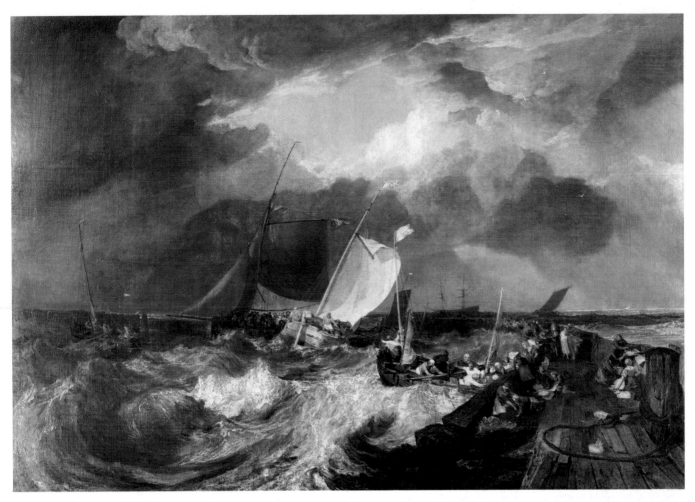

123 *J. M. W. Turner. Calais Pier, with French Poissards(?) Preparing for Sea: an English Packet Arriving. 1803. Oil on canvas, 68½x88 in. London, National Gallery.*

124 *John Constable. Brighton Beach with Colliers. 1824. Oil on paper, $5\frac{7}{8} \times 9\frac{3}{4}$ in. London, Victoria and Albert Museum.*

125 *Richard Parkes Bonington. A Sea piece. Oil on canvas, $21\frac{1}{2} \times 33\frac{1}{4}$ in. London, Wallace Collection, by permission of the Trustees.*

133

126 *David Cox. Shakespeare's Cliff, Dover.*
Water-colour, $6\frac{1}{4} \times 8\frac{3}{4}$ in. London, British
Museum.

evoking historic costume and event, and paintings of sea and coast which in contrast were wonderfully fresh and contemporary in character. He seems to have mastered the technique of oil-painting with the same ease as water-colour. The paintings that resulted from his coastal tours in Normandy and Picardy were a magnificent achievement in their certainty of technique and rendering of open-air effect. The 'Sea Piece' (Wallace Collection, London) ranks among the master-pieces of marine art in its buoyancy of atmosphere, beauty of colour, and sparkle of detail. Turner himself could scarcely have bettered the wave movement painted with so much truth of observation, the feeling he was able to convey of the sea's fluid motion.

'The Coast of Picardy' is another masterpiece in the same collection. The tilted mast of a boat on shore at low tide is unerringly placed in the composition against the spaciousness of sky and in relation to the distant cliffs. In 'Sunset in the Pays de Caux' the small figures at various distances from the spectator on the far-spreading beach under the cliffs emphasize the recession of distance and the aerial glow that envelops the scene. More than well-placed accents of light and dark, they belong to their environment. His paintings of the expanse of sea and sand at Boulogne bring to mind the sense of space that the Dutch masters of the seven-teenth century derived at their much favoured and often painted place of resort, the shore at Scheveningen.

The freshness of atmosphere so distinctive in the work of Bonington has some

127 *John Constable. Coal Briggs on Brighton Beach. Water-colour, 7×10¼ in. Bedford, Cecil Higgins Museum.*

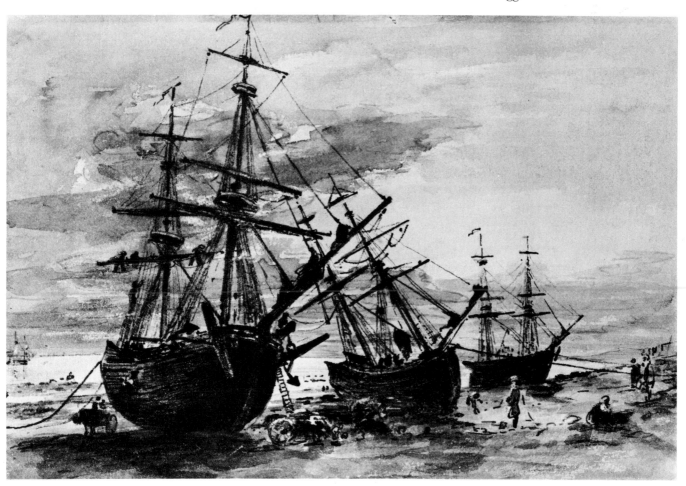

parallel in the paintings of David Cox (1783–1859). His mastery of water-colour enabled him to develop a method of evoking an outdoor vividness of effect by means of broken touches of colour. He successfully applied this method to oil-painting also, at a late stage of his career. His 'Rhyl Sands' (Victoria and Albert Museum, London) is a vivacious impression in water-colour of sea, sky, and beach in an unsettled moment of weather, and in its way an original departure in the treatment of such a theme.

6

Local schools

Two outstanding contemporaries of Turner and Constable who also have their place in the history of marine painting were John Crome and John Sell Cotman. Both were associated with one of the few groups of artists to flourish in Britain outside London, the Norwich School. The word 'school' as so used implies the leadership of a master whom others were content to follow, some consequent community of aims among them, and also a geographical link. John Crome (1768–1821), mainly instrumental in founding the nucleus of the School, the Norwich Society of Artists, in 1803, was the acknowledged leader. His associates were both professional painters of landscape and amateurs who looked to him for tuition. A number of them belonged to the same families. Norwich was their centre and many of their themes were taken from the neighbouring region of the Broads with their picturesque waterways and the coast around Great Yarmouth where the river Yare flowed into the North Sea. It was on the banks of the Yare that Crome made his memorable statement to the pupils with him, 'Here is our Academy'.

'Old' Crome as he was familiarly known to distinguish him from his eldest son John Bernay Crome (1794–1842) was born at Norwich, the son of a weaver who kept an inn. He had little education and at 12 was a messenger boy to a doctor in Norwich. After that he gained at least a knowledge of craft from seven years as apprentice and assistant to a local carriage- and sign-painter. In 1790 he was able to study the Dutch and English paintings in the collection of Thomas Harvey at Catton House. Admiring Richard Wilson and Gainsborough, he was especially influenced by Wilson's breadth of style. Study of the Dutch masters of the seventeenth century completed his visual training and his work like theirs, divides between woodland, rustic river, and coastal scenes, mostly painted between 1805 and 1821.

The example of Aert van der Neer led him to paint several night scenes of which 'Moonrise on the Yare' (Tate Gallery, London) is the most celebrated. Though the Dutch painter's work suggested the motif, Crome's strong silhouettes have the breadth of design that was his own avowed aim. His 'View of Bruges River looking towards Ostend' (Iveagh Bequest, Kenwood) painted after his one expedition abroad to France and Belgium, was more elaborate in its combination of sea, river, and wooded shore, and the contrast drawn between the sails of boats and those of a windmill on land. Here he seems to emulate Hobbema, whom he so much admired, in the complexity of detail.

Yet though Crome's reputed last words expressed his particular affection for Hobbema, other Dutch masters had a greater influence on his work. Ruisdael could inspire him to paint a stormy sea and a ship scudding before the wind, as well as to paint and etch sturdy oaks and parcels of woodland after Ruisdael's manner. Conceived in the vein of Cuyp was the 'Yarmouth Water Frolic' (Iveagh Bequest, Kenwood) left unfinished in Crome's studio at the time of his death but

128 *John Crome. Moonrise on the Yare.*
1808 or 1811–16. Oil on canvas, 28×43¾ in.
London, Tate Gallery.

129 *Miles Edmund Cotman. Boats on the*
Medway. Oil on canvas, 21⅜×19½ in. Nor-
wich, City Museums.

completed by his son, John Bernay Crome. The painting is in consequence somewhat less personal in style than the oil sketch now in an English private collection that was entirely the handiwork of the elder Crome. The composition has a serenity recalling that of Cuyp's views of Dordrecht and the finished picture was sold in 1864 as 'an Old Crome in the manner of Cuyp'. In the sketch there is a quality of colour and liveliness of contrast between dark sails and light of a more personal kind. The affinity is less with the Dutch than with that other Norwich master, John Sell Cotman.

Cotman (1782–1842), like Crome was an artist with a wide range of landscape subjects that included brilliant seapieces, though unlike him in temperament and training. Born in Norwich he went to London to study before he was 20. Whereas Crome was brought up on the examples of oil landscape he could see in Norfolk, Cotman was inducted into the tradition and technique of English water-colour as represented in the collection made by Dr Monro in his London house. Young students were welcomed there and made a little money by copying or finishing the drawings by J. R. Cozens and others that the doctor, himself an amateur artist, had acquired.

The young Cotman profited by these studies at Adelphi Terrace as Girtin and Turner had done before him. He exhibited at the Royal Academy from 1800 to

130 *John Sell Cotman. Yarmouth River. Water-colour, 9⅜×13⅜ in. London, British Museum.*

139

131 *John Sell Cotman. Seashore with Boats. c.1808. Oil on board, $11\frac{1}{8} \times 16\frac{1}{8}$ in. London, Tate Gallery.*

132 *Joseph Stannard. Yarmouth Roads. 1829. Oil on panel, $29\frac{3}{4} \times 40\frac{1}{4}$ in. Oscar and Peter Johnson Ltd (Private Collection).*

133 *John Ward. Hull Whalers in the Arctic. Oil on canvas,* 19×28 *in. Hull Museums.*

1806 and produced such early masterpieces as his views of the river Greta in York-shire, but failed to win material success. Restless and discontented he returned to Norwich at the age of 25, contributing to the Norwich Society exhibitions and having a number of pupils. He was elected President of the Society in 1811. Later he moved to Yarmouth with his wife and family. It was there he made the remark-able water-colours of ships and sea, represented at their best in the Reeve Collec-tion at the British Museum.

The 'Dismasted Brig' (British Museum) is an example of his highly individual style, characteristic in the way he made a bold generalization of the movement of the waves, applying the same decisiveness of pattern to the clouds, the brig, sharply silhouetted, being drawn with a fine precision of line. Equally original and incisive in style is 'Yarmouth River' (British Museum), at one time called 'The Mumbles, Swansea'. Produced though they were when he was in straitened circumstances at Yarmouth, his seapieces are among the most distinguished examples of his art. But success still eluded him. After many disappointments he went back to London, in 1834, to become drawing master at King's College School.

The followers of Crome and Cotman were numerous and their work is still a field for exploration. Broadly speaking, those inclined to oil-painting went to Crome for instruction, the water-colourists to Cotman. They varied in choice of

subject between inland and sea coast picturesqueness. Crome's principal pupil was James Stark (1794–1859), born at Norwich, the son of a Scots dyer who had settled in the city. After having Crome's tuition he entered the Royal Academy Schools in 1817 and was subsequently a frequent exhibitor at both the Academy and Norwich. Apart from his Norfolk woodland scenes and views in Windsor Great Park where he lived for some years he painted attractive pictures of Norfolk beaches and fishing-boats.

Other painters of the School, variable though they might be in choice of subject, usually produced their quota of pictures of sea and Norfolk coast. John Bernay Crome (1794–1842) who succeeded his father as an art-teacher at Norwich and exhibited at the Academy from 1811 to 1842 tended to specialise in moonlight scenes. Members of a large family of artists were Joseph Stannard (1797–1830) and his younger brother Alfred (1806–89), who specialized in marine and river scenes, often in collaboration. They gave a placid charm to views of sea and coast at Cromer and Yarmouth. Henry Bright (1810–73) left his position as a dispenser at Norwich Hospital after lessons from Crome and Cotman to become a painter. He applied to marine subjects a dramatic treatment in oil and pastel that owed something to Bonington, a good example being the oil 'North Beach, Great Yarmouth' (Castle Museum, Norwich). Pupils of Cotman and water-colourists of the Norfolk scene were Thomas Lound (1802–61) and Jon Thirtle (1777–1839).

Norwich was unique in the number and size of the families whose successive generations contributed to the local Society of Artists. The Cromes, the Cotmans, the Stannards, the Ladbrookes were prolific dynasties. The sons and other relatives of the principal figures became teachers in their turn of a host of amateurs

142

who raised the total number of exhibits at the Society between 1803 and 1828 to nearly 5,000. The influence of Crome extended elsewhere in eastern England. It appears in the work of John Moore (1820–1902) who was born at Woodbridge in Suffolk and painted there and at Ipswich. His 'Barques and Fishing Boats becalmed in Yarmouth Roads' (Lowndes Lodge Gallery) shows both his love of ships and a sense of distance and marine perspective.

The Smythes of Ipswich, Edward Robert Smythe (1810–99) and Thomas Smythe (1825–1907), were artists who spent most of their lives in East Anglia. Their varied output included many sporting and rustic subjects but both gave pleasant glimpses of sea and Norfolk and Suffolk coast, such as E. R. Smythe's 'Yarmouth Jetty' (Lowndes Lodge Gallery).

A local school of marine painting at Kingston-upon-Hull came into being with the growth of the port and its whaling and fishing fleets in the late eighteenth

(*facing*)
137 *Henry Redmore. A Merchantman in Distress.* 1873. *Oil on canvas, 35×60 in. Private Collection.*

(*facing*)
138 *Edward Robert Smythe. Yarmouth Jetty. Oil on canvas, 21×38¼ in. Private Collection.*

139 *John Moore. Barques and Fishing Boats becalmed in Yarmouth Roads.* 1871. *Oil on canvas, 32×48 in. Private Collection.*

and early nineteenth century. Less well known outside their own region than the artists of Norwich and without the special prestige conferred on Norwich by the eminence of Crome and Cotman, the Hull painters have left a record of great interest of the Humber and its ships and the northern expeditions that were essentially a part of local history. By 1769, whaling was already a theme for an anonymous artist who depicted the fleet of Sir Samuel Standidge with an agreeable naïveté of style in the picture preserved at the Ferens Art Gallery, Hull. Marine painting was later developed by a group of house- and ship-painters and decorators as a pictorial extension of their craft. Principal among them was John Ward (1798–1849), son of Abraham Ward, a master mariner of Hull. He may have had encouragement to paint from his father who himself had some artistic talent. He was first apprenticed to a house- and ship-painter, an occupation in which he continued to practise on his own account. His style is said to have been formed by copying the work of the Scottish marine painter William Anderson (1757–1837), who was noted for his accuracy and refinement of detail, qualities that Ward also displays.

140 *Atkinson Grimshaw. Scarborough. 1880–5. Oil on canvas, 24x36 in. Private Collection.*

Anderson evidently visited the city to paint the large composition 'The Battle of the Nile' in the Hull Trinity House.

Ward produced many pictures of ships in the Humber, a number of which were reproduced in engravings and lithographs. He visited the whaling grounds and one of his most striking works is his 'Hull Whalers in the Arctic' (Hull Museums) a composition in which icebergs, floes, polar bear, and other details give the impression of first-hand observation. His nicety of detail appears in his picture of the paddle-steamer *Victoria* of Hull painted in the year of the Queen's accession. With less than his accomplishment, but with a naïveté of style that did not lack vividness, other local and largely self-taught artists portrayed the whaling ships and other vessels, Robert Willoughby (1768–1843), Thomas Fletcher (fl.c.1790), Thomas Bink (1799–1852) being among the more interesting.

The local tradition was continued by James Wheldon who was active in the 1870s and Henry Redmore (1820–87) and his son Edward King Redmore (alive in 1939), a follower of his father as a painter though cruder in style. Henry Redmore is of some note for the unpretentious care with which he painted ships on the wide stretch of the Humber and shore views along the north-east coast. Docks and shipping encouraged local artists to take to marine painting in other cities. Born at Newcastle upon Tyne, James Wilson Carmichael (1800–68) became popular in the north-east for his marine paintings in both oils and water-colour. Early seagoing experience and later employment as a designer in a shipbuilder's office were part of his training. He exhibited at the Royal Academy, 1835–1859, and

during the Crimean War made sketches from a warship sent to the Baltic for the *Illustrated London News*. Thomas Miles Richardson the elder (1784–1848) was another Newcastle artist and the author of boldly-executed seapieces and coast scenes. He worked in both oils and water-colour, exhibited at the Royal Academy, 1844–5, and also produced engravings, etchings, and lithographs. He founded the Newcastle Water-colour Society in 1831.

The stimulus given by the northern docks and coasts is again illustrated in the work of Atkinson Grimshaw (1836–93). His paintings associate him especially with Whitby and Scarborough and the docks at Liverpool and Hull. He painted the mysteriously poetic effect of sea and harbour in moonlight in sensitive fashion. His pictures of the waterfronts at night in the hazy glow of gas lamps with the silhouetted forest of masts beyond were Victorian in an individual way – nocturnes into which he put a wealth of romantic feeling.

7

Nineteenth-century developments in Britain and America

Marine painting in nineteenth-century Britain was practised by a surprising number of specialists, testifying to the popularity of the genre in the later period of sail and the early years of the steamship. Some of these painters were active while the war with Napoleon was still in progress, but after his final defeat a demand continued for pictures of victory at sea. The importance of the sea, patriotically viewed as 'Britannia's Realm' in John Brett's painting of that title, made for renewed demands for pictures of merchantmen, the tea clippers built for speed, the yachts of sporting competition.

The specialists on the whole were expert within limits that separate their work from the freedom of expression of the great artists when they looked at the sea. One does not repair to them for such a revelation of marine atmosphere as Constable gave in his oil sketches at Brighton. Sea and sky were a setting for which they had prescribed conventions. Knowledgeable about ships, they did not invest them with the majesty or sentiment that Turner conveyed in the 'Fighting *Téméraire*', though well equipped to describe them in detail. The individual differences between them as artists are slight. At the same time their work has the value of a form of historical portraiture and often the structure of the ships portrayed imparts a decorative quality to the works that represent them.

Many of them had the advantage in accuracy of having been sailors. Samuel Atkins, who exhibited at the Royal Academy, 1787–1808, voyaged in the East Indies before settling in London in 1804 as marine painter and drawing-master. He worked mainly in water-colours picturing East Indiamen and other merchant ships in spirited fashion. Nicholas Pocock (1740–1821) was the son of a merchant at Bristol and as a young man commanded merchant ships sailing from Bristol. He taught himself to draw and kept an illustrated diary of his voyages. Encouraged to paint by Sir Joshua Reynolds, he devoted himself to pictures in both oils and water-colour of naval engagements and warships, being a prolific contributor of such themes to the Royal Academy from 1782 to 1817. Thomas Luny (1759–1837) was similarly employed, combining marine paintings with service in the Navy until 1810.

The vogue for portraits of sailing ships long continued and the list of marine portraitists is also long. An even level of accomplishment in which the Dutch tradition, modified by the eighteenth century, still left its trace, marks the work of such competent men as Thomas Whitcombe (*c*.1760–1824), Thomas Butterworth (active 1798–1827), John Christian Schetky (1778–1874), William John Huggins (1781–1845), Nicholas Matthew Condy (1816–51), and Henry Moses (1782–1870). A 'little master' who seems to have profited by the Dutch tradition and that of Italian view-painting was Robert Salmon (1775–1826) who worked for a long time at Liverpool and produced some admirable views of the Mersey and its shipping before embarking on a fresh stage of his career in the United States. Some likeness

142 *Clarkson Stanfield.* The Victory *towed to Gibraltar. Oil on canvas.* 18×27½ *in. London, Guildhall Art Gallery.*

143 *George Chambers. A View of Dover. 1832. Oil on panel,* 19½×28 *in. Royal Collection, reproduced by gracious permission of H.M. the Queen.*

144 *John Crome. The Yarmouth Water Frolic.* c.1821+. *Oil on canvas,* 41¾×68 in. *Kenwood, Iveagh Bequest. The State Barge in the centre bears the arms of Yarmouth. Some variations of style suggest the work was finished after Crome's death in 1821 by his son, John Bernay Crome.*

145 *John Sell Cotman. Dismasted Brig.*
c.1823. Water-colour, 7⅘×12⅕ in. Lon-
don, British Museum.

146 *Edward William Cooke. Off the Port of Le Havre.* 1840. *Oil on canvas,* 53×71 *in. Bury, Public Library and Art Gallery.*

to his style appears in the paintings of William Clark (*c*.1800–45) at Greenock where Salmon also spent some years.

A new form of the romantic-picturesque was a development of the Victorian age of which Clarkson Stanfield (1793–1867) gives an instance. Without the poetry and imaginative range of Turner, Stanfield had a love of the sea he was well able to convey in his paintings, rendered the brisk movement of wind and wave in a way attractive in itself and expressive of a forthright and unaffected personality. Ruskin was over-enthusiastic in asserting that 'One work of Stanfield's alone presents us with as much concentrated knowledge of sea and sky, as diluted, would have lasted any one of the old masters his life' but little exception could be taken to his further remark that 'Stanfield, sea-bred, knew what a ship was and loved it; knew what rocks and waves were and wrought out their strength and sway with steadiest will'.

Stanfield was born at Sunderland, the son of an Irish man of letters. He was given the name Clarkson after the leader of the anti-slavery movement, Thomas Clarkson. He seems to have been press-ganged into the Navy at an early age, but was injured by a fall from a ship's rigging and discharged in 1818. He is said to have shown talent in painting scenery for the naval officers' amateur theatricals when stationed on a guard-ship at the Nore and scene-painting became his first occupation on his discharge. For some time he worked at theatres in Edinburgh and London together with his painter-friend David Roberts but early success with sea pictures made him a full-time picture painter by 1829. He became a regular contributor to the Royal Academy exhibitions and R.A. in 1835.

He was a prolific artist, his Academy oil paintings numbering 132 at the end of thirty-nine years, and was noted for his rapid execution, perhaps the result of his theatre training. The open-air atmosphere and certainty of his style show little influence from other painters but suggest the advantage he gained from his knowledge of seamanship and direct observation. He painted in home waters with the vigorous realism of which 'Tilbury Fort – Wind against Tide' (Port of London Authority) is a fine example. Going abroad at intervals, he favoured Holland and Italy, painting at the mouth of the Scheldt with the same gusto as in the estuary of the Thames though he was even more attached to the Mediterranean. He made a

147 *Nicholas Matthew Condy. A West Indiaman off Plymouth. Oil on panel, 6x8 in. London, Omell Gallery.*

number of views of Venice and his 'Castle of Ischia' with its sea dashing against the rocks was one of his most popular works in engraving.

Apart from the contemporary seascapes he produced other pictures of an historical kind though near enough in time to be a vivid memory. His 'Battle of Trafalgar' depicting the concluding stages of the action and painted for the United Services Club was praised both for its drama and the accuracy of sails and rigging when exhibited in 1836. 'The *Victory* with the body of Nelson on board towed into Gibraltar' was a sensation of the Academy in 1853. He painted war on land also, an instance being 'The Battle of Rovereto' (Royal Holloway College, Surrey) the mountain background having all a scene-painter's assurance. Without any of Turner's brooding meditation on the fate of mankind or any approach to Turner's range of style his work was aptly summed up by his friend Charles Dickens (with whom he co-operated in the novelist's amateur theatricals) as 'manly and vigorous'.

Some relation to Stanfield's work is to be found in that of Edward William Cooke (1811–90). There was even a measure of collaboration between them, as Cooke made some drawings of detail that Stanfield used in his painting, 'Opening of the New London Bridge by William IV', 1831. Though he was a professional marine painter, Cooke added wide interests besides to this specialization, including the study of geology, botany, and zoology. He was probably unique in becoming not only a Royal Academician but a Fellow of four learned societies including the Royal Society.

Edward William Cooke was the son of George Cooke the engraver who produced an illustrated periodical publication, the *Botanical Cabinet*, for some years, as well as topographical works. His son was a precocious assistant in these enterprises, and also turned his attention to the sea at an early age, publishing a series of plates of 'Shipping and Craft' while still in his teens. Sketching expeditions to the English south coast at Hastings, Brighton, Portsmouth, and the Isle of Wight confirmed him in the role of marine painter. While still in his 20s he also painted many subjects on the Dutch coast. From 1837 onwards, the beach at Scheveningen was a favoured region, where he made many studies of the broad-beamed fishing boats known as 'pinks'. One of his most spirited compositions is his 'Beaching a

154

Pink, Scheveningen' now in the National Maritime Museum, Greenwich. Something of Stanfield's briskness of style in painting a rough sea appears in Cooke's 'Scheveningen Pinks running to anchor off Yarmouth' (Royal Academy) his Diploma picture after he was elected R.A. in 1863. His exhibits of marine subjects at the Academy ranged from 1835 to 1879.

In the 1840s he began to include the Mediterranean in his expeditions abroad, painting scenes off the coasts of southern France and Italy. The change to southern light and colour is reflected in his 'Salerno' (Guildhall Art Gallery, London) and numerous paintings and drawings of Venice and Venetian fishing craft in the Adriatic on his several visits between 1850 and 1877. The number of his pictures added to his scientific studies in botany, geology, and zoology that gained him some international repute, give an impression of constant industry and a modest talent of which he made good use.

Related in picturesque style to the work of Stanfield and Cooke is that of George Chambers (1803–40). He made a number of copies of paintings of sea fights by other artists, including some by Stanfield, but his original work is seen to advantage in his off-shore paintings with attractive glimpses of land in the background. Born at Whitby, he was a sailor's son and went to sea at an early age, but the precocious ability he showed in drawing made an impression strong enough

148 *Thomas Whitcombe. West Indiaman of 32 Guns off Deal. Oil on canvas, 17x24 in. London, Omell Gallery.*

155

149 *John Brett. Britannia's Realm. 1880.
Oil on canvas, 41½×83½ in. London, Tate
Gallery.*

to secure the cancellation of his indentures so that he could study art. Working
at Whitby as a house-painter he took drawing lessons and painted scenes of ship-
ping in his spare time. After that, he worked his way to London on a coastal vessel
and like Stanfield found employment as a scene painter. For some years he took
part in the production of the panorama of London exhibited at the Colosseum,
Regent's Park. As a marine painter he worked in both oils and water-colours and
exhibited at the Academy from 1827 to the year of his death. His talent for a
composition that included human figures as well as ships and shore is well illus-
trated in his view of Dover (Royal Collection), much admired by Queen Victoria.

Inevitably the advent of the steamship had its effect on marine painting. The
mechanically propelled vessels lacked the picturesqueness and the associations of
sentiment and tradition that belonged to the age of sail. Eventually their portrayal
ceased to be of particular interest to painters or at all events was little called for.
Steamship companies came to attach more value to the three-dimensional model
as a record of progress in design and a means of attracting potential passengers.
Yet in the period of transition when the steamship was still a novelty, often carry-
ing the adjunct of sail, a number of painters set themselves to deal with the pic-
torial problems thus presented.

Turner in his own original way was quite prepared to give a steamboat a prin-
cipal and even a poetic part in a marine composition. An instance in addition to
the 'Fighting *Téméraire*' was the painting he made in 1832 after travelling by
steamer to Staffa and Iona in search of subjects to illustrate the poems of Sir
Walter Scott. The stormy weather encountered inspired his 'Staffa, Fingal's Cave'
in which the ship seen through spray and mist with a plume of smoke issuing from
its stove-pipe funnel acquired a phantom elegance.

At a more placid and documentary level were the ship portraitists concerned
with the accurate delineation of the new type of vessel. John Ward of Hull painted

156

the paddle-steamer *Victoria* in 1837 (Trinity House, Hull) with neat precision. Henry Redmore's fondness for views of sailing ships in the Humber did not deter him from painting a steam coaster with the port of Hull in the background. Other painters appreciative of the slender lines of the Early Victorian steamship were William Clark and J. Scott (active 1850–73). Later in the century interest waned, though the stately aspect of Queen Victoria's principal yacht, *Victoria and Albert II*, with its three masts and two funnels, was portrayed by George Mears (active in the 1870s) and also by A. W. Fowles, active in the same period, who painted a number of yachting scenes and naval reviews in the Solent and at Spithead.

A separate development in the later nineteenth century was the seascape as an aspect of the study of nature, which relegated the ship to a minor role. The 'truth to nature' of the Pre-Raphaelite movement had some influence though the application of this aim to landscape was not without its problems. The career of John Brett (1830–1902) gives an unusual instance. Brett entered the Royal Academy Schools in 1854 when Pre-Raphaelitism was in the ascendant. Fired by the enthusiasm for minute detail that the movement aroused he produced when still in his twenties the two works by which he is mainly remembered, 'The Stonebreaker' (1858) and 'Val d'Aosta' (1859). The effort involved in the latter may have convinced him that the minuteness of Pre-Raphaelite detail was not suited to landscape without figures. He took to marine painting in a greatly altered style, exchanging the prodigies of detail for large-scale panoramas of the sea, such as the vast 'Britannia's Realm' (Tate Gallery, London). His Cornish seascapes were regular exhibits at the Royal Academy of which he became an Associate in 1881.

A similar direction is to be found in the work of Henry Moore (1831–95), son of a portrait painter at York and brother of Albert Moore, the painter of classi-

150 *James Clarke Hook. Wreckage from the Fruiter. Oil on canvas, $35\frac{1}{2} \times 60\frac{1}{2}$ in. London, Tate Gallery.*

cally beautiful girls. Henry Moore was a student at the Royal Academy in 1853 and like Brett passed through a Pre-Raphaelite phase in his impressionable early years but concentrated on pictures of the sea from the 1860s onwards. A typical example of his careful technique was 'Catspaws off the Land', a Chantrey purchase for the Tate Gallery in 1885. He became R.A. in 1893. Both Moore and Brett were conscientious students of sea effect but their way of painting was not quite up to the task of sustaining interest by originality of vision in views in which human interest was minor or absent.

American painters of marine subjects in the nineteenth century represent separate developments; a continuation of the Romantic tradition that began so impressively with Benjamin West and John Singleton Copley and the paintings of ships and coastal views that were a parallel to the works of the English marine specialists. These more documentary pictures were sometimes produced by artists who had emigrated to the United States from England. Robert Salmon, already mentioned among the English painters for his pictures of ships at Liverpool, Glasgow, and Greenock, left England in 1829 to continue his career at Boston,

151 *Washington Allston. Rising Thunderstorm at Sea.* c.1804. *Oil on canvas,* $38\frac{1}{2}×51$ *in. Boston, Museum of Fine Arts, Evertt Fund.*

152 *Martin Johnson Heade. Approaching
Storm: Beach near Newport. Oil on canvas,
28x58¼ in. Boston, Museum of Fine Arts,
Karolik Collection.*

153 *Thomas Moran. The Much-Resounding
Sea. 1884. Oil on canvas, 25x62 in.
Washington, D.C., National Gallery of Art,
gift of the Avalon Foundation.*

Massachusetts. He painted numerous views of Boston harbour and his 'Wharves of Boston' hangs in the Boston State House. Other paintings by him are in the Peabody Museum, Massachusetts.

Another view-painter who came from England to the United States about 1813 was Thomas Thompson (1776–1852). He exhibited many paintings at the National Academy of Design from 1831 to 1852 and though not many seem to have survived, the titles in exhibition catalogues have shown that he specialized in marine subjects, New York harbour being a favourite subject. An attractive surviving example is a 'Scene from the Battery with a portrait of the *Franklin*. 74 Guns' (Metropolitan Museum, New York). The array of ships is well composed, having as a prominent central feature the *Franklin*, built in accordance with the act passed by Congress after the War of 1812 providing for additions to the navy. The style, except for a certain hardness, suggests that the artist profited by study of the Dutch masters.

Also originally from England was Thomas Chambers (1815–66+) who went to the United States in 1832 and became a naturalized citizen. After 1838, he was listed as a marine painter in the New York directory. Later he worked in Boston and the Hudson Valley but reappeared in New York in the 1860s. Many of his paintings were based on prints but his own dramatic handling and brilliant colour made them original in effect. An example is 'The *Constitution* and the *Guerrière*', *c*.1845 (Metropolitan Museum, New York), a painting of a sea-fight during the war of 1812, based on an engraving by Cornelius Tiebout after a picture by the Philadelphia painter Thomas Birch (1779–1851). The painting came to the Museum from the collection of American 'primitives' formed by Edgar William and Bernice Chrysler Garbisch which contained other works by Chambers, as much romantic as primitive in their drama and forceful action.

American Romantic painting in the nineteenth century can be viewed as a tradition that began in landscape with Washington Allston. Born in 1779 on a plan-

tation in Southern Carolina, Allston evinced an early liking for the 'wild and marvellous' that was encouraged by his stay in England as a young man. After leaving Harvard he spent some years in Paris and Rome as well as London, but the longest period was spent in England, 1811–17 (he was elected A.R.A. in 1818). He admired the conceptions of John Martin whose romanticism was much to his taste. It was a friendly disagreement about the way 'Belshazzar's Feast' should be painted that led Martin to work out Allston's proposal in the stupendous canvas that established Martin's fame in 1821. It was a sad irony that the version of the subject Allston began on his return to America should occupy him during twenty-five years, becoming more chaotic as time went on and as a friend of Allston's put it, 'the incubus, the tormenter of his life'.

He painted little else while haunted by this tantalizing vision, nor was he at any time concerned with the sea except as conveying a mood, an idea of elemental force. Yet this was an important exception and even if the idea is said to have only one example of his work, the 'Rising Thunderstorm at Sea', painted in 1804 (Museum of Fine Arts, Boston) this was thoroughly in the Romantic spirit and an influence on a younger generation.

Many writers on American Painting have also attributed to Allston 'The Deluge' in the Metropolitan Museum of Art, New York, since 1909, at one time belonging to Allston's father in South Carolina. The onrush and subsidence of waters described in the Book of Genesis were subjects that appealed strongly to the Romantic love of the spectacular and Allston was as likely to be attracted by them as Turner and John Martin. But other artists of less celebrity were equally ready to

156 *Winslow Homer. The Herring Net. 1885. Oil on canvas, 29½×47½ in. Chicago, The Art Institute.*

157 *Winslow Homer. Eight Bells.* 1886. *Oil on canvas, 25×30 in. Andover, Massachusetts, Addison Gallery of American Art, Phillips Academy.*

try their hand at a theme then so popular. Doubts have been cast on Allston's authorship and the 'Deluge' has been ascribed to the English-born painter Joshua Shaw (c.1777–1860) and identified with the painting he showed at the British Institution in 1813. However this question may be resolved there seems no doubt that Allston by a few works exercised an influence both dramatic and idyllic that contributed to the largeness of outlook in artists who followed. The great panoramas, the luxuriance of nature in America itself translated the fanciful element in English Romanticism into the enthusiastic discovery of a majestic landscape existing in reality, first exemplified by the Hudson River School.

'The painter of scenery' wrote Thomas Cole (1801–48), a founder of the Hudson River School, 'has indeed privileges superior to any other. All nature here is new to art.' Mountains, forests, lakes, and rivers were the first objects of delighted discovery but the sea coast also had its devotees. The bay and city of New York

158 *Winslow Homer. The Gulf Stream.
1899. Oil on canvas,* 28⅛×49⅛ *in. New
York, Metropolitan Museum of Art
(Wolfe Fund,* 1906).

as seen from the heights of Weehawken made up a superb panorama of which Robert Havell the younger (1793–1878) took full advantage in the picture of the scene he painted in 1840 (Metropolitan Museum of Art, New York). Havell, the son of the English engraver and art publisher Robert Havell the elder, was responsible for most of the aquatint engraving of plates in Audubon's *The Birds of America*. On the completion of this work he determined to see America for himself and lived there from 1839 until his death. He painted a number of pictures along the Hudson and in the Hudson River style, the view from Weehawken well combining the spaciousness of water and far distance with a foreground richness of detailed foliage.

A fresh wave of enthusiasm for the vast extent and majestic scenery of America that came with the opening of westward routes to the Pacific characterizes the work of Albert Bierstadt (1830–1902). Born at Solingen in Germany he was taken to the United States as a child but went back to Düsseldorf to study art. Returning to America in 1857 he joined General Lander's expedition that was to map out the wagon route to the West. His views of the Rockies and the prairies with their herds of buffalo resulting from this and later explorations of unknown territory brought him fame and fortune. The sea also came within the compass of his grandiose art and he depicted it with all the exuberance he applied to mountains, waterfalls, and animals of the wild.

The drama of sea and storm was impressively conveyed by Martin Johnson Heade (1819–1904), born in Bucks County, Pennsylvania. He began as a portrait-painter, but as time went on paid increasing attention to landscape and seascape, varied by an expedition in Brazil in 1863 to make sketches for a proposed book on the hummingbirds of South America. He was one of those artists who are almost

unknown for a long period but eventually come to be recognized as possessing a real individual merit. Surprisingly impressive in this respect are his coastal scenes in which he pictured the approach of a storm, the sails of boats being sharply silhouetted against a sullen background of cloud. His 'Approaching Storm: Beach near Newport' (Museum of Fine Arts, Boston), painted in 1860, is an example, waves and rocks taking on an almost surrealist strangeness in their sharpness of detail. The vigour that American painting derived from the American scene as in this instance contrasts with many unavailing efforts to emulate European masters of the past in style and subject.

The realism natural to the American painter was a significant development of the second half of the nineteenth century in the work of Thomas Eakins (1844–1916) and Winslow Homer (1836–1910). Eakins, born in Philadelphia had a varied training including a scientific course in anatomy, painting study in Paris under the academic auspices of Gérôme and Bonnat and the study of Velázquez and Ribera in Spain; but the outcome was a determination to depict contemporary life in the United States with uncompromising truth. Much of his work, comprising portraits, and a wide variety of figure subjects, is outside the scope of this book, but reference is due to the outdoor scenes of sporting activities, sailing, sculling, and shooting that occupied him in the 1870s.

Winslow Homer was more directly concerned with the sea and life at sea. He gained a recognition denied to Eakins in works that may be called realist in his adventurous choice of subjects. Born in Boston, Homer had no formal art school training and his first experience of art was gained as apprentice to a lithographer. He took readily to book and magazine illustration and was a war-correspondent artist during the American Civil War. He became known as a painter by his popular war picture 'Prisoners from the Front' (Metropolitan Museum of Art, New York). He continued as illustrator during the 1870s, also painting many pictures of farm and country life in the United States. A visit to England, 1881–2, when he made water-colours and drawings at Tynemouth, was a turning-point in his career, inclining him to the paintings of the sea that were a main and dramatic feature of his later work. Settling at Prout's Neck, Maine, in 1883, he produced an epic series of paintings of stormy Atlantic seas and the life of the fishermen on the Grand Banks. 'Eight Bells', 1886 (Addison Gallery of American Art) and 'The Herring Net' (Art Institute, Chicago), are powerful examples of this phase of his

159 *Thomas Thompson. Scene from the Battery, New York with the United States Frigate,* Franklin, 74 *Guns. Oil on canvas, 26¾×63¾ in. New York, Metropolitan Museum of Art, Edward C. Arnold Collection of New York Prints, Maps and Pictures.*

work. Sombre epics were followed by the sunny water-colours of the West Indies that became his regular winter resort.

'The Gulf Stream' of 1899 (Metropolitan Museum of Art, New York) is characteristic of his later work in oils. His illustrative skill is effectively employed in this picture of a dismasted boat with its lone Negro sailor drifting in a shark-infested ocean, with the further menace of a water spout looming in the background. The open jaws of a shark bring to mind the predatory monster of Copley's 'Brook Watson' though the picture may be criticized for the want of that psychological tension that Copley was able to give and the full horror of the castaway's predicament that Géricault and Delacroix had been so well able to impart. Nor was this illustrative realism compatible with such fastidious consideration of tone and colour as appears in the work of his great compatriot and contemporary, James McNeill Whistler.

Whistler (1834–1903), who produced some of the most beautiful paintings of the sea that have ever been done, has an isolated eminence in nineteenth-century painting. He worked in Europe and yet was not deeply affected by current trends

160 *James McNeill Whistler. The Coast of Brittany. Oil on canvas, 34⅜×46 in. Hartford, Connecticut, The Wadsworth Atheneum. The first of Whistler's major seapieces, painted in 1861, originally exhibited at the Royal Academy as 'Alone with the Tide' (1862).*

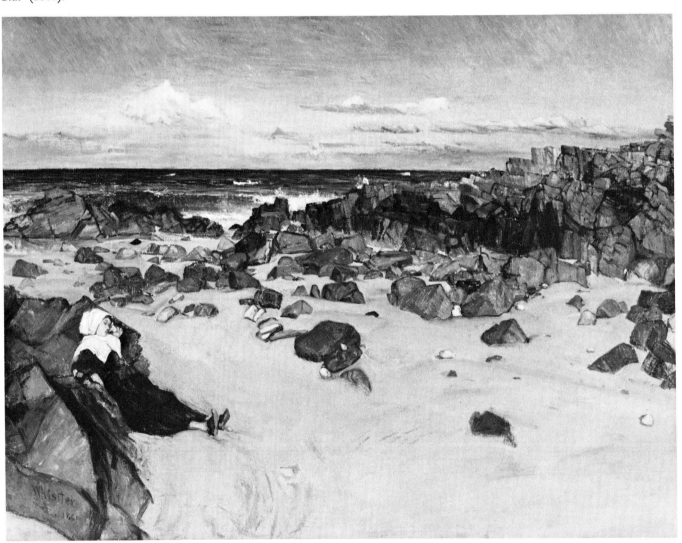

161 *James McNeill Whistler. Coast scene, Bathers.* c.1875. *Oil on canvas,* 5×8½ *in. Chicago, The Art Institute.*

in European art. Born in Lowell, Massachusetts, spending adolescent years in St Petersburg where his father was employed in the construction of Russian railroads, equally associated later with Paris and London, he had no exclusive ties to any one place or system of ideas other than that he worked out for himself. He showed some attachment to Gustave Courbet's idea of realism as in the 'Coast of Brittany' (Wadsworth Atheneum, Hartford, Connecticut), exhibited in the Royal Academy of 1862 under the title 'Alone with the Tide'. By that time Whistler was living in London and had already produced his early masterpieces of etching, the 'Thames Set'. In 1862 an intended journey to Spain halted at Biarritz. The painting that resulted, 'The Blue Wave, Biarritz', was an anticipation of the studies of wave form in which Courbet was later to excel.

The two artists worked together at Trouville in 1865 but Whistler could no longer be regarded as Courbet's disciple. His independence appeared in a series of seapieces of nicely calculated simplicity. The decorative sense that Whistler in the '60s had begun to derive from acquaintance with the Japanese print and Chinese porcelain was no part of Courbet's realism. Realism was evidently the wrong word for harmonies of tone and colour offering a certain parallel with musical harmony. The titles Whistler was later to give to the Trouville paintings, 'Harmony in Blue and Silver, Trouville' (Isabella Stewart Gardner Museum, Boston), 'Blue and Silver, Trouville' (Freer Gallery, Washington), 'Grey and Green, The Silver Sea' (Art Institute, Chicago) clearly show his intention. The marine atmosphere was exquisitely distilled in the paintings of 1866–7, the result of his sudden and still mysterious excursion to South America. It can scarcely be supposed he was vitally interested in the struggle of Chile and Peru to free themselves from Spanish rule. In fact he kept at some distance from the hostilities then in progress. He viewed the ships in

162 *James McNeill Whistler. The Lagoon, Venice – Nocturne in Blue and Silver. 1879–80. 20x26 in. Boston, Museum of Fine Arts, E. L. Ainsley Fund.*

Valparaiso harbour from a purely aesthetic standpoint, to be translated into 'arrangements' and delicacies of tone in which his studies of Oriental art bore fruit and his emancipation from the realism of Courbet was completed.

The half-dozen Valparaiso paintings of which 'Crepuscule in Flesh Colour and Green' (Tate Gallery, London) is a fine example heralded those 'nocturnes' of the evening Thames that were a principal achievement of the 1870s. After the famous libel suit against Ruskin which they provoked, the twilight dimness enveloping ships and water was the motif of a few paintings made at Venice in the 1880s, for example 'The Lagoon, Venice – Nocturne in Blue and Silver' (Museum of Fine Arts, Boston). He continued to paint the sea at intervals during the rest of his life, though after his return from Venice he abandoned the nocturne theme and style and took to swiftly executed sketches on small panels about the size of a cigar-box lid.

In these seascapes executed either on the English or Normandy coast, he combined the quality of the rapid sketch with a concentrated command of design. Apropos of such an example as 'Grey and Silver, the Angry Sea' (Freer Gallery,

163 *James McNeill Whistler. Crepuscule in Flesh and Green: Valparaiso.* 1866. *Oil on canvas,* 22½×29¾ *in. London, Tate Gallery.*

164 *Edward William Cooke. Beaching a Pink, Scheveningen. Oil on canvas, 42x66 in. Greenwich, National Maritime Museum.*

Washington), Walter Sickert could remark that Whistler 'will give you in a space nine inches by four an angry sea piled up and running in, as no artist ever did before'. He was still producing these small marine gems in both oil and water-colour at Pourville and elsewhere late in the 1890s.

As individual as Whistler but with the Romantic quality of vision that came from an inward emotional source was Albert Pinkham Ryder (1847–1917). Moonlit seascapes were a characteristic aspect of his work, but instead of representing actual scenes they seemed to express the world of mystery that existed in his mind. Born in New Bedford, Massachusetts, Ryder went to New York as a young man and had a few lessons at the National Academy of Design but is considered to have been largely self taught. He was apparently little responsive to outside influences and travel in Europe produced no inspiring contact with the work of others. Like the Romantics of the early years of the century he relied on the mystic power of inspiration, in the limited number of his works that he evolved in seclusion. Such paintings of boats on moonlit seas as are to be found in the Metropolitan

165 *James McNeill Whistler. The Ocean – Symphony in Grey and Green. c.1866–7. Oil on canvas, 31×38⅞ in. New York, The Frick Collection.*

Museum of Art, New York, and the Addison Gallery of American Art, Andover (for example, 'Toilers of the Sea') have something of the mystery and symbolic suggestion that pervades the paintings of Caspar David Friedrich.

Ryder worked over and over on such paintings, with heavy layers of colour in a way that has caused much cracking and physical deterioration. His remark on this was that 'When a thing has the elements of beauty from the beginning it cannot be destroyed' and it is certainly true that the feeling that inspired his paintings retains its force.

8

The naïve painters of the sea

From a present-day point of view a delightful aspect of marine painting is the work of those artists who are variously described as primitive, naïve, or natural. They do not belong to any one period, school, or country. The term 'school' in any of its meanings would be especially out of place for such painters are essentially unschooled. Nor are they exactly amateurs like those non-professionals who aim at some measure of academic accomplishment. Naïve painting is the product of a natural instinct unaffected by technical training or the sophistication of theory.

The operation of instinct, nevertheless, relates together the works of these artless adults, just as it does the spontaneous paintings of children encouraged to express themselves in freedom. Characteristics they have in common are precision of outline, bright, flat colour unmodified by any attempt to render light and shade realistically or otherwise disturb the image existing in purity in the mind's eye.

In the past they have usually been disregarded on this account as childishly lacking in mature competence. A changed attitude may be dated from the discovery early in this century of remarkable qualities in the paintings of an ex-inspector of a toll station on the outskirts of Paris, Henri Rousseau, known as 'Le Douanier' (1844–1910). In the 1880s, when he retired from his minor official post, he devoted himself to painting. He was acclaimed in 1906, when he began to exhibit at the Salon d'Automne, as a great original by the Parisian *avant-garde*. Appreciation has grown since both for his work and for that of other painters in whom a kindred spirit has been discovered.

The 'modern primitive' has been a discovery in France. Similar discoveries have been made in America and England in the art of the eighteenth, nineteenth, and twentieth centuries. The subjects of the naïve painters are various. Rousseau, the most extraordinary of them, placed his special stamp on portraiture, allegory, still-life, and landscape; but ships also came within his range – he had his own very personal conception of 'Ships in a storm' (Louvre, Paris). The naïve paintings of the sea and ships by other hands are many and bear witness to the particular affection they could arouse in artists without desire for celebrity who often enough have remained anonymous. Collections have been formed both in England and the United States containing unique examples. The period of the Napoleonic wars incited simple sailormen and others with little sophistication to express their pride in the men-of-war and their prowess in battle, in a style radically different from that of the accomplished skill of a De Loutherbourg or a Clarkson Stanfield.

In the Kalman Collection among other examples is 'The *Indefatigable*' depicted with an heraldic brilliance of colour and a fine audacity in the use of allegorical figures. Enclosed in a medallion an inscription with a lavish use of capital letters reads 'His Majestys Ship Indefatigable of 40 guns Sir Edw. Pellew Engages & takes La Virginia a French Frigate of 44 guns on the 22nd of April 1796 off the

166 *Anonymous English Painter. The Fleet Off-Shore.* c.1780–90. *Oil on canvas, 16¼x 65 in. Kalman Collection.*

167 *T. L. Mourilyan, R.N. A Terrible Shipwreck.* 1870. *Oil on canvas, 13½x16½ in. Kalman Collection. Seemingly an eye-witness's memory of a wreck at Sandwich, February 12, 1870.*

(facing above)
168 *Thomas Birch. The* Wasp *and the* Frolic. *1820. Oil on canvas, 20x30 in. Boston, Museum of Fine Arts.*

(facing below)
169 *Thomas Chambers. The* Constitution *and the* Guerrière. *Oil on canvas, 24¾x 34¼ in. New York, Metropolitan Museum of Art. The subject from the War of 1812 was based on an engraving by Cornelius Tiebout after the Philadelphia marine painter Thomas Birch, but with an added effect of drama and vivid colour.*

Coast of France'. The figures of Fame, Hope, and Britannia (as Ruler of the Waves) are decoratively arranged above and in the ocean Neptune and Amphitrite, god and goddess of the seas, ride triumphant waving British flags.

Ships were popular subjects in pictures worked in wool, and in this medium it was possible to vie with oil colour in brilliance as 'Gunner Baldie of the Royal Artillery' demonstrated in his 'The Yacht *Sunbeam* in the Solent'. Other naïve painters represented in this collection show an instinctive sense of design. In the anonymous picture of a yacht race at Whitehaven in 1795 the angles of masts and sails give the suggestion of swift movement the artist desired. Some curiosities of proportion add to the pictorial interest instead of detracting from it. The primitive artists shaped the waves into patterns vigorously in accordance with an imaginative idea. J. Starling, a nineteenth-century artist known only by his signature, brought out the drama of a stormy sea in his 'Lowestoft Lifeboat' with a determined system of brush-strokes all his own. In a similar fashion, T. L. Mourilyan, R.N., placed immense emphasis on the fury of a storm and the heights to which the sea was lashed in his interpretation of a shipwreck in 1870.

The 'natural' artists in the United States were those who stayed at home, unlike the professionals who were able to go to Europe to study. Many were spare-time painters whose work was done for the benefit of family and friends. Others were modest whole-time practitioners little thought of in the nineteenth century when the gloss of the European 'finishing-school' was so much prized. The gusto with which they painted American life and the American scene was a general characteristic. There was the advantage in the absence or limitation of special training that free expression had the more scope. Ships and the sea had their place among a variety of genres. There was the romantically naïve seascape, exemplified in the Karolik Collection, Museum of Fine Arts, Boston in 'Meditation by the Sea', the work of an anonymous artist who painted (*c.*1850–60) a lone figure surveying the expanse of ocean with haunting effect. The painters of ships included the little-known J. H. Wright (1813–83), who portrayed in 1833 the historic frigate *Constellation*, one of the two last remaining ships of the original American navy (Karolik Collection). But mechanical forms were no less attractive to the naïve painters than such reminders of past history. A striking example is to be found in the work of James Bard (1815–97) for whom painting steamships became an ob-

171 *Thomas Chambers. Storm-tossed Frigate.* c.1845. *Oil on canvas,* 21¾×30½ *in. Washington, D.C., National Gallery of Art (Garbisch gift).*

172 *James Bard. The Steamer,* St Lawrence. *Oil on canvas,* 29⅖×48⅘*in. Washington, D.C., National Gallery of Art (Garbisch gift).*

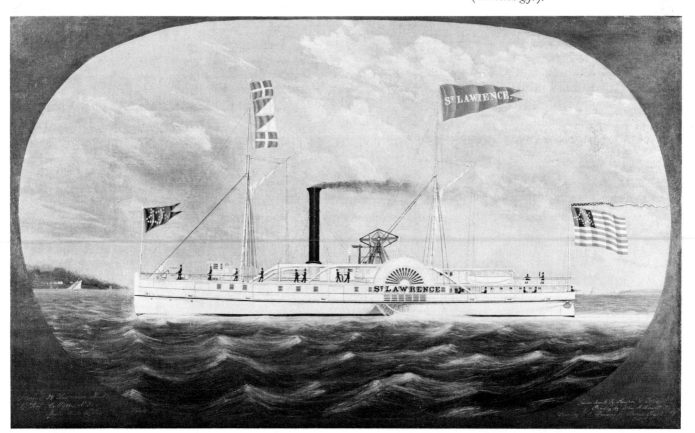

173 *Leila T. Bauman. Geese in Flight. c.1860. Oil on canvas, 20¼×26¼ in. Washington, D.C., National Gallery of Art (Garbisch gift).*

session. From the age of 12, it is recorded, in the house where he was born in New York overlooking the Hudson River, he made drawings of almost every steamer using the port. He acquired such facility that a shipbuilder, it was said, could have laid down the plans of a vessel from one of his pictures. His love of precise detail is well illustrated by his painting of 'The Steamer, *St Lawrence*' (National Gallery, Washington).

The delightful pictorial quality of many naïve works as well as their historic part in the growth of art in America has in this century admitted a number of the once-unknown or little known into the great public collections. Among those that may be singled out in the National Gallery, Washington, for their maritime interest are Leila T. Bauman's 'Geese in Flight', L. M. Cooke's 'Salute to General Washington in New York Harbour', J. Evans's 'White Squall', and the anonymous 'Imaginary Regatta of America Cup Winners'. A late instance of the sailor who took to painting was Charles S. Raleigh (1831–1925), who after long experience as a seaman settled in Massachusetts when about 40 and devoted himself to marine subjects.

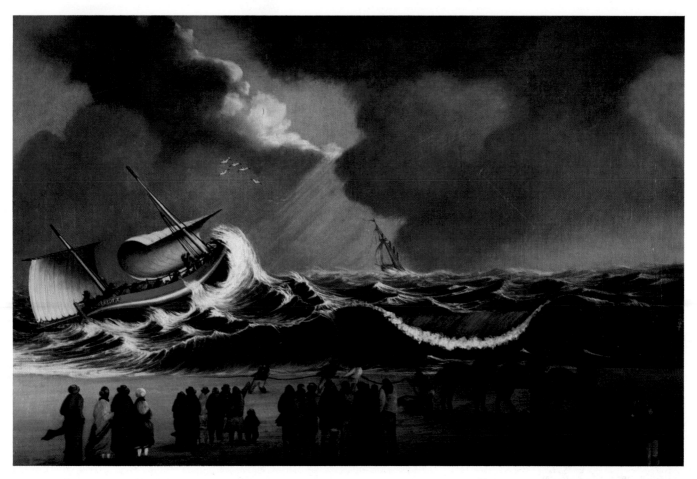

174 *J. Starling. The Lowestoft Lifeboat.*
Oil on canvas, 17x26 in. Kalman Collection.

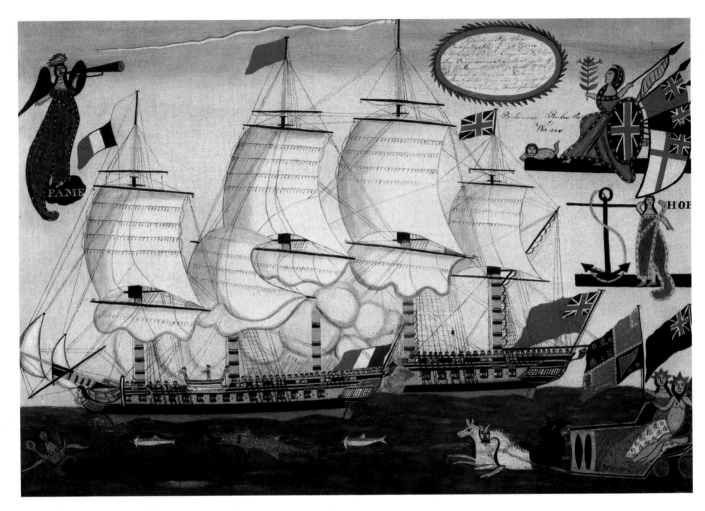

175 *Anonymous English Painter. The* Indefatigable. *Oil on canvas, 18x25½ in. Kalman Collection. Represents the capture of a French frigate in 1796 with various symbols of triumph.*

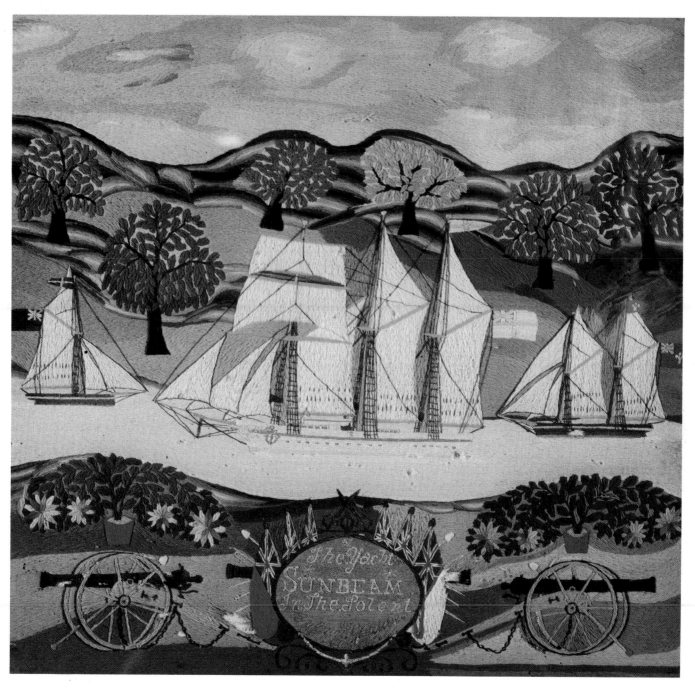

176 *Gunner G. Baldie of the Royal Artillery. The Yacht* Sunbeam *in the Solent. Wool picture,* 23¼×24 *in. Kalman Collection.*

177 *Alfred Wallis. The Blue Ship.* ?c.1934.
Ship's oil-paint on cardboard, mounted on
plywood, 17¼×22 *in. London, Tate Gallery.*

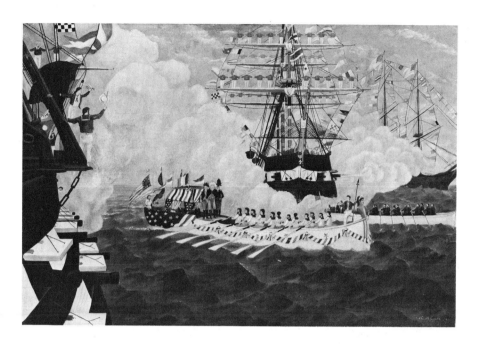

178 *L. M. Cooke. Salute to General Washington in New York Harbour.* c.1875. *Oil on canvas, 27×40¼ in. Washington, D.C., National Gallery of Art (Garbisch gift).*

179 *Charles S. Raleigh. Chilly Observation. 1889. Oil on canvas, 30×44 in. Philadelphia Museum of Art, The Edgar William and Bernice Chrysler Garbisch Collection.*

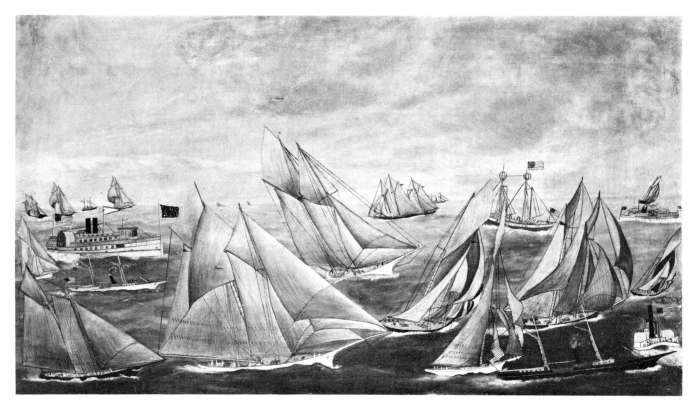

180 *American Primitive. Imaginary Regatta of America Cup Winners.* c.1889 or later. *Oil on canvas,* $26\frac{3}{4} \times 47\frac{1}{8}$ *in. Washington, D.C., National Gallery of Art (Garbisch gift).*

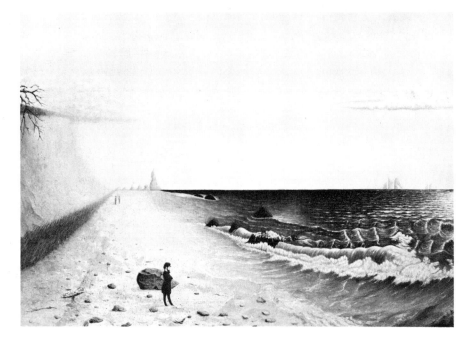

181 *Anonymous American painter. Meditation by the Sea. Nineteenth century. Oil on canvas,* $13\frac{1}{2} \times 19\frac{1}{2}$ *in. Boston, Museum of Fine Arts.*

He showed an amusing originality in 'Chilly Observation', 1889, a painting of a polar bear watching the arrival of ships among ice-floes, now in the Philadelphia Museum of Art.

If England has been less apt to admit the naïve painter into the company of professional masters in the public galleries, at least one now celebrated discovery of this century, Alfred Wallis (1855–1942), has found his way into the Tate Gallery. Born at Davenport, Wallis first went to sea at the age of 9 as cabin-boy on an Atlantic steamer, was later a fisherman on the Cornish coast, and after that a marine store dealer at St Ives. He began to paint in the 1920s to relieve the loneliness he

182 *Anonymous English Primitive. Yacht Race, Whitehaven. 1795. Oil on canvas, 20½×28¼ in. Kalman Collection.*

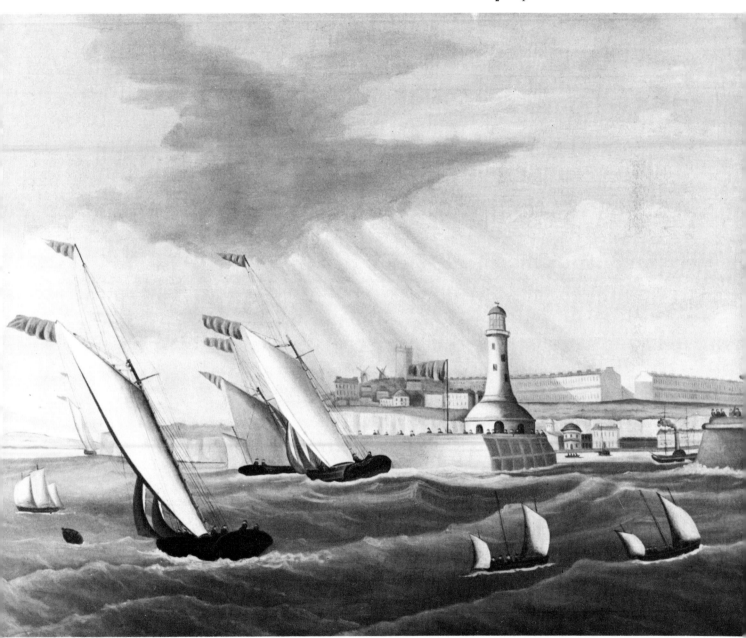

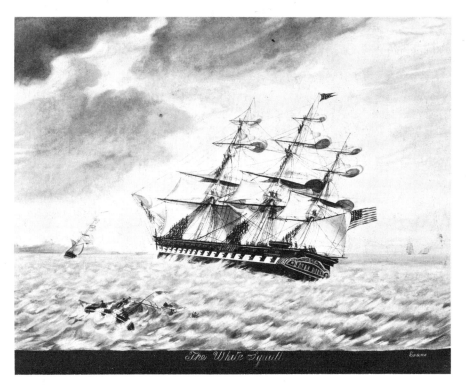

183 *James I. Evans. The White Squall. Early nineteenth century. Oil on canvas, 29x36 in. New York, Collection of Eegar William and Bernice Chrysler Garbisch.*

184 *'E.S.' (English Primitive). The Harbour Mouth. 1906. Oil on canvas, 14¾x18½ in. Kalman Collection.*

185 *Henri Rousseau ('Le Douanier'). Ship in a storm.* 1890–3. *Oil on canvas,* 23⅝×28 *in. Paris, Louvre.*

felt after his wife's death. A simple and unlettered old man, he never thought of himself as 'a real artist', this being his description of the accomplished professionals who made the Cornish resort their painting-ground. Crude as they might seem by conventional standards, his paintings of ships and harbours, tacked to the walls of his cottage and executed on any fragment of paper, canvas, or wood that came to hand, attracted the admiring notice of such artist visitors to St Ives as Ben Nicholson and Christopher Wood. Encouraged by them, but with no thought of selling, he continued to paint prolifically, even after he had been moved to a Penzance workhouse in 1941.

'I do most what used To Be what we shall never see no more as everything

187

is altered' was how he described his pictures of sailing-ships such as in his youth had taken him out to the fishing grounds of Newfoundland and Labrador. Other works included representations of steamers and motorboats and even so contemporary a subject as 'Gunboats in Wartime', as well as many coastal scenes. Cottages by the shore, lighthouses, jetties, boats, leaned all ways without regard to realistic proportion or perspective but were always united in a fascinating design. The directness and simplicity of his art were of some importance as a stimulus to modern painting in Britain. Wallis may be regarded as a necessary figure in making for a freedom from inhibition almost as Rousseau was for the Cubist circle in Paris, though he would not have understood this. For him his work was the memory of a seafaring life.

9
Marine painting in the Impressionist age

The freshness of style and outlook that marked Constable's paintings of English country and English shores had a later parallel in French art of the nineteenth century and the related developments of Realism and Impressionism. Marine painting, like other genres, was susceptible to the change of attitude these movements conveyed. Realism implied painting only what was present to the eye in actuality. One result was a growing tendency among landscape painters to go outside their studios and work from nature in the open. It followed that they discarded the invented or spectacular themes of an earlier generation. A truthful rendering of the realities of light and atmosphere was a main purpose of the Impressionists. Those who painted the sea tended to study it as a phenomenon of light, space, and colour rather than a background for the portrayal of ships.

The transition from the Romantic love of the grandiose and unusual to the Realist's more objective study of nature was gradual at first. Jules Dupré (1811–89), some of whose most striking works were seascapes, had something of both attitudes. Born at Nantes where his father owned a china factory, he quickly gave up the art of porcelain for picture painting and was inclined towards new ideas by an admiration for the work of Constable, which impressed him on a visit to England, and by association with the pioneers of the Barbizon School in France, Théodore Rousseau (1812–67) and Diaz de la Peña (1808–76), with whom he was one of the first artists in France to paint direct from nature. Like them he worked in the forest of Fontainebleau, though there was always the alternative of the Channel coast to which the Barbizon painters often repaired. Dupré there produced pictures derived from his open-air studies, but still romantic enough to give an intensified drama to the menacing sky of his 'Stormy Day' (Mesdag Museum The Hague) or the forces of waves breaking on the Normandy cliffs in 'The Headland' (Glasgow Art Gallery).

A move nearer to Impressionism appears in the work of Charles François Daubigny (1817–78). A painter of landscape and seascape, born in Paris, he was the pupil of his father, also a landscape painter, and of the academic painters Granet and Delaroche. As a young man he was responsive to the idea of a return to nature represented by the 'School of 1830', the painters who congregated at the village of Barbizon and worked directly from nature there and in the neighbouring forest of Fontainebleau. He was thus associated with Théodore Rousseau, Corot, Diaz de la Peña, and Jules Dupré. He carried the practice of painting in the open air a stage further than Dupré who began his pictures on the spot, but worked them up later in the studio. Daubigny made a consistent habit of completing a picture on the spot, as Claude Monet was to do later. He gained success with his views of the beautiful river scenery of northern France, having his own small boat on one or other of the rivers Oise, Marne, and Seine as a kind of floating studio (an example that Monet was to copy). But Villerville-sur-Mer on the Normandy coast was his

186 *Eugène Boudin. Trouville. 1888. Oil on panel, 13¾×10½ in. London, Lefevre Gallery.*

most regular place of resort. From 1854, he regularly spent the summer there. Though he also worked on the coast of Brittany, and in 1866 when he visited London at Sir Frederic Leighton's invitation painted a number of pictures of boats on the Thames estuary, it was at Villerville that most of his seascapes were produced.

The wide canvas he favoured was suited to convey space and distance. These are distinctive qualities in his views of the sea. The distance was emphasized by the incidental presence of a fishing-boat or such small figures onshore – gatherers of mussels or seaweed – as appear in his 'Sunset over the Sea at Villerville', 1872 (Mesdag Museum, The Hague). The picture was painted at intervals on the same stretch of shore. Daubigny waited for weather conditions approximating to those that prevailed when he began work on his canvas.

Studies of the sea at Villerville occupied him regularly until a year or two before his death. He developed a method of painting swiftly with touches of broken colour, called for in the attempt to hold the transient effects of light. He added a new vitality of technique to the evolution of the seascape. This was a faculty bril-

190

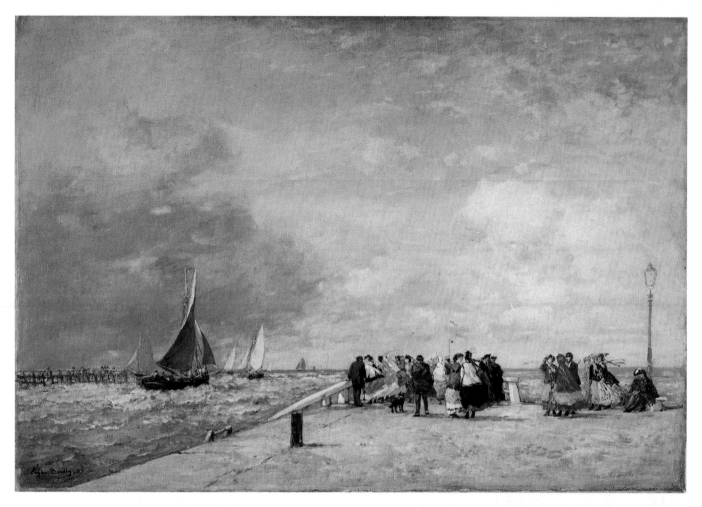

187 *Eugène Boudin. The Pier at Trouville.
1869. Oil on canvas, $25\frac{1}{2} \times 36\frac{1}{2}$ in. Glasgow
Art Gallery, Burrell Collection.*

188 *Claude Monet. The Rocks of Belle Isle.*
1886. Oil on canvas, 25×31½ in. Reims,
Musée.

189 *Georges Seurat. Sunday at Port-en-Bessin.* 1888. *Oil on canvas,* $25\frac{7}{8} \times 28\frac{3}{16}$ *in. Otterlo, Kröller-Müller Museum.*

190 *Paul Signac. Entrance to the harbour at Marseilles. Oil on canvas. Paris, Musée d'Art Moderne.*

liantly exercised also by Eugène Boudin (1824–98) who was uniquely able to combine a sense of light and space with an unflagging interest in ships and harbours.

Born at Honfleur within sight and sound of the sea, Louis-Eugène Boudin was the son of a ship's captain, Léonard Boudin, whose boat *Polichinelle* plied for some time between Honfleur and Rouen. When Eugène was 10 he served as ship's boy and had already begun to draw. The family moved to Le Havre in 1835 and Léonard captained the cross-estuary steamboat (Havre to Honfleur) until his death in 1862. Eugène, after a short time at school, worked in a stationer's shop at Le Havre and in 1844 set up in business for himself as stationer and frame-maker. Artists visiting the coast who came to him to have their pictures framed encouraged him to paint. The marine painter Eugène Isabey was among them, though if he influenced the direction of Boudin's ambitions, it can only have been in a general way and not specifically in approach. Isabey, a Romantic still, painted the sea-fights of the past and theatrical scenes of shipwreck. For Boudin this was obsolete matter. 'Henceforward' he wrote in 1854, 'it is necessary to study the simple beauties of nature.' It was the lesson of the Barbizon School though requiring a different application on the Normandy coast from that suggested by the forest glades of Fontainebleau. There all was heavy and still; Boudin's impressions on the contrary were of the breezy restlessness of the Seine estuary, variable skies, transient

191 *Eugène Boudin. Harbour Scene. Oil on panel, 9½×12¾ in. Bristol, City Art Gallery.*

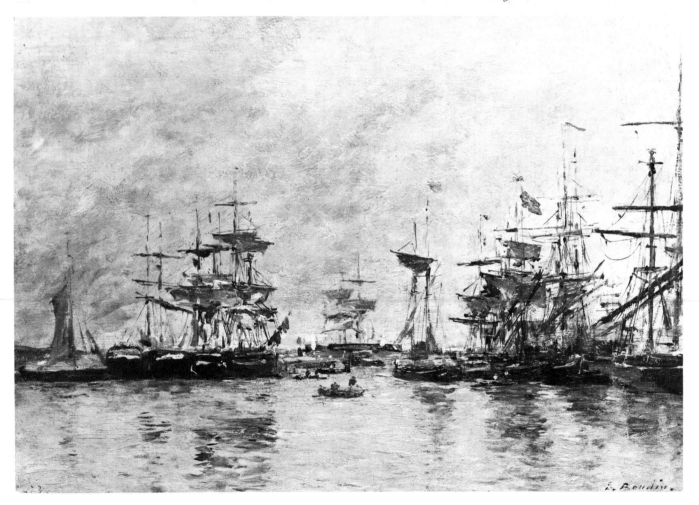

192 *Jules Dupré. The Headland. Oil on canvas, 28½×36 in. Glasgow, Art Gallery and Museum.*

193 *Charles François Daubigny. Sunset at Villerville.* c.1870.+ *Oil on canvas, 35× 51 in. The Hague, Mesdag Museum.*

gleams of light, dancing waves. After a struggling period in Paris he returned to Normandy to paint in the open on the coast with the conviction that 'Everything painted directly and on the spot always has a strength, vigour and vivacity of touch that can never be attained in the studio'.

Success came to him in the 1860s when his beach scenes at Trouville and Deauville concided with the popularity of these resorts with fashionable visitors from Second Empire Paris and mid-Victorian England. He introduced their like into a number of water-colours and oils, though he thought of them as 'little dolls' and the flutter of fashion as incidental to the liveliness of nature. His style, owing something to the Dutch painter, Jongkind, was fully formed in the 1870s, justifying Baudelaire's earlier prediction that he was one destined to reveal 'the prodigious wonders of air and water'. Figures were dispensed with, the masts and sails of ships, the changing patterns of sky, the sparkle of sea were sufficient in themselves. Boudin travelled considerably but never far inland. He seems to have taken with him a mental image of his native shores and looked elsewhere for similarities in harbour and shipping. In the 1870s and 1880s he painted the port of Antwerp and the harbours and beaches favoured by the Dutch masters in the past at Rotterdam, Dordrecht, and Scheveningen. Painting expeditions in the 1890s extended to the bay of Antibes and Venice and the Adriatic though his attachment to Le Havre and Trouville continued to find expression in oil-paintings and water-colours so brilliantly executed that in spite of their similarities of theme they never became monotonous. The small size of his canvases was suited to his direct method of painting in the open air and also made for a very large output. The sixty canvases and 180 panels which his brother, Louis, presented to the Musée du Havre in 1899 were but a fraction of the total distributed in many public and private collections.

Though less specialized, Stanislas Lépine (1835–92) added to the views of Paris and the city's environs, by which he is best known, paintings of ships and harbours that attractively complement those of his friend Boudin in their refinements of grey tone. The great realists of the century in France, Gustave Courbet (1819–77) and Edouard Manet (1832–83), both had a remarkable contribution to make to the development of the genre, in a few works that give a special meaning to the idea of the *vérité vraie*, the real truth that they pursued in varied forms. Painting at Trouville in the 60s together with Whistler, Courbet produced his rendering of waves that stands out as a masterpiece. Simple in essence without recourse to ex-

aggeration, the 'Mer Orageuse' (otherwise known as 'La Vague') had a weight and majesty of a memorable kind. Exhibited at the Salon of 1870 it asserted the triumph of Courbet's realistic aims just before the misfortunes of war and the troubles of the Commune that followed put a terminus to his success.

The last thing that Manet might have been expected to paint was a scene of naval warfare, but he chanced to be at Cherbourg in 1864 and was an eye-witness of the engagement between the American Civil War ironclads, the Confederate *Alabama* and the Federal frigate *Kearsage*, when it was taking place in the neighbourhood of the French port, the *Kearsage* having overtaken the Confederate commerce raider at that point. There before his eyes was a spectacle unforeseen but conformable as a subject to his realistic theory of being contemporary. Manet painted the moment when the *Alabama* was sinking and boats stood by to pick up survivors. He produced one of the most vivid and least conventional renderings of naval warfare. But the choice of the subject actually seen does not entirely explain what Manet meant by being contemporary. Unlike Courbet, whose method of oil painting was traditional, he evolved a technique of a freer and more spontaneous kind, expressive of his feeling for essentials, especially by the use of colour in a role of new importance as representing both light and form. In his painting of the port of Bordeaux, 1871 (Bürhle Collection, Zurich), laced with a forest of masts of the ships in harbour, he was able to convey its intricacy with only a suggestion of line

195 *Johan Barthold Jongkind. Brig and Barques at a Port. 1866. Oil on canvas, 13 × 18 in. London, Tooth Gallery.*

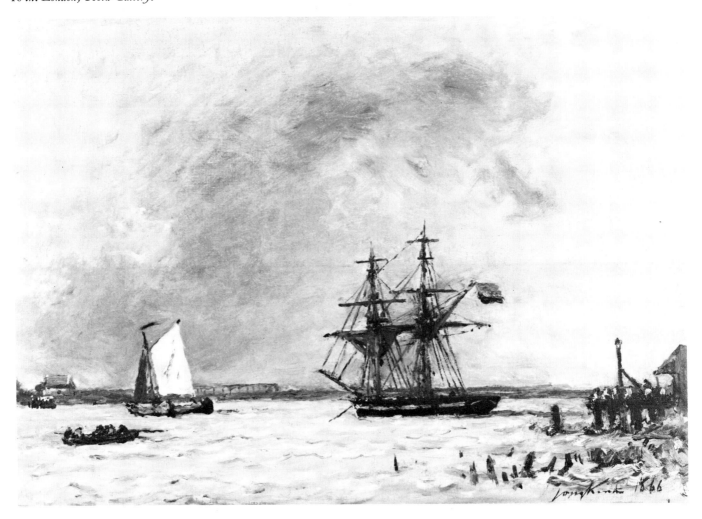

196 *Claude Monet. Entrance to the Port of Honfleur. 1870. Oil on canvas, 19¾×24 in. Private Collection.*

197 *Claude Monet. Rough Sea, Etretat. 1883. Oil on canvas, 31⅞×39⅜ in. Lyons, Musée des Beaux-Arts.*

198 *Gustave Courbet. Stormy Sea ('The Wave'). 1870. Oil on canvas, $45\frac{3}{8} \times 63\frac{11}{16}$ in. Paris, Louvre.*

199 *Camille Pissarro. The Pilots' Jetty, Le Havre. 1903. Oil on canvas, $25\frac{5}{8} \times 32$ in. London, Tate Gallery. One of a series painted from a hotel window overlooking the harbour.*

rather than careful linear detail but with touches of colour that magically gave the scene life and substance. The method that gave a new importance to colour was systematically carried further by the young admirers of Manet who were the nucleus of the Impressionist group, led by Claude Monet (1840–1926). The colours of the spectrum they assumed could be so combined as to solve every problem of picture-making, whatever the subject. Impressionist subjects in the main were quiet stretches of inland country and river as well as the life of the boulevards. Monet was exceptional in the number of his paintings of sea and coast. He demonstrated with great effect how well the art of pure colour was adapted to this purpose. He pursued it with affection of long standing.

Born in Paris, Monet spent his early years at Le Havre where his father set up in business, and was familiar with all the coastal environment. As home ground, the region was his refuge in recurring periods of penury in the 1860s and 1870s. Until towards the end of his life he made periodic visits to the places for which he had as strong an affection as Boudin. Paintings of the sea at Honfleur, Trouville, Sainte-Adresse, Etretat, Fécamp, and Pourville are frequent in his work.

It was Boudin who first encouraged him to give up youthful essays in caricature and take to painting in the open air. Both he and Boudin gained a lesson in the value of sharp accents and broken touches of colour from the Dutch painter Johan Barthold Jongkind, whom Monet met at Trouville. Manet's bold use of colour was a third phase of Monet's technical education, leading to the typical Impressionist method of translating light and shade into terms of pure colour He

applied it consistently to a wide range of themes, from his views of the Seine at Argenteuil in the 1870s to the paintings of water-lilies in his garden at Giverny that were a product of his old age, but with unfailing enthusiasm returned at intervals to the sea. An early work in which his affinity with Manet appears is the fine 'Entrance to the Port of Honfleur' (Lefevre Gallery). The chalk cliffs of Etretat, curiously sculptured by wind and wave, and the pounding breakers beneath, were always inspiring to him as they had earlier been to Courbet. After his stay in England during the Franco-Prussian War he returned to France by way of Holland and Belgium producing beautifully atmospheric paintings of Zaandam and the harbour at Antwerp. In the 1880s he was attracted by the stark grandeur of the island of Belle-Isle off the coast of Brittany and his studies of the rough seas that dashed against its barren rocks were impressive in demonstration of how little beyond the primary sense of atmosphere and movement the Impressionist needed to make a great marine picture. In subsequent visits to the south of France he was incited by the Mediterranean light to brighter colour though the softer light of the north was more congenial in allowing a subtler range of hues, such as distinguishes his Thames paintings of *c.*1900 in which sky and water dissolve into a chromatic mist. The remarkable evolution of Monet's work was in many respects different from that of Turner but in the final stage of near-abstraction, a parallel between them appears.

French example was partly responsible for the return of a realistic attitude in Holland. Dutch painters had not been happy in their ventures in Classicism or Romantic subject pictures. The French 'School of 1830' encouraged them to a fresh study of nature about midway through the century. This also involved a return to the spirit of Dutch art in the great period of the seventeenth century. The sea, the beaches and dunes, the canals, the grey harmonies of sky and water again had their interpreters. The era of naval battles and picturesque fleets was over but the environment had lost none of its character.

The sea was the special study of Willem Mesdag (1831–1915). Born at Groningen, the son of a banker, he was dutiful in the same occupation until he was 35 when he could no longer resist the urge to paint. Like Daubigny he worked in the open and the beach at Scheveningen, so often inspiring to the Dutch masters in the past, was a vantage point from which he studied the movements of the flat-bottomed surf-boats of the region and the sea in all its moods. One of his seascapes was exhibited in the Salon of 1870 alongside Courbet's famous 'Wave'. His pictures, often of impending storm and with no great variety of subject, became widely popular in his own time. The influence of the Barbizon painters, whose work Mesdag admired and collected, also appears in the paintings of Jacob Maris (1837–99). Born at The Hague, he finally settled there after some years in Paris and devoted himself to delicate grey pictures evoking the atmosphere of Holland. Jozef Israels (1824–1911) was another painter with a realistic bent though distinct in his interest in the struggle of a fishing community to wrest a living from the sea. Born at Groningen, he studied art in Paris and returned to Holland to paint scenes of peasant life, spending much time at the fishing village of Zandvoort near Haarlem. His painting of fishermen carrying a drowned seaman ('The Shipwrecked') 1861, was dramatic in a way that appealed to the taste of the 1860s in subject-matter

202 Georges Lemmen. Heyst. 1891. Oil on canvas, 5×8½ in. Private collection, U.S.A. A Belgian painter, Lemmen adopted the pointillist technique of his friend, Seurat.

203 *John Singer Sargent. Santa Maria della Salute, Venice. Water-colour, 18×12 in. London, Victoria and Albert Museum.*

though somewhat out of context in the National Gallery, London, to which it was presented by Israels' widow.

The most original of the Dutch Realists was Johan Barthold Jongkind (1819–91), whose way of rendering the nuances of tone and colour in sky and water, retaining all the freshness of a sketch, seems to have been entirely his own, though stimulating in suggestion to others. Jongkind was born at Lathrop near Rotterdam and was first the pupil of a Dutch landscape painter, Schelfort; later, when he went to Paris in 1846, of the marine painter, Eugène Isabey. He accompanied Isabey to the Normandy coast and Isabey tried to help him in gaining picture commissions, but Jongkind's temperament made him difficult to deal with. After a time he returned to Holland but was back in France in 1860. Unknown to the public, regularly refused at the Salons, erratic and alcoholic, he found a guardian angel in a Dutch teacher of drawing, Mme Fesser, and was no doubt restored by her care to some degree of normality at the time of his meeting with Boudin and Monet at Trouville, when his method of painting made so deep an impression on them. Subsequently, Jongkind painted with success in various parts of France though he still suffered from alcoholism and a form of persecution mania and died in the asylum at Grenoble. In his varied work which included views of the older quarters of Paris, the canals and polders of his native land and coastal scenes ranging from Trouville to Marseilles, his oils and water-colours of ships in harbour have a distinguished place. From such an example as the 'Brig and Barques at a Port' (Arthur Tooth & Sons) one can gain an idea of what Boudin meant when he said that Jongkind 'opened a door' for him and why Monet lamenting Jongkind's sad personal history could add that he was the best of marine painters.

Impressionism implied a feeling for colour which might be thought opposed to specialization in being applicable to any theme. But paintings of sea and ships none the less call for notice in the work of artists by no means restricted in their choice of subject. It was after all Monet's 'Impression of sunrise over the harbour of Le Havre' that gave a name to the movement he represented. Through colour, Vincent van Gogh (1853–90) expressed a depth of personal emotion whether he was painting a portrait, a still-life, or a landscape, but one of his most memorable pictures is of boats and sea, the result of a week's stay on the shore of the Mediterranean. In 1888 he went on a trip from Arles to the coastal village of Saintes-Maries de la Mer (so called from the legend that the 'two Maries', Mary Cleophas and Mary Salome, landed there in A.D.45 and converted the region to Christianity). He was fascinated by the elusive hues of the sea. 'The Mediterranean has the colours of mackerel' he wrote '. . . You don't know if it is green or violet, you can't even say it's blue, because the next moment the changing light has taken on a tinge of pink or grey.' The seascape of 1888 (National Museum, Vincent van Gogh Collection) set down on canvas the conditions he had put into words. The changes of surface were denoted with a characteristic decision of brush-stroke. The result was as personal an image of the sea as any artist has given.

It is a sign of his intense industry that in the six days spent at Saintes-Maries he covered three canvases and produced about a dozen drawings, including studies of boats on the beach. Green, red, and blue, he found them 'so pretty in form and colour that one is reminded of flowers'. They appear in one of his most famous paintings, the 'Boats at Saintes-Maries' (National Museum, Vincent van Gogh Collection) in which his own powerful sense of design was linked with appreciation of the grace of line belonging throughout history to the type of Mediterranean craft he depicted.

Paul Cézanne (1839–1906) also painted the Mediterranean but with a different purpose, not as a moving surface of many colours but a flat plane of deep blue setting off the structural variations of the rim of mountainous country and buildings on the coast. 'The Gulf of Marseilles seen from L'Estaque', 1883–5 (Metropolitan Museum of Art, New York) is a great example of the feeling for space he was able to convey while retaining a two-dimensional flatness of design. L'Estaque, then a village on the outskirts of Marseilles, was his frequent resort between 1870 and 1886 (the year in which his father died) and several versions show the pleasure he took in this sun-baked region. The Mediterranean bursts upon the view in a

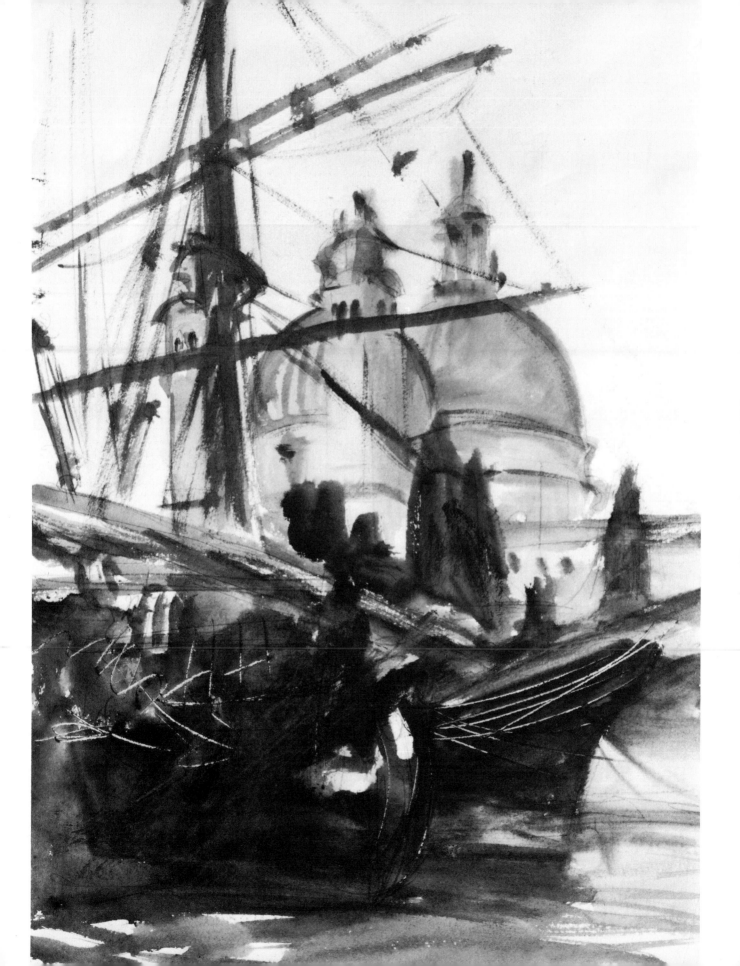

splendour heightened by the contrast of its blue and the warm ochre of the foreground.

The 1880s were indeed fruitful years in France in which paintings of sea and coast gained an extra brilliance through the stimulus of Impressionist colour. The list of French artists and artists working in France who have left superb examples includes, besides Jongkind, Boudin, Manet, Monet, Cézanne, and Van Gogh, the great though short-lived Georges Seurat (1859–1891). He was, like most of his eminent contemporaries, a painter of many subjects. Equally remarkable in his brief career are the variety of his themes, the number of masterpieces he produced, and the interest of new methods. The Normandy coast inspired a beautiful series of works. Born in Paris, he studied at the Ecole des Beaux Arts from his sixteenth to twentieth year. He read extensively in the works on the theory and science of colour by Chevreul, Rood, Henry, and with reference to Delacroix whom he admired. In two ways, he gave a fresh direction to the Impressionist mode of painting. Like Monet and Pissarro he translated light and shadow into terms of pure colour, but with a more scientific and systematic form of analysis. He called it 'divisionism', the use of small dots or patches of the colour-constituents of the spectrum. Blue, violet, red, orange, yellow, and green fused at a certain distance into every subtle variety of tone. With this went a stronger framework of design than had been usual with the Impressionists in their concentration on atmosphere. Seurat first worked on the Seine in the vicinity of Paris and his first large canvas, 'La Baignade' (Tate Gallery, London) was the result of sketches made at the in-

204 *Gustav Klimt. Insel im Attersee. c.1901. Oil on canvas, 39½×39½ in. New York, Dr and Mrs Otto Kallir. Always interested in surface textures the Austrian painter here studies the pattern of quiet waters as a theme in itself.*

205 *Paul Signac. The* Fanny Crossfield *at Paimpol. 1928. Water-colour and crayon, $10\frac{1}{2} \times 17\frac{1}{2}$ in. London, Marlborough Fine Art.*

dustrial suburb of Asnières. But the originality of his divisionist method remained to be displayed in the 'Dimanche à la Grande Jatte' the picture of a Parisian Sunday outing, 1884–6. From 1885 he spent most of his summers on the Normandy coast, at Grandcamp, Port-en-Bessin, Honfleur. His last paintings of sea and coast were of Gravelines between Calais and Dunkirk. He worked on his figure subjects in Paris during the winter and in them the experimental side of his genius appeared in the effort to convey by geometrical forms mood and movement as seen in various forms of popular entertainment. In contrast with such works as 'Le Chahut', 1889–90, with its high-kicking dancers, his seascapes and harbour scenes were serenely reposeful, the division of colour an exquisite refinement. In 'The Beach at Bas-Butin, Honfleur', 1886 (Museé des Beaux-Arts, Tournai) he achieved this effect without the aid of the masts and architectural harbour features, of which he made use in other paintings. The division of colour is a quiet vibration uniting sky, sea, and cliff in delicate harmony. A masterpiece of 1890, 'The Harbour at Gravelines' (John Herron Art Institute, Indianapolis), shows how exact calculation, as in the spaces between the boats, the long perspective of the quay, the placing of lighthouse and bollard, and the controlled gradations of colour could look entirely natural and poetic at the same time.

A friend of Seurat and associated with him in the development of the divisionist method, Paul Signac (1863–1935) applied it with great consistency to the marine subjects that came to occupy him almost exclusively as a painter. In addition, he was the theorist of the movement, the author of an influential book on colour and the history of its use in the nineteenth century, *D'Eugène Delacroix au Neo-Impressionisme*, 1899. As an amateur sailor, he is said to have owned and sailed in more than thirty boats from the first, acquired before he was 20 (on the prow of which he

207

painted the names of Manet, Zola, and Wagner), to the small drifter *La Ville de Honolulu* which took him to Corsica in the last year of his life. There was scarcely a harbour in Europe from Rotterdam to Istanbul where he had not moored his craft and painted ships.

Signac was born in Paris and first painted there in the Impressionist manner. He exhibited at the first Salon des Indépendants in 1884 where he met Seurat and became interested in his ideas. They were both invited by Camille Pissarro to take part in the eighth and last Impressionist exhibition when their innovations in style and approach, especially in Seurat's 'Grande Jatte', aroused much controversy. After some early figure-paintings and views of the Seine painted in Seurat's company, he embarked on his travels by sea. He painted, in both oils and water-colours, preferably sailing-ships. Between 1920 and 1930 he could claim to have painted water-colours in 200 French ports.

In oils he remained faithful to the method of using the spectrum colours in separate touches, alternatively known as pointillism, divisionism, and neo-Impressionism. In his early oils he used small dots of colour like Seurat, later he applied colour in oblong patches like the tesserae of a mosaic, more assertive in brightness. Marseilles and Saint-Tropez, for instance, were seen through a glowing veil of colour, a three-masted sailing-ship often having prominence in the composition. His water-colours were as distinctive in their fluid touches of transparent colour.

Another friend of Seurat was the Belgian painter, Georges Lemmen (1865–1937) who added poetic feeling to the science of colour division. He gave his own demonstration of the aptness of both to marine subjects.

10

The Far East

Oriental works of art and in particular the Japanese colour-prints of the popular *Ukiyo-e* school were the dramatic discovery of painters in nineteenth century Europe. For the Impressionist age the prints confirmed the value, also derived from other sources, of clear colour and colour harmonies as opposed to the traditional dark chiaroscuro of the oil-painting; of new possibilities of composition released from the formal recipes of the past. The tender blue and simplified design of a Whistler nocturne paid a certain tribute to the master of Japanese landscape, Hiroshige. The vivacity of a ballet scene by Degas owed as much to the asymmetry of Japanese design.

Landscape painting in the Far East had its origin in the Buddhist art of China. In the Sung period (tenth to thirteenth century) there developed the characteristic style of brush-drawing, mainly in monochrome, through which the artist could express thoughts and feelings of a religious, philosophic, or poetic kind. Pictures of mountains, shrouded in mist with lakes and rivers below and perhaps a boat with a solitary fisherman, were the kind of scene that conveyed the serenity of communion with nature. The nearness of Chinese brush-drawing to calligraphy and often the union of a poetic thought in writing with the pictorial image was a further identification of artist and theme.

The Chinese form of landscape was carried over to Japan and adapted by the Zen Buddhist priests of the islands. Misty expanses of mountain and water were typical in the work of the fifteenth-century monk Shubun who had famous pupils in Sesshu (1420–1506) and Sesson (1504–89). The Kano school, led by Masanobu (1434–1530), added the richness of decorative colour to the simplicity of Sung brush-work.

A character distinct from the meditative calm of China, a dynamic vigour and boldness of design belonged to this phase of Japanese art. Outstanding in the Kano tradition was Korin (1658–1716) whose decorative art as exemplified by his screens made magnificent use of the curving forms and rhythms of cloud and wave. The Tosa School of court painters had long kept alive the idea of reflecting national life. Their fineness of execution and colour as in the work of Sotatsu (early seventeenth-century) was eventually combined with the boldness of the Kano school in the pictures of contemporary life, entertainments, occupations, and landscapes of the *Ukiyo-e* school. Through the medium of the colour-print the pictures of 'the transient world' by great Japanese artists in the eighteenth and nineteenth centuries had the widest distribution. Though prints of actors and theatrical performances and the courtesans of the Yoshiwara quarter were numerous, the sea had its necessary place in the record of island life, and environment.

Hokusai (1760–1849), the prolific genius who gave an encyclopaedic picture of his time, which he saw from many different angles as book-salesman, wood-engraver, assistant to the portrayers of theatre characters, Shunsho, as book-illustrator,

206 *Hiroshige. View of the whirlpools at Naruto. Japanese colour-print triptych, 13½×28 in. London, Victoria and Albert Museum. One of a set of three representing sun, moon, and flowers, the whirlpools being poetically called 'flowers of the waves'.*

and even as a street-hawker, had a style of drawing that places him among the world's greatest draughtsmen. The imaginative sense of design that adds a dimension of grandeur to his celebrated 'Views of Fujiyama' appears equally in seascape. A universally celebrated masterpiece in interpretation of the sea is the colour-print 'The Hollow of the Deep-Sea Wave off Kanagawa' in which though the design is stylized into decorative patterns the effect of the mountainous comber is an essential distillation of nature. The small boat making its way through the trough of the wave adds to the impression of magnificent scale. Hokusai's originali-

207 *Kōrin. The Islands of Matsushima. Japanese six-fold screen. Edo period (1658–1716), 61×24⅘ in. Boston, Museum of Fine Arts Fenellosa-Weld Collection.*

208 *Hiroshige. Wind-blown Waves. 1852. Japanese colour-print from the series of Thirty-Six Views of Mount Fuji. 7×10 in. London, Victoria and Albert Museum.*

209 *Kuniyoshi. Fishing-boats with distant view of Fuji.* c.1843–4. *Japanese colour-print, 9×13¼ in. London, Victoria and Albert Museum, Crown Copyright.*

(*facing*)
210 *Hokkei. Mount Tateyama with European ship.* c.1835–40. *Japanese colour-print from a series of views of famous places. London, Victoria and Albert Museum, Crown Copyright. The archaic galleon seems a reminiscence of the foreign ships depicted by the earlier* Namban *School at Nagasaki.*

(*facing*)
211 *Kuniyoshi. Nichiren calms the waves.* c.1835. *Japanese colour-print, 8¾×14⅛ in. London, Victoria and Albert Museum, Crown Copyright. From a series illustrating the life of the Buddhist priest, Nichiren.*

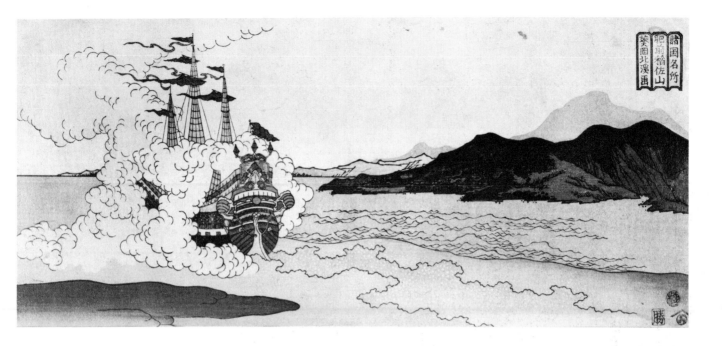

諸国名所
肥前稲佐山
葵岡北溪画

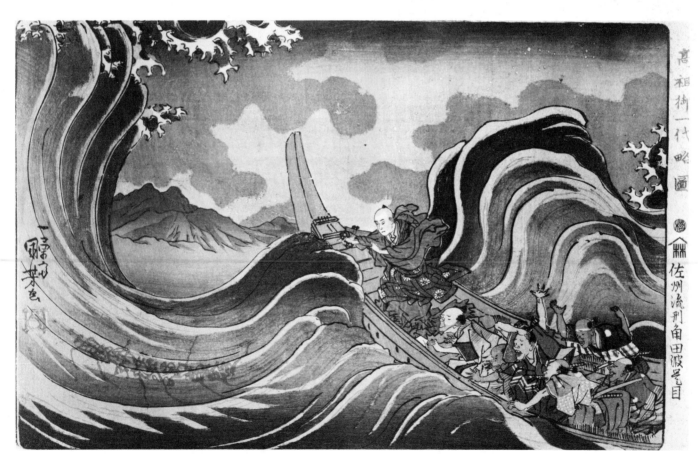

高祖御一代略圖

佐州流刑角田波号目

213

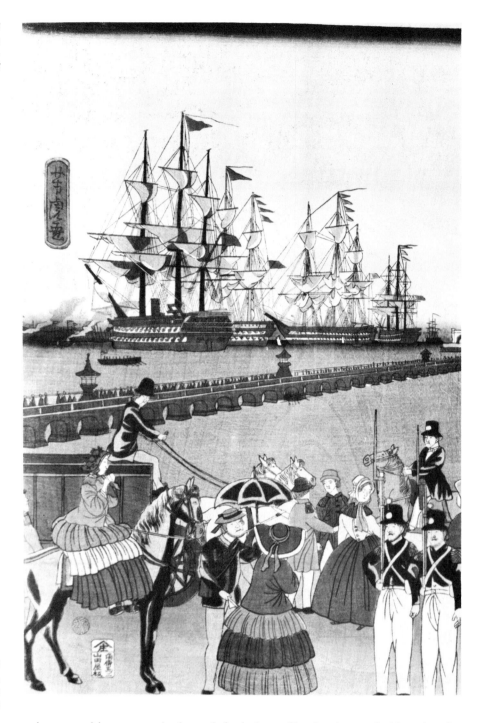

ty in composition appears in the varied relations of land and water in his series, the 'Views of Famous Bridges', the 'Waterfall', the 'Views of the Lu-Chu Islands', the 'Thirty-Six Views of Mount Fuji' and the monochrome 'Hundred Views of Mount Fuji', the volcanic peak having a place in his work and affections like that of the Montagne Sainte-Victoire for Cézanne. Hiroshige (1797–1858), as prolific as Hokusai, concentrated even more on landscape, though well able to include figures

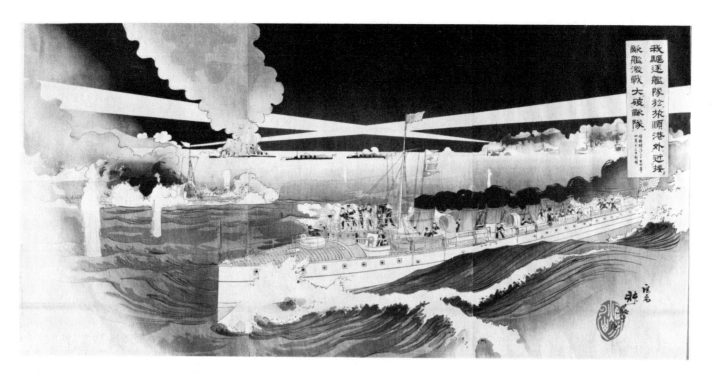

我驅逐艦隊於旅順港外迎撃
敵艦激戰大破敵隊

appropriate to the landscape theme when the subject might require them. Hiroshige travelled about Japan with sketch-book ready to hand. Every season and condition of weather, sun, snow, hail, rain, mist, appealed to him and he was skilled in rendering them by a linear pattern or subtlety of tint.

The problems of representing moving water by a design, which though formalized was near enough to nature to keep the feeling of reality, was a challenge to his inventiveness, strikingly met in the triptych view of the whirlpools at Naruto (Victoria and Albert Museum, London). The triptych symbolized flowers, the circles of the whirlpool being poetically known as 'flowers of the sea' a suggestion however in which the artist did not depart too far from reality. In other prints Hiroshige, like Hokusai, gave an impression of mountainous seas. The windswept waves in one of a series of views of Mount Fuji seem to be designed as illusionary mountains to be contrasted with the solid permanence of Fuji in the background.

The straits, gulfs, and channels around the deeply indented Japanese coast no doubt in themselves suggested to artists effects of restless movement. In the work of Kuniyoshi (1797–1861) they were keyed up to a new dynamic pitch. One of the least inhibited of artists, Kuniyoshi let imagination run wild in renderings of battle and legendary adventures by sea in which the sea itself became a combatant. Without knowledge of the historical or legendary incident represented, the spectator may still experience an overwhelming impact from the towering waves and billowing sails of a print such as Kuniyoshi's 'Benkei in the boat', where Benkei, warrior monk, rescues the hero Yoshitsune from the angry waves; or in the ferocity of an underwater fight between two individuals portrayed by Kuniyoshi's pupil, Yoshitoshi (1839–92).

The great age of the Japanese colour-print was drawing to its close when the connoisseurs of Paris in the 1860s were excited by the specimens brought to Europe after Japan opened trade with the Western world. Curiosity about this other world from which Japan had so long remained aloof was soon to turn into the aim of sharing in modern progress. A pupil of Kuniyoshi, Yoshitora, pictured in imagination the Port of London, presumably with the aid of English prints and from observation of the big ships that anchored in Japanese waters. The Japanese feeling for decorative line remained in his portrayal of the wooden walls and their forest of rigging. More startling is a print by Kokyo (late nineteenth to early twentieth

century) depicting an incident in the Russo-Japanese wars, 1904, outside Port
Arthur. The dynamic force of style was not lost but instead of a source of pleasure
for a wealthy mercantile class, the print had become a propaganda instrument for
a nation equipped with up-to-date armament and modern efficiency. As a form of
reproduction the colour woodcut was obsolete by then though the graphic master-
piece of earlier years had not ceased to influence artists in Europe.

11

Sea and ships in art of the twentieth century

After the Post-Impressionist period, many brilliant paintings inspired by the sea and ships were still to come. This might seem surprising if one were to think of the evolution of modern art solely in terms of abstract theory. But in fact, new ideas of form and colour have not necessarily proved incompatible with established types of subject. Signac, whose career extended well into the first half of the twentieth century, was perhaps exceptional in his equal loyalty to a theoretic principle of colour and the sea as a theme. Yet he made clear the difference between a dull copy of the thing seen and the endless possibilities of creative treatment. The work of Turner in his later years, which Signac remarked on when he visited London in 1898, provided him with a great example. In the course of modern art in France there are numerous instances of the gain in interest of an unconventional approach to the maritime subject.

Post-Impressionism led in the early years of the century to that free use of the brightest possible colour that caused Henri Matisse and the group that worked with him or in a similar spirit to be described as the 'wild beasts' of art, *les Fauves*. Their liberation of colour, far from being unsuited to as sober-seeming a subject as marine painting, gave it a welcome vividness. André Derain, Raoul Dufy, Georges Braque, and Albert Marquet, all of whom passed through a *fauve* phase, had their several interpretations of the theme. Boats and water in Derain's paintings at the port of Collioure in 1905 glowed with intense vibrations of primary colour, once one accepted the key they fell naturally into place. André Derain (1880–1954), born at Chatou, studied art at the Académie Carrière and was influenced as a young painter by the work of Van Gogh and by Henri Matisse whom he met in 1899. Brilliant colour was a Post-Impressionist heritage in the extension of which he had the guidance of Matisse and the friendly alliance of Maurice de Vlaminck with whom he shared a studio at Chatou for a time. The free use of colour cultivated at Collioure and Chatou was the main feature of the works he sent to the Salon des Indépendants and the Salon d'Automne in 1905, when he and others of similar aims were described as *fauves*. His colour so impressed the dealer Ambroise Vollard, that Vollard commissioned him to go to London and paint the series of views of the Thames that turned out to be one of Derain's most successful undertakings.

His method might be thought little adapted to the sober atmosphere of London's river, though Claude Monet had found the fog-laden air an inspiring source of colour on his visits to London between 1899 and 1904. It was Vollard's wish for a companion series that led him to commission Derain. The latter proved able to employ the boldest resources of his palette without becoming implausible in his rendering of the actual scene. He worked at various points between Westminster and Greenwich but was especially attracted by the spectacle of the cargo-boats in the Pool of London as seen from Tower Bridge. The painting of this subject, made in 1906 and now in the Tate Gallery, is one of the best-known examples of

218 *Vincent van Gogh. Boats on the beach at Saintes-Maries de la Mer. 1888. Oil on canvas, 25⅜×31⅞ in. Amsterdam, National Museum, Vincent van Gogh Collection.*

his art, though no less striking are other works in the series of the Thames and its variety of craft such as the 'Barges on the Thames' (City Art Gallery, Leeds). They remain unique in his work seen as a whole, which was later subject to large modifications of style and variations of theme in his reactions to, and departures from, modern trends.

More frequently a painter of boats, though as unconventional as the *fauve* Derain, was Raoul Dufy (1877–1953). He was born at Le Havre where he had his first lessons in art and later studied in Paris. A vivacious simplicity of style finally resulted from the influences of Cézanne and the *fauves* and the calligraphic tendency appropriate to his work as a designer of textiles as well as a painter in oils and water-colours. Witty and sophisticated, his mode of expression was well suited to convey the character of such favourite themes as the regatta, the race-meeting, the concert performance. It was natural enough that an artist whose early impressions were of the Normandy coast, as those of Boudin and Monet had also been, should continue

219 *Georges Braque. La Barque au Drapeau.*
1939. Oil on canvas, $21\frac{1}{4} \times 25\frac{1}{2}$ in. New
York, Collection E. V. Thaw and Co.

220 *André Derain. Barges on the Thames.*
1906. Oil on canvas, 32×39 in. Leeds, City
Art Galleries.

221 *Lyonel Feininger. Dalmatia. 1934. Oil on canvas, 15¾×18 in. London, Marlborough Fine Art.*

222 *Pablo Picasso. Mediterranean land-scape. Ripolin on board, 32×49⅛ in. Private Collection. The feeling is that of the ancient Mediterranean world of coast and sea, in spite of Cubist angularities.*

223 *Edward Wadsworth. Signals.* 1942. *Tempera on linen mounted on plywood, 40x28 in. London, Tate Gallery.*

the tradition of painting on those shores, at Honfleur, Trouville, Sainte-Adresse, but Dufy's fondness for the sea took a special form. Not for him the spectacle of everyday navigation, the realistic treatment of wave and cloud, the changeability of the elements; instead the cheerful pageantry of the regattas he painted with unceasing delight at Le Havre, Deauville, and across the Channel at Cowes, a flutter of bright pennants, yachts lightly touched in on waves of the most ornamental kind. He was not confined to one locality. The sea became a background of cosmopolitan fashion as he viewed it in 1932 from the front at Nice. The later journeys that took him to the United States in search of treatment for his arthritis had their record in his views of New York and Boston Docks. Marine painting for him was a reflection of the lighter side of contemporary life.

Another French painter who specialized in pictures of the sea and ships was Albert Marquet (1875–1947). Like Dufy with whom he painted for a while at Trouville he had an early contact with the Fauve movement but arrived at a style of his own in which a concentrated simplicity of line and tone took the place of the

224 Vincent van Gogh. Seascape at Saintes-Maries de la Mer. 1888. Oil on canvas, $20\frac{1}{16} \times 25\frac{3}{16}$ in. Amsterdam, National Museum, Vincent van Gogh Collection.

excitements of colour. This was a departure from the *fauve* freedom by which he was first attracted and a return to a carefully studied naturalism. After trial essays in landscape and Parisian views in the first decade of the century a growing clarity in his method of painting coincided with extensive travel. Paris remained his headquarters but the ports and harbours of Europe and the French 'Orient' (north Africa) became his themes. He roamed from north to south and rivalled Signac in the number of seaports he painted, from Stockholm and Hamburg to Venice and Algiers, including every kind of boat. He was indifferent to the obviously picturesque either on land or sea and was as ready to portray a battleship, a liner, or a tramp-steamer as a fishing-boat. A trim white launch moored at Stockholm, a cruise-ship towering among the gondolas at Venice, local sailing-craft at Sete, tugs and cargo-boats at Algiers were placed at such intervals in each composition as emphasized space and perspective. The same applied to the human figures he introduced which, however small and sketchily painted, seemed convincingly human and rightly belonging where he put them. In the work of Marquet the art of concealing art was carried to a point where the total impression it gave was that of spontaneous and instant vision.

225 *Paul Cézanne. The Gulf of Marseilles seen from L'estaque. 1883–5. Oil on canvas, 28¾×39½ in. New York, Metropolitan Museum of Art.*

226 *Albert Marquet. Port of Algiers.* 1927. *Oil on canvas,* $21\frac{1}{4} \times 32$ *in. Paris, Private Collection.*

To invest marine motifs with a decorative charm was an accomplishment of Georges Braque in a separate category from the works by which he is most widely known. So much has been written of the part he played with Picasso in the dramatic evolution of Cubism, so distinctive are his Cubist still-lifes and collages, his monumental figure compositions, the reconstructions of space and rearrangement of objects in his *atelier* that it is possible to overlook the quality of the paintings of boats and shore that he produced at intervals between his larger undertakings. Yet reference to the sea is indispensable to an account of his career.

Braque (1882–1963), born at Argenteuil-sur-Seine, was taken to Le Havre as a child when his family went to live there, and like Boudin was brought up in that maritime region. On leaving school in 1889 he was apprenticed to a painter-decorator at Le Havre, but soon went to Paris to study art and by 1904 was working there on his own. In 1905 he was impressed by the *fauve* paintings in the Salon d'Automne and had a closer connexion with the movement through his friendship with Raoul Dufy and Othon Friesz. Paintings of ships in harbour at Le Havre were early productions, followed by harbour scenes at Antwerp where he painted in company with Friesz, using bright colour in the *fauve* manner, and by paintings at L'Estaque in Provence in a bolder version of the *fauve* style.

The radical changes of theory and practice attaching to the Cubist development

227 *Emil Nolde. The Sea.* 1915–17. *Oil on canvas,* 28¾×39¼ *in. London, Marlborough Fine Art. Impression of a stormy crossing of the Kattegat.*

next occupied him. It was after many years following a visit to Dieppe in the 1920s that the marine motif again came into his mind. He began to paint the small pictures of cliffs, boats, and beaches in various arrangements that extended into a whole series. They represented no actual point of the coast but were like scenes of a familiar world that had somehow become strange. In part the transformation was a product of the Cubist outlook to be compared with the incidental familiar-unfamiliar glimpses of the Mediterranean and its boats in landscapes by Picasso of the south of France. In more general terms one might apply to them Braque's own remark that 'Objects always adapt themselves easily to any demands one may make of them . . . Once an object has been integrated into a picture it accepts a new destiny'. So, it might be said, does the beached boat in the work here illustrated accommodate itself to poetic reflection.

That paintings suggested by or suggestive of the sea might become almost completely abstract had had its great instances in the work of Turner and Seurat and was once again exemplified in modern French art by the paintings of Nicolas de Staël (1914–55) produced towards the end of his life. The works that resulted from his visits to Gravelines in 1954 evoked by means of colour alone the sensations given by sea and sky without any element of descriptive detail. The clarity and intimation of freshness and sun they gave contrasts with the stormy and violent

mood projected by the work of the German artist Emil Nolde in both oil paintings and water-colours. Nolde (1867–1956), born at Nolde, Schleswig, studied at a school of wood-carving and was a teacher in the school of arts and crafts at St Gallen, 1892–8, before embarking on an independent career in the course of which he travelled extensively. Born near the sea he spent most of his life within easy reach of it and produced a large number of seascapes both of home waters and in the course of his expedition to Melanesia in 1913. He had that regard for primitive virtues in art and life that was an uneasy element in the Brücke movement of which he was a member for a time. Harsh and at the same time ecstatic, his religious compositions were a passionate expression of this belief and the same conception of a primal force is to be found in his paintings of the sea. He records the vivid impression of a stormy crossing of the Kattegat in a small fishing-boat, when clinging to the rail he looked in amazement at the wildness of waters. The day, he recorded, 'remained in my imagination so vividly that for years afterwards I used my memory to paint my seascapes – the pictures of choppy wild green waves with just a little yellowish sky at the upper edge'. His water-colours of waves, like the flowers he also painted, had the extraordinary intensity of colouring in which he was unique. In oils he painted more than a dozen versions of the steamer battling through the turbulent sea as he remembered it. More than a thousand works by Nolde were confiscated from public collections by the Nazis in 1937 and in 1941 he was forbidden to paint at all. He continued to do so surreptitiously at Seebull in his native region where in 1956, the year of his death, the Nolde Foundation was established to preserve his works.

228 Georges Braque. Cliffs and Boats. Oil on canvas, 10×15½ in. Private Collection.

229

Without the vehemence of Nolde, though his career was in some respects similar, Max Pechstein (1881–1955) also painted ships and sea in oils and water-colours, in a vivid style that owed something to the example of the French *fauves*. Pechstein studied art at Dresden and was a member of the expressionist *Brücke* group, 1906 to 1912. He resembled Nolde in long distance travel and the humiliations he suffered at the hands of the Nazis. In 1914 he visited the islands of the south Pacific (where he was arrested by the Japanese). In 1934, again like Nolde he was penalized for his unusual style, dismissed from the Berlin Academy, and forbidden to exhibit, and in 1937 his works in public collections were confiscated as 'degenerate'. Many of his paintings of boats and beaches, the result of summer visits to Nidden on the coast of East Prussia survive the period of persecution.

In France and Germany, paintings of the sea could be regarded as a delightful by-product of modern movements in art; in Italy it was otherwise. The Italian Futurists with their admiration for mechanical progress in all its forms might have been expected to portray the new ships of war, the armour-plated, multi-turreted,

229 *Georges Braque. The Port of Antwerp. 1906. Oil on canvas, 19⅝×24 in. Ottawa, National Gallery of Canada.*

230 *Philip Wilson Steer. A Procession of Yachts. 1922–3. Oil on canvas, 24¾×30 in. London, Tate Gallery.*

turbine-propelled 'dreadnoughts' (so called after H.M.S. *Dreadnought*, launched in 1907) as well as the great liners of the period. No one hailed the appearance of these majestic shapes with more enthusiasm than the Futurist leader, Marinetti. But no Futurist artist seems to have given an objective portrayal of the ships Marinetti described with poetic extravagance. To convey the sensation of speed and dynamic power was their aim, but a realistic image did not satisfy them as the means. They tried to find a more direct way of summing up the quality they called 'dynamism', which led to the substitution of sharply angular abstract patterns in place of the recognizable image.

The Futurists in consequence had nothing to add to the subject of marine painting. In contrast, an artist such as Lyonel Feininger, in a way essentially modern but with no fixation about speed and power, found the ship a rewarding motif. Feininger (1871–1956) was born in New York, but went with his family to Ger-

231 *Edward Wadsworth. A Seaport. 1923. Tempera on linen mounted on plywood, 25×35 in. London, Tate Gallery. Possibly a view of La Rochelle from the fortress that also appears in another painting of the same date.*

many when he was 16. His original intention was to study music, but painting was his chosen alternative which he studied at Hamburg, Berlin, and Paris. The idea of a musical element in colour, as demonstrated by Charles Delaunay, whom he met in Paris, and of a basic geometry that was the lesson of Cubism, were both influential in the development of his art. In Germany, after some youthful occupation as cartoonist and illustrator, he became a teacher at the famous school of design, the Bauhaus, at Weimar, 1919–24 and at Dessau, 1925–32. The tenets of the Bauhaus applied in particular to the possibilities of an architecture rigorously conceived in terms of present-day purpose without reference to the styles of the past and to the various forms of machine production amenable to the same logic. Feininger's main themes, ships reminiscent of the sailing vessels of bygone days, and architecture like that of old German towns, were some way from complete conformity to the Bauhaus system of design derived from the geometry of Cubism. The fanciful vessels he painted in oil and water-colour, at times recalling the ghostly ships of Caspar David Friedrich, were figments of the imagination. They could be said to illustrate some basic properties of line and form but, like Paul Klee, his colleague, Feininger was poetic in approach and had some analogy with music in mind. Perhaps his admiration for Bach encouraged the many variations of arrangement in his paintings and drawings of ships that always avoid-

ed the imitation of reality. Very personal in style, Feininger can be equally well appreciated in relation with Klee and Kandinsky in Germany and with painters in the United States (where Feininger returned in 1934 and spent the rest of his life). Like him as one who was responsive to modern art in Europe but had much of his own to express was John Marin (1870–1953).

Born at Rutherford, New Jersey, Marin worked in an architect's office to start with but turned to the study of art at the Pennsylvania Academy and the Art Students' League, New York. Between 1905 and 1911 he was mainly active in Paris, but in 1911 he returned to New York and became noted for water-colours of the city executed with great zest and boldness of technique. His brilliance as a water-colourist was affirmed by the seascapes he painted on the coast of Maine, full of a restless energy and a feeling of the play of natural forces expressed in the vehemence of the free brush-strokes that also defined his compositions. In comparison, Feininger's water-colours of ships and sea seemed scholarly exercises in design; on the other hand, arbitrary in style as Marin was, his direct contact with nature made itself acutely felt in some of the century's best water-colours.

The coast of Maine was as much a magnet for American painters of the sea as Normandy for the French and Scheveningen had been for the Dutch. Winslow

232 *Christopher Wood. Boat in Harbour, Brittany. 1929. Oil on millboard, $31\frac{1}{4} \times 42\frac{3}{4}$ in. London, Tate Gallery.*

(facing)
234 *Max Pechstein. The Rowers. 1913.
Oil on canvas, 75×34 in. Berlin, Brücke
Museum.*

Homer and John Marin settled there. Marsden Hartley (1877–1943), born at Lewiston, Maine, eventually went back to the region after years of travel. He studied art at Cleveland and New York and in 1912 was able, with the help of Alfred Stieglitz, to visit Europe, staying in both Paris and Berlin but finding especially congenial the painters of the *Blaue Reiter* group in Germany. He went through an abstract phase and a long interval elapsed before he rediscovered how strong were the ties 'of heritage, birth and environment' that bound him to Maine. In his later years he expressed this attachment with a weight of style in which there was a romantic force akin to that of Ryder. His paintings of waves beating against the rocky coast suspend their advance at an instant of grandeur.

The romantic feeling for the mystery of the sea so intensely marked in the paintings of Albert Ryder has had its periodic renewal. The Swedish-born artist Henry Elis Mattson has painted moon, stars, and ocean with marked effect. But there has also been the trend towards abstraction in the United States to be taken into account. The coast scenes of Milton Avery (1893–1965) give some anticipation of the abstract developments of the New York School.

233 *Eric Ravilious. The Ark Royal in
action. 1940. Water-colour, $17\frac{3}{4}×22\frac{1}{2}$ in.
London, Imperial War Museum.*

234

235 *Muirhead Bone. Winter mine-laying off Iceland.* c.1940–1944. *Oil,* 50⅜×63¼ *in. London, Imperial War Museum.*

The difference between the specialist concerned with accurate illustration and the painter with other aims for whom the sea was an incidental theme remained strongly marked in twentieth-century Britain. In the first category there have been such artists as William Lionel Wyllie (1851–1931), Charles Pears (1873–1958), and Norman Wilkinson (1878–1970). They were as much at home on sea as on land, portraying ships with the accuracy the professional sailor would look for and in wartime having a role not unlike that of the marine painters of the seventeenth and eighteenth centuries. Principal among them was W. L. Wyllie, 'odd mixture of painter and sailor' as he has been called, who exhibited more than 200 paintings at the Royal Academy in the course of sixty-three years and produced a vast number of oils, water-colours, drawings, and etchings. Born in London and trained in the Royal Academy Schools, he was only 17 when his first picture was exhibited at the Academy. There followed historical subjects (e.g. 'The Battle of the Nile', Tate Gallery, London), pictures of every type of vessel in the Royal Navy, yachts of all descriptions; but a main theme was always the tidal Thames and the spectacle (to borrow the splendidly late-Victorian title of his Chantrey Bequest picture, now

236

in the Tate Gallery) of 'Toil, glitter, grime, and wealth on the flowing tide'. His record of traffic on the Thames at a period when it was busiest, of the traditional sailing-barges before they had gone out of use, and of adjoining dockland from the Tower to Blackwall before this region had become a problem of re-planning and development, is bound to acquire a growing historical value.

A freshness of atmosphere marks the work of Charles Pears, illustrator, yachtsman, and official artist to the Admiralty in the First and Second World Wars. Norman Wilkinson had a parallel career and a special place in the history of naval warfare as the inventor of the camouflage device that disguised the outlines of ships by geometric 'dazzle' patterns that made them difficult targets. The Cubists could make the ironic comment that this device of World War I was an application of their idea! Accuracy of detail together with a sense of drama gave the works of Pears and Wilkinson their special value as records. They satisfied the eye of the seaman to whom a picture was of little worth (this was an admiral's ruling) if the spars, sails, rigging, and other equipment were not correctly represented. The test was not new, even Turner had failed to meet it in the version of 'H.M.S. *Victory* at Trafalgar' commissioned in 1823 by George IV as one of a series of battle-pictures to hang in St James's Palace. The details were so heavily criticized by naval officers that the picture was relegated from St James's to Greenwich, though eventually to be hung in the National Maritime Museum. Nevertheless, in the twentieth century there were, as there always had been and as Turner himself is better assessed, painters of the sea whose merits are to be appraised on broader grounds.

Philip Wilson Steer (1860–1942), for example, is an artist who produced among

236 *Laurence Stephen Lowry. The North Sea. 1966. Oil on canvas, 22×34 in. London, Lefevre Gallery. Best known for his paintings of the crowds and detail of industrial towns the artist gives a distinctive stamp of a contrasting kind to views of open sea.*

237 *Pierre Bonnard. Sur le Yacht. 1906.*
Oil on panel, 14½×18⅛ in. Poitiers, Musée
des Beaux-Arts.

other works paintings of the sea and yachts memorable as works of art and
'accurate', if the word is in any sense appropriate, to atmosphere rather than to
detailed facts. The son of a portrait and landscape painter, Steer studied art in
Paris as a young man and returned to England in 1884 with an outlook consciously
or unconsciously formed by an art world in which Impressionism and neo-Impres-
sionism were main factors. Staying at Walberswick on the Suffolk coast and later
at Boulogne, he beautifully rendered the crispness of sea air and the sparkle of
water with broken touches of colour reminiscent of Seurat's 'divisionism'. With-
out Seurat's scientific discipline of method, Steer enveloped the coastal scene in ex-
hilarating light, sometimes adding figures on the shore but on occasion finding
sufficiency of subject in the sea alone.

A visit to Cowes in 1892 inspired remarkable paintings of yachts. It was prob-
ably immaterial to him whether the newly launched *Britannia* competed success-
fully with *Valkyrie II* in the races in the Solent, but there could be no doubt of the

effective use he made of billowing sail and the verticals of masts. The pictorial pattern is impressive in the 'Procession of Yachts', 1892–3 (Tate Gallery, London). No sailor, but always attracted to the sea, he entered on a second phase with the water-colours that were long to mark his visits to the coast. In them he revived the freshness of technique appropriate to the medium and gave vivid suggestion of boats and sea without any detail whatever.

A painter with a more specific attachment to these was Edward Wadsworth (1889–1949). After early years spent in the West Riding of Yorkshire he came to the Slade School in London from 1910 to 1912, and was one of those influenced by the mechanistic aims of Wyndham Lewis and the Vorticists. It was in wartime he first became an intelligence officer in the R.N.V.R. in the Mediterranean until 1917. Like Signac he was a connoisseur of harbours and ships. Extensive travel in the Mediterranean during the 1920s provided material for his book of line-engravings, *The Sailing Ships and Barges of the Western Mediterranean and Adriatic Seas*, 1926,

238 *Ben Nicholson. St Ives, Cornwall. 1943–5. Oil on canvas board, 16×19¾ in. London, Tate Gallery. The artist translates the primitive vision of the St Ives fisherman, Alfred Wallis into terms of aesthetic refinement. Compare also Christopher Wood's 'Boat in Harbour, Brittany' in which the primitive influence is differently absorbed.*

239

239 *John Marin. Cape Split, Maine. Water-colour,* 15⅜x20½ *in. Chicago, The Art Institute.*

that combined careful research with graphic skill. Wadsworth painted in tempera with a precision and preference for clear-cut forms like that of his wood-cuts and engravings. An original departure was a form of still-life, the assembly of unrelated objects after the manner of the Surrealists, introducing an element of surprise and fantasy. Yet his choice of objects, buoys, ropes, masts, flagstaffs, binoculars, sextants, sometimes with a background of jetties, was as evocative of the sea and ships as any realistic composition. The still-lifes, well exemplified in the 'Signals' and 'Bronze Ballet' (Tate Gallery, London) replaced the paintings of harbours he had made until about 1925.

The wars of 1914–18 and 1939–45, at sea as on land, gave varied employment to artists officially chosen, the result being the great amount of interesting documentary material preserved in the Imperial War Museum and National Maritime Museum. Sir Muirhead Bone (1876–1953), as war artist to the Admiralty (1939–46), following his service as artist on the Western Front in the earlier war, depicted the ships of wartime with all his technical mastery as a draughtsman. Wilson Steer painted wartime harbours in the first war. Wadsworth was employed on the

dazzle camouflage of ships. The illustrative skill of Charles Pears and Norman Wilkinson was aptly employed on such subjects as the *Jervis Bay* action, 1940, and the sinking of the *Bismarck*, 1941. An accomplished painter of the sea in water-colour, Vivian Pitchforth (*b*.1895) was well equipped to give impressions of the movement of convoys and escorts in wartime. An episode such as the withdrawal from Dunkirk, 1940, lost nothing of its drama in the painting by Richard Eurich (*b*.1903). An artist who gave vivid impressions of naval action as an eye-witness was the brilliant water-colourist and designer Eric Ravilious (*b*.1903, died on active service 1942).

Official policy allowed considerable latitude to the war artists in their choice of subject; what impressed them personally being regarded as historically of value. Ravilious was one of those who wished to be in the thick of events. It was by his own wish that he went on a destroyer in 1940 bound for Norway and was able to make his two water-colours of H.M.S. *Ark Royal* (Imperial War Museum) in action from observation on the spot. His emphatic light and shade and decision of brush-stroke vividly transmitted the tense moments.

Warfare, however, has never been the sole *raison d'être* of marine painting even

240 *Salvador Dali. Landscape of Port Lligat.* 1950. *Oil on canvas,* 23x31 *in. Cleveland, Ohio, Collection of Mr and Mrs A. Reynolds Morse, the Dali Museum.*

241

241 *Marsden Hartley. The Wave. Oil on fibre-board, 30¼×40⅞ in. Worcester, Massachusetts, Worcester Art Museum. Like Winslow Homer and John Marin this American artist found inspiration on the sea-coast of Maine for his sense of abstract force in nature.*

though it has encouraged the production of certain types of subject. A nostalgia for sailing-ships of a now almost extinct type as among the many good things belonging only to the past has led to the continued production of sentimental canvases seeking to convey the spirit of adventurous voyages on the high seas. If the sentimental is often superficial, it may be recalled that the work of the primitive genius of St Ives, Alfred Wallis, was largely inspired by his memories of the past but was contemporary in the suggestions of style. In the paintings of Christopher Wood (1901–30) what he and Ben Nicholson discovered in the works of the Cornish ex-fisherman was added to the sophisticated influence of the School of Paris. Wood's paintings of fishing-boats in the little harbours of Cornwall and Brittany gained an unusual charm from this fusion. What the sea has to convey as a subject depends to a great extent on the temperament and outlook of the painter. An exceptional instance is to be found in the works of L. S. Lowry who has turned from the crowded spectacle of the industrial city to paint an empty sea. Even an empty sea can convey the personality of a painter.

242 *Milton Avery. White Sea.* 1947. *Oil on canvas,* 30×40 *in. New York, Mr and Mrs Warren Brandt Collection. One of the paintings of rocks and sea in which this American artist simplified nature to the point of almost complete abstraction.*

Biographical Notes

ANDERSON, William (1757–1837)
Born in Scotland and trained as a shipwright, Anderson established himself in London as a painter of sea and river views. He exhibited forty-five works, usually small, at the Royal Academy from 1787 to 1834 and made numerous drawings in which his care for accuracy in ship detail appears. A set of views of the Battle of the Nile was engraved after him by W. Ellis. A painted version of the subject in Trinity House, Hull, seems to have been executed during his stay in the city when the Hull marine painter John Ward was influenced by his work. He is represented in the National Maritime Museum, Greenwich and by drawings and a sketch-book in the Victoria & Albert Museum, London.

ATKINS, Samuel (exhibited 1787–1808)
A marine painter in oils and water-colours, Atkins first exhibited at the Royal Academy in 1787. He spent some years at sea, remaining in the East Indies from about 1796 to 1804. On his return he again exhibited at the Academy until 1808 and also taught marine drawing in London. East Indiamen were frequently his theme, and he added delicacy of style to accuracy. Examples of his water-colours are in the Victoria & Albert Museum, London.

BAKHUIZEN, Ludolf (1631–1708)
Born at Emden, East Friesland, the Dutch marine painter, Bakhuizen, who also signed his name with the variant spellings of Ludolph Bakhuisen, Backhuysen, and Backhuyzen, came to Amsterdam, *c.*1650 as a merchant's clerk and writing-master. From making pen drawings of ships, he afterwards turned to painting. His style was first formed on the model of Allart van Everdingen and Hendrick Dubbels, but his mature work shows the strong influence of Willem van de Velde the Younger. Though not of the same quality as an artist, he came near enough to the more routine products of Van de Velde's studio as to raise dispute of attribution in some instances. He specialized in pictures of storm for which, like Turner and Vernet, he is said to have gained inspiration from personal experience and risk. After the Van de Veldes, father and son, went to England in 1672, he was regarded as the chief of

Dutch marine painters with eminent patrons from abroad, including Peter the Great of Russia, who took lessons in painting from him. Among his pupils was Wigerus Vitringa (1657–1725), a distinguished lawyer who combined marine painting with his legal practice. Bakhuizen is represented in numerous galleries including the Rijksmuseum, Amsterdam, the National Gallery, London, and the National Maritime Museum, Greenwich.

BARD, James (1815–97)
Born in New York in a house overlooking the Hudson River, Bard from the age of 12 until his death, made drawings of the steamships using the port of New York and the paddle-boats on the Hudson River. He always showed the ship in profile with human figures to give scale. Shipbuilders valued his accuracy, and it was said the plans of a boat could be laid down from one of his pictures. 'Hudson River Steamboat, *Rip Van Winkle*', 1854 (Museum of Fine Arts, Boston) is a characteristic work. His brother John Bard (*d.*1856) was his collaborator for some time.

BERCHEM, Nicolaes (1620–85)
Though celebrated mainly as a painter of Italian pastoral scenes, Berchem also painted many views of imaginary southern harbours. Born at Haarlem, he worked mainly at Haarlem and Amsterdam, but drew on memories of time spent in Italy, 1642–5. In the imaginary harbours, a borderline marine genre of Dutch seventeenth-century painting, he may be compared with Jan Asselijn (1610–52), Jan Baptist Weenix (1621–60), Jan Beerstraaten (1622–66), and Adam Pijnacker (1621–73), all of whom painted pictures of this kind, though incidental to other themes.

BONE, Sir Muirhead (1876–1953)
Born at Glasgow and trained as an architect, Bone was primarily an architectural draughtsman but was an official war artist in both the First and Second World War and was knighted in 1937. He made many records of battleships and other vessels from 1939 to 1946, when he was artist to the Admiralty. He is represented in the Tate Gallery and Imperial

War Museum. His son, Stephen Bone (1904–58), painter and critic, was attached to the Navy as official war artist, 1943–5. His naval pictures are in the Imperial War Museum and National Maritime Museum, Greenwich.

BONINGTON, Richard Parkes (1801–28)

Born at Arnold near Nottingham, Bonington was the son of a former governor of Nottingham Gaol and amateur painter from whom he may have had his first lessons in art. In 1817 the family moved to Calais where Bonington's father became occupied in the lace business. At Calais, Bonington was pupil for a time of the water-colourist F. L. Francia, first painting fishing-boats and shore scenes in Francia's manner. Later he studied in Paris under Baron Gros and at the Louvre, his work being much admired by Delacroix. He exhibited at the Salon from 1822 and was one of the English painters, Constable pre-eminent among them, who made so strong an impression in the famous Salon of 1824. He painted direct from nature, mainly in northern France, among his best works being seascapes and beach scenes on the Normandy coast. Paintings of Venice, which he visited in 1826, were among his last productions. In a separate category from his coastal masterpieces were historical figure pieces in the Romantic manner. Bonington worked in both oils and water-colour and used the then new graphic medium of lithography with much effect. Brilliant but short-lived, he died in London in 1828. The marine aspect of his work is well represented in the Wallace Collection, London and the Victoria & Albert Museum.

BONNARD, Pierre (1867–1947)

Like André Derain, the modern French master, Pierre Bonnard, had many themes including impressions of Paris streets, and domestic interiors, and paintings of the nude figure, landscape, and still-life, but his large output comprised a number of vivid pictures of sailing and sea. A good example is 'Sur le Yacht', 1906, (Musée des Beaux-Arts de Poitiers). His colour sense responded to the Mediterranean, especially from 1925 onwards when he bought a house at Le Cannet near Cannes and the 1930s were fruitful in seascapes painted at St Tropez and Cannes. An example is 'Le Golfe de Saint Tropez' 1937–40, exhibited in the 1965 *Trois Millenaires d'Art et de Marine*, exhibition at the Petit Palais, Paris and now in the Musée Toulouse-Lautrec, Albi.

BOUDIN, Louis-Eugène (1824–98)

Born at Honfleur, Boudin was the son of Léonard Boudin, ship's captain, whose boat, *Polichinelle*, plied for some time between Honfleur and Rouen. When Eugène was 10 he served as ship's boy and had already begun to draw. The family moved to Le Havre in 1835 and Léonard captained the cross-river steamboat (Havre–Honfleur) until his death in 1862. Eugène, after brief schooling, worked in a stationer's shop at Le Havre. In 1844 he started his own stationer's and frame-maker's shop and was encouraged to paint by visiting artists whose pictures he framed. He spent struggling years in Paris in the 1850s, influenced by painters of the Barbizon School and much helped by the advice and encouragement of Corot. By 1858 he had begun the practice of working direct from nature in the open-air, to which he faithfully adhered. Suc-

cess came to him in the 1860s when his beach scenes at Trouville and Deauville coincided with the popularity of these resorts with fashionable visitors, French and English. Boudin subsequently specialized in paintings of the Seine estuary, ports and harbours, and Channel shipping, always distinguished by freshness of atmosphere and spontaneity of execution. The estuary of the Seine remained his main theme, but marine subjects engaged his interest elsewhere. He painted at Antwerp, 1870, at Bordeaux, his 'Port de Bordeaux' appearing in the Salon of 1875, in Holland in the 1880s, and in the 1890s in the South of France and at Venice. He died at Deauville in 1898. He was a prolific painter and is well represented in a variety of collections. His brother Louis Boudin in 1899 presented sixty canvases and 180 panels to the Musée du Havre.

BRAQUE, Georges (1882–1963)

Born at Argenteuil-sur-Seine, Braque spent his youth, like Boudin and Monet, at Le Havre where in 1899 he was apprenticed to a painter–decorator. He studied painting in Paris 1902–04. After early paintings of harbour scenes he was much occupied from 1908 by the dramatic development of Cubism. As a relaxation in the 1920s, following a visit to Dieppe, he produced paintings of boats and shore, and works of this kind followed at intervals between his major undertakings. They were not pictures of actual scenes but marine motifs with a decorative charm.

BRETT, John (1830–1902)

Born at Bletchingley, Surrey, Brett was trained in the Royal Academy Schools and was at first much influenced by Pre-Raphaelite minuteness of detail as in 'The Stonebreaker', 1858 and 'Val d'Aosta', 1859. Later he turned to highly finished pictures of sea and rocks mainly on the Cornish coast. 'Britannia's Realm', a Chantrey Purchase for the Tate Gallery, 1880, is typical of many works shown at the Royal Academy. He was made A.R.A. in 1881.

BROOKING, Charles (c.1723–59)

A short-lived artist, Charles Brooking, who died in London in 1759 before he was 40, was said more precisely by Samuel Redgrave (in his *Dictionary of Artists of the English School*, 1878) to have then been 36, though there is no actual record of the date, or place, of his birth. His seapieces, of which some hundred are extant, assign him a distinguished place in the development of the English School of marine painting, as it gradually became freed from dependence on the Dutch School. Little is known of his earlier life. He was possibly the son of a Charles Brooking employed as painter and decorator at Greenwich Hospital. Edward Edwards in his *Anecdotes of Painters*, 1808, refers to his having 'been bred in some department of the dockyard at Deptford' and perhaps quotes the view of Brooking's friend, Dominic Serres, in remarking that 'as a ship-painter . . . he certainly excelled all his countrymen'. There is a picture in the Dutch style (in a private American collection) signed 'C. Brooking pinxit aged 17 years'. Between 1745 and 1748 he painted the exploits of the 'Royal Family' privateers in their recent action against the French (engraved by Boydell in 1753). By 1752 he was well enough known to be

invited to illustrate a work on the plant-like marine parasite, the Corallines by the naturalist John Ellis. In 1754 he followed the example of Hogarth and others in presenting a work to the Foundling Hospital, an outsize canvas, 6 × 10 ft. of naval vessels, and was duly appointed a Governor of the Hospital. His address was then given as Token House Yard, Lothbury, but he seems later to have moved and died in poor circumstances in Castle Street, Leicester Square, leaving wife and children in need. His paintings, it is said, were often sold through the shops of print-sellers and frame-makers, who often concealed the identity of the painter. He is well represented in the National Maritime Museum, Greenwich, and also at the Tate Gallery, London.

BRUEGEL THE ELDER, Pieter (c.1520/5–69)

Making use of a majestic scope of subject-matter, including allegory, history painting, landscape, and peasant genre, the Flemish master often introduced ships into his works. His attention was drawn to them on his journey to southern Europe (Italy and Sicily) 1552, probably to collect material for engravings to be published by Jerome Cock at Antwerp. They appear in numerous engravings after his designs, including a series of *Vaisseaux de Mer* in eleven plates. Attributed to his early period is the 'Landscape with Ships and a Burning City' (Dortmund, Becker Collection). To c.1558 belongs 'The Harbour at Naples' (Gallery Doria, Rome), related to an engraving of a naval battle at Messina after a Bruegel drawing. A masterpiece of the same period was 'The Fall of Icarus' (Musées Royaux des Beaux-Arts, Brussels) with its stately ship. Ships foundering have their part in the allegorical 'Triumph of Death' (Prado, Madrid), c.1562–3 and are depicted with minute care in 'The Tower of Babel' (Kunsthistorisches Museum, Vienna), 1563. The magnificent 'Storm at Sea' (Vienna) is attributed to him by most authorities and placed among his last works, c.1568. Though it shows some moralistic intent, it can be regarded as the first great seapiece in Netherlandish painting.

CANALETTO (Giovanni Antonio Canale, 1697–1768)

Though Canaletto was primarily a painter of city views and in particular his native Venice, boats of various kinds and ships were inevitably a feature of them. Not only the Venetian gondola, but a variety of craft was depicted with an equal skill to that he lavished on architecture. Examples are the many pictures of boats clustered about the Bucentaur, the ornate ship of state on which the Doge sailed each Ascension Day to perform the ceremony of wedding the city with the Adriatic (examples in the Pushkin Museum, Moscow; Royal Collection, Windsor Castle; Aldo Crespi Collection, Milan). The harbour of St Mark's enabled him to make much use of shipping in various compositions of the subject. A masterpiece is 'The Harbour of St Mark's towards the East' (Museum of Fine Arts, Boston), 1735–40. Other versions of the scene are in the Wallace Collection and National Museum of Wales, Cardiff. His visits to England produced among other outstanding works his beautiful view of Greenwich Hospital seen from across the Thames, 1747–50, now in the National Maritime Museum, Greenwich.

CAPPELLE, Jan van de (c.1623/5–79)

Born in Amsterdam, Van de Cappelle became outstanding as a painter of sea and river views and winter landscapes. He was also a man of wealth gained from his share in the weaving and dyeing business owned by his father; a connoisseur who assembled a large collection of paintings and drawings by his Dutch contemporaries. He was the subject of portraits by his friend, Rembrandt and by Frans Hals and Gerbrandt van den Eeckhout. The last-named described him as self-taught as a painter, but his collection might be thought an education in itself and had an influence on the formation of his style. In the grey tones of his early work he followed Simon de Vlieger by whom he possessed nine paintings and as many as 1,300 drawings. It is significant, in view of the atmospheric quality of his marine paintings, that he also owned sixteen paintings by Jan Porcellis. He made copies after both De Vlieger and Porcellis. Also represented in his collection were Jan van Goyen and Esaias van de Velde. The absence of dated pictures after 1663 has led to the supposition that he may have given up painting in middle age to devote himself to business. A rough guide to date is provided by the altered spelling of his name in signed works, 'Capel' or 'Capelle' up to 1651, 'Cappelle' subsequently. His paintings are well represented in Dutch and American public galleries and in Britain at the National Gallery, the Iveagh Bequest, Kenwood, Glasgow, and Birmingham. The 'Evening Calm' (Wallraf-Richartz Museum, Cologne) is supposed to have been the first rendering of sunlight in Dutch painting.

CARMICHAEL, James Wilson (1800–68)

Born at Newcastle upon Tyne, Carmichael went to sea at an early age and was afterwards employed as a shipbuilder's draughtsman. He first painted in water-colour but turned to oils about 1825, his marine paintings in the medium being highly thought of in the north of England. He exhibited at the Royal Academy from 1835 to 1859. During the Crimean War he went to the Baltic in a warship and made sketches engraved in the *Illustrated London News*. He worked in London after 1845 until retiring to Scarborough where he died. Works by him are at Newcastle and in the National Maritime Museum, Greenwich.

CHAMBERS, George (1803–40)

Born at Whitby, Chambers, a fisherman's son, went to sea at the age of 10, but the precocious ability he showed in drawing made an impression strong enough to secure the cancellation of his apprenticeship so that he could take up art. Working as a housepainter at Whitby for a living, he took drawing lessons and painted shipping scenes in his spare time. After this, he worked his way to London on a coastal vessel and found employment for seven years as assistant in producing the panorama of London at the Colosseum, Regents Park, afterwards working as scene-painter. In London, he came to the notice of Admiral Lord Mark Kerr who secured his introduction to King William IV. His subjects in both oil and water-colour were mainly coast and river scenery and naval engagements. He exhibited at the Royal Academy from 1827 to 1840, also at the British Institution and Old Water-Colour Society. A number of his paintings are in the National Mari-

time Museum, Greenwich. His water-colour 'View of Greenwich' at the Laing Art Gallery, Newcastle, may have been one of those selected by Queen Adelaide, three of his paintings being in the Royal Collection.

CHAMBERS, Thomas (1815–after 1866)
Born in England, Chambers went to the United States in 1832 and became a naturalized citizen. He was listed in New York as a landscape painter in 1834 and after 1838 as a marine painter. Later he worked at Boston and from 1852 to 1857 in the Hudson Valley, where many of his pictures have been found. From 1861 to 1866 he was again in New York, but the date and place of his death are not recorded. Most of his pictures were based on engravings of subjects by other artists, but were original in the primitive force of colour and design that transformed his borrowings. An example is 'The *Constitution* and the *Guerrière*', a naval episode in the war of 1812, taken from a print after the Philadelphia painter, Thomas Birch (Metropolitan Museum of Art, New York).

CLARK, William (c.1800–45)
A marine painter who worked at Greenock when shipbuilding there was flourishing, Clark painted somewhat after the style of Robert Salmon, whom it is possible he met in his young days when Salmon was working at Greenock. Like Salmon, he was able to place the ship portrait convincingly in marine setting and perspective.

CLAUDE, Lorrain (Claude Gellée, 1600–82)
Though Claude was a great master of imaginative landscape with classical elements of architecture and theme, whose work as a whole needs to be surveyed in a broad context, the marine aspect is not to be overlooked. After his first arrival in Rome and before he finally settled there, a stay at Naples left abiding impressions of coast and sea. To this early experience was added study at Rome with Agostino Tassi, a painter of harbour scenes. The many splendid sea ports and imagined 'Embarkations' – of which there are examples in the Louvre, National Gallery, London, the Uffizi, Florence, the Prado, Madrid – with all their picturesqueness of detail in the portrayal of ships and the fancied appearance of ancient harbours introduced a new element of seascape. His treatment of the light of a rising or setting sun is seen to full advantage in these pictures where sea and sky are brought into harmonious combination.

CLEVELEY family, The
The Cleveleys were a family of marine painters associated with Deptford as a centre of shipbuilding. The principal artist of the family was John Cleveley the Elder (c.1711–77), born at Deptford, who specialized in paintings of the river and dockyards, producing many pictures of shipbuilding and launching, the latter often signalizing the presence of royalty. 'The Dockyard Deptford' (Royal Collection) and 'A Shipyard on the Thames' (Glasgow Art Gallery) are characteristic works. His twin sons, John Cleveley the Younger (1747–86) and Robert Cleveley (1747–1809), born at Deptford, were also marine painters. John had lessons in water-colour from Paul Sandby and exhibited paintings at the Royal Academy from

1770. He was draughtsman to Sir Joseph Banks on his voyage to Iceland in 1772 and to Captain Phipps (later Lord Mulgrave) on his North Sea expedition in 1774. Robert Cleveley painted marine views and sea-fights and exhibited at the Royal Academy from 1780 to 1803. He became marine painter to the Prince of Wales and draughtsman to the Duke of Clarence. He was killed by a fall from the cliffs at Dover. All three artists are represented in the National Maritime Museum, Greenwich, and John and his brother Robert at the Victoria & Albert Museum, London.

CONSTABLE, John (1776–1837)
The sea comes incidentally into the work of the great landscape painter, but with outstanding effect in a certain number of paintings and sketches, illustrating his ability to find 'delight in every dress nature can possibly assume'. A number of the 130 sketches of ships and weather conditions 'in close imitation of van de Velde', which he made in 1803 when he sailed to Deal on the South Coast, are in the Victoria & Albert Museum. He sketched the *Victory* at Chatham, though the water-colour of the ship in the Battle of Trafalgar, exhibited in 1806, was an imagined scene unusual for him and untypical in aspect. Sea and coast in 'Weymouth Bay', 1816 (National Gallery, London) are auxiliary to the grandeur of sky. The oil sketch for this painting has the vivid directness that characterizes the superb small paintings of 'Brighton Beach, Colliers' and 'Coast Scene with Fishing Boats' of 1824 (and other studies of sea and shore in the Victoria & Albert Museum, London). The more elaborate 'Marine Parade and Chain Pier, Brighton' (Tate Gallery, London), for which there are two oil studies in the Philadelphia Museum of Art, was exhibited at the Royal Academy in 1827.

COOKE, Edward William (1811–80)
Born at Pentonville, Cooke was the son of the engraver, George Cooke who gave him an early training in engraving. Edward assisted his father in producing botanical illustrations, then turned his attention to the sea and ships. The plates for 'Shipping and Craft', published in 1827, were his own unaided work. Thereafter, he sketched often at Hastings, Brighton, Portsmouth, and the Isle of Wight, developing a parallel interest in botany and the sea and ships. He began to paint in oils about 1833, and from 1837 painted on the Dutch coast at Scheveningen, Rotterdam, Leyden, Volendam, Marken, Hoorn, and other maritime towns. As a professional marine painter he visited the Mediterranean in the 1840s, painting in the south of France, Italy, and Sicily, later producing a number of views of Venice. He exhibited sea and river pictures at the Royal Academy from 1835 to 1879. He was elected R.A. in 1863, his scientific studies electing him also Fellow of the Royal Society and other learned societies. A visit to Egypt in 1873 produced many drawings of the Nile. He died at the country house near Groombridge, near the Kent–Sussex border, designed for him by Norman Shaw. His work is represented in the Guildhall and Royal Academy Collections, the Victoria & Albert Museum, National Maritime Museum, and numerous regional galleries. His masterpiece, 'Beaching a Pink, Scheveningen', is at Greenwich.

COTMAN, John Sell (1782–1842)
Born at Norwich, the son of a draper in the city, Cotman went to London to study art when about the age of 17, and like Turner and Girtin gained a knowledge of water-colour under the auspices of Dr Monro. His mastery of the medium is shown in the works he contributed to the Royal Academy until 1806, including the beautiful products of a Yorkshire journey, among them the famous 'Greta Bridge' (British Museum). Lack of success in London prompted his return to Norwich where he became, with John Crome, the mainstay of the recently-formed Norwich Society of Artists. There and at Yarmouth, where he lived subsequently until 1834, he included numerous marines in his varied output. They were mainly in water-colour, though his rare oils included 'Fishing Boats off Yarmouth' (Castle Museum, Norwich). His 'Dismasted Brig' and 'Yarmouth River' (British Museum) are water-colour masterpieces. Other seapieces are in the Victoria & Albert Museum and at Norwich, Birmingham, and Manchester. Cotman removed to London in 1834 to become drawing master at King's College School, and died in London in 1842. His son, Miles Edmund Cotman (1810–58), who was born and died at Norwich, also painted seapieces and the tradition was continued by John Sell's nephew, Frederick George Cotman, born at Ipswich in 1850 and active until *c.*1911.

COURBET, Gustave (1819–77)
The great apostle of realism, Courbet, applied its vigorous tenets to seascapes as well as to his wide range of other unconventionally treated themes. His work in this respect has a special focus in the mid-1860s, when he worked on the Normandy coast at the same time as Monet and Daubigny and in company with James McNeill Whistler. He represents the development of the nineteenth century that regarded the sea as subject enough without the picturesque addition of shipping or coastal features. He gave an architectural force to the movement of waves, typically illustrated in the 'Mer Orageuse' of 1870, now in the Louvre.

CROME, John (1768–1821)
Born in Norwich, the son of a weaver, Crome first learned the craft of painting as apprentice to a carriage- and sign-painter. In 1790 he was introduced to the wealthy master-weaver and picture collector Thomas Harvey, who let him study the Dutch and English landscapes in his collection. He acquired a great reverence for the seventeenth-century Dutch School, Ruisdael, Hobbema, Cuyp, Van der Neer, Van de Velde, and Wijnants as well as being influenced by Wilson, Morland, and Gainsborough. For many years a drawing-master at Norwich, he took a leading part in the foundation of the Norwich Society of Artists in 1803 and was the main pillar of the local school thus formed. His work alternated between woodland and heath scenes and pictures of coast and sea. Examples are 'Yarmouth Jetty' (Castle Museum, Norwich), a study for which is in the Tate Gallery, the 'Coast Scene near Cromer' (Courtauld Collection), rivalling Ruisdael in its stormy sea, 'Bruges River' (Private Collection, London), a souvenir of his journey to the Continent after the Truce of Amiens. His 'Yarmouth Water Frolic' (Iveagh Bequest, Kenwood), inspired to some extent by Cuyp, was only begun at the time

of his death and finished by his son, from an extant study now in a private collection.

CUYP, Aelbert (1620–91)
Born at Dordrecht, Cuyp was the pupil of his father, the portrait-painter, Jacob Gerritz, Cuijp Seapieces were one element of a varied output that included portraits, landscapes, still-lifes, and studies of cattle and horses. From early landscapes in the manner of Jan van Goyen he diverged, when about 30, to scenes luminous with a mellow golden sunlight. In this development he was influenced by the Italianate Dutch painters of the Utrecht School, more particularly by Jan Both (*c.*1618–52), who was impessed when in Italy by the luminosity of Claude's skies. Jan Both returned from Italy to the Netherlands in 1641. Cuyp never visited Italy but lived all his life at Dordrecht, save for sketching expeditions elsewhere in Holland. The ancient estuary port on an island at the confluence of the Meuse and Waal was the background for numerous paintings of ships and open water. In his estuary scenes he frequently introduced cows and horses. He also painted fanciful pictures of rocky shores and some nocturnes. His responsibilities as landowner, with a seat in the High Court of Justice for the province of Dort apparently diverted him from painting after 1665. His work was prized by British connoisseurs in the eighteenth century and admired by Turner and Constable, Turner inviting direct comparison with Cuyp's 'View of Dordrecht' (the 'Iveagh Sea Piece', Kenwood) in his 'Dordrecht: The Dort Packet-Boat from Rotterdam Becalmed' (Mellon Collection, Washington, D.C.). Cuyp is especially well represented in English collections – the Royal Collection, the Dulwich College Gallery, which has fifteen of his paintings, the National Gallery, which has nine, the Wallace Collection, London and the Ashmolean Museum, Oxford. Others are widely distributed in the Rijksmuseum, Amsterdam, the Mauritshuis, The Hague, the Louvre, Paris, Kunsthistorisches Museum, Vienna, Metropolitan Museum, New York, National Gallery, Washington, and elsewhere.

DAUBIGNY, Charles François (1817–78)
Born in Paris, Daubigny was first the pupil of his father, also a landscape painter, then of the academic painters, Granet and Delaroche. The example of the painters congregating at Barbizon turned him to the direct study of nature towards the end of the 1830s. He gained success with the river views which it became his habit to paint from a boat converted into a floating studio – a practice adopted later by the Impressionist Monet. Regular visits to Villerville-sur-Mer on the Normandy coast produced pictures of sea and shore in which the impression of light and space was all important. The unifying effect of light was specially remarked on by the critic Thoré in comment on 'Villerville-sur-Mer', 1872 (Mesdag Museum, The Hague). This picture was painted on the spot at intervals, the artist waiting for the weather conditions that gave the desired tones. To his many French seascapes he added numerous views of boats in the Thames on his visits to England in 1866 and 1870, 'La Tamise à Erith', 1866 (Louvre) being an example. Daubigny died at Auvers-sur-Oise in 1878. He is well represented in the Louvre, Paris and other French museums, also in the Metropolitan Museum of Art, New York,

the National Gallery, Washington, the Tate Gallery, London, and the Glasgow Art Gallery.

DELACROIX, Eugène (1789–1865)
The great representative of French Romanticism, Delacroix was fascinated by the sea, which for him was symbolic of an enigmatic universe in which humanity was faced with tragic misfortune. In this spirit he conceived his 'Shipwreck of Don Juan' (Louvre), so titled when exhibited at the Universal Exposition of 1855, though originally 'A Shipwreck' when appearing in the Salon of 1841. Inspired by Byron's *Don Juan*, the picture shows the desperate castaways drawing lots for survival or sentence of death, the agitation of colour in the scene offset by the green waste around. The work had precursors in Delacroix's 'The Bark of Dante' (Louvre) exhibited in the Salon of 1822, and Géricault's 'The Raft of the *Medusa*' (Louvre) shown in the Salon of 1819. There is a link in the works by Delacroix and Géricault with the 'Shipwrecks' of Turner. Delacroix returned to the theme in 'After the Shipwreck', 1847 (Hermitage Museum, Leningrad).

DERAIN, André (1880–1954)
The paintings of ships and sea by the French artist André Derain belong mainly to the early period of his career when he worked at the Mediterranean fishing port of Collioure in company with Henri Matisse and Maurice de Vlaminck. He applied the use of brilliant colour that caused these artists to be described as *Fauves* (wild men) to many paintings of fishing-boats in Collioure harbour. This was in 1905, the year of their celebrated contribution to the Salon d'Automne in Paris. The dealer, Vollard, as a result, commissioned Derain to paint a series of works of London and the Thames and these, including 'The Pool of London' (Tate Gallery, London), 'Barges on the Thames' (City Art Gallery, Leeds), 'St Pauls, Waterloo Bridge' (Musée de l'Annonciade, St Tropez), and 'Blackfriars' (Art Gallery, Glasgow), 1906–07 provided a memorable sequel to the style fashioned at Collioure. Though Derain branched out in many ways later both in style and subject, his coastal visits had such later products as his 'View of Martigues', 1912 (Hermitage Museum, Leningrad) and 'Gravelines', 1934 (Musée d'Art Moderne, Paris).

DUBBELS, Hendrick (c.1621–1676)
Born at Amsterdam, Hendrick Jacobsz Dubbels was a shopkeeper in the city as well as a painter, but was listed as being made bankrupt in 1665. He was a painter of sea and river scenes and some winter landscapes, influenced by Jan van de Cappelle and the younger Van de Velde. He was an accomplished artist and though of lesser stature than Van de Cappelle, the seascape by him in the National Gallery, London was long attributed to the greater master.

DUFY, Raoul (1877–1953)
Born at Le Havre, Raoul Dufy retained throughout his career an attachment to harbours and boats which he expressed in both oil-paintings and water-colours. He studied art in Paris at the Ecole des Beaux-Arts and in 1905 adopted the brilliant colour gamut of the Fauves under the influence of Matisse. His activities included designing silks and tapestries, in as-

sociation with the Bianchini Ferier silk factory at Lyons, and he was employed on other forms of decorative art, but he was also prolific in pictures of occasions of pageantry and pleasure by land and sea. He visited England in the 1930s, painting numerous pictures of yachts and regattas at Cowes. They were complementary to his studies of regattas at Le Havre and Deauville. He was awarded the International Prize for Painting at the Venice Biennale in 1952, but died in the following year at Forcalquier in the Basses-Alpes. Works by him are in the Musée d'Art Moderne, Paris, the Tate Gallery, London, the Museum of Modern Art, New York, and numerous private collections.

DUNCAN, Edward (1803–82)
Born in London, Edward Duncan began his career as pupil of the aquatint engraver, Robert Havell, but later turned to water-colour and specialized in marine subjects. He exhibited at the Water-Colour Societies, 1830–82 and occasionally at the Royal Academy. A number of his water-colours and drawings are in the Victoria & Albert Museum and the National Maritime Museum, Greenwich.

DUPRE, Jules (1811–89)
Born at Nantes where his father owned a china factory, Dupré was an early admirer of Constable and the seventeenth-century Dutch masters, and an early representative of the movement in France to paint direct from nature. He was associated with Théodore Rousseau and Diaz among the pioneers of the Barbizon School and worked in the forest of Fontainebleau, but is also noted for paintings of the sea as viewed from the channel coast. He was sufficiently of the Romantic generation to appreciate especially the violence of a stormy sea, a characteristic example being 'The Headland' (Glasgow Art Gallery).

EURICH, Richard (b.1903)
Born at Bradford, Richard Eurich studied art at the Bradford College of Art and at the Slade School, being distinguished later as a painter of landscapes and seascapes. As Official War Artist to the Admiralty, 1940–45, he made spirited compositions of 'The Withdrawal from Dunkirk', 1940 (National Maritime Museum, Greenwich) and 'The Landing at Dieppe, 19th August 1942' (Tate Gallery). Informal beach scenes with distant ships were among his later paintings. He is represented by a number of pictures in the National Maritime Museum, and the Imperial War Museum as well as the Tate Gallery. He was elected R.A. in 1953.

EVERDINGEN, Allart van (1621–75)
Born at Alkmaar, Van Everdingen is said to have been the pupil of the Flemish-born artist Roelandt Savery who settled at Utrecht in 1619 and painted landscape as well as the flower and animal pictures by which he is better known; Van Everdingen was later the pupil of Pieter de Molijn at Haarlem. A visit to Scandinavia as a young man, somewhere about the year 1644, seems to have resulted in the landscapes of mountains, fir forests, and waterfalls, for which he is celebrated. With them he introduced a new motif into Dutch painting, to be broadly described not so much in topographical terms as in a sense of the grandeur of nature undisciplined by man. This

applies also to his few remarkable seapieces, e.g. 'Snowstorm at Sea' (Musée Conde, Chantilly). The dramatic sombreness of his work obviously encouraged a likeness of mood and theme in both landscapes and seascapes by Jacob van Ruisdael. A 'View of Alkmaar' (Lugt Collection, Institut Néerlandais, Paris) represents the art of Van Everdingen in more characteristically Dutch aspect. His pupil, though evincing evidence of learning more from Van de Velde the Younger, was the marine specialist, Ludolf Bakhuizen. After working for some considerable time in Haarlem, Van Everdingen settled in Amsterdam where he died in 1675.

FEININGER, Lyonel (1871–1956)
Of German origin, Lyonel Feininger was born in New York, spent youthful years in Berlin and Paris, and began to paint in 1907, being much influenced by the Cubist movement. From 1919 to 1933 he painted and taught at the Bauhaus in Weimar and Dessau. He emigrated to the United States in 1937 and lived in New York until his death in 1953. He was unusual in applying the geometrical system of Cubism to themes generally treated in a more traditional manner. Besides free renderings of buildings, they included many seascapes of a fanciful kind in both oil and water-colour. The sailing-ship was a motif that particularly interested him in compositions, which, though disregarding nautical accuracy, made full use of masts, sails, and rigging as elements of geometrical design. His work is represented in both American and German public galleries.

FIELDING, Anthony Vandyke Copley (1787–1855)
A prolific painter of landscapes and seapieces in water-colour, Fielding was born at East Sowerby near Halifax in Yorkshire and was the pupil of John Varley. He exhibited from 1810, mainly at the Old Water Colour Society, but also at the Royal Academy, 1811–42. He was awarded a gold medal at the Paris Salon of 1824. His fresh and lively style is well exemplified in his 'Plymouth Sound' (Victoria & Albert Museum, London). He lived and worked for many years at Brighton.

FRANCIA, François Louis Thomas (1772–1839)
Born at Calais, Francia settled in London early in his career as a water-colour painter. He exhibited at the Royal Academy, 1795–1822, and was appointed painter in water-colours to the Duchess of York. He went back to Calais in 1817 and remained there, producing many vivacious water-colours and drawings of coastal scenery, ships, and sea. He had a favourable influence on the development of Bonington, who was his pupil at Calais and whose early efforts closely resembled Francia's in style. Francia is represented by fourteen drawings in the British Museum and as many in the Victoria & Albert Museum. Painters of shore and sea who may be considered in the same category were Charles Bentley (1805/6–54) and Anthony Vandyke Copley Fielding (1787–1855).

FRIEDRICH, Caspar David (1774–1840)
Painter of ships and sea with a symbolic significance, Friedrich was born in the harbour town of Greifswald in the part of Pomerania that was then Swedish but was ceded to Prussia in 1815. He first studied art at Greifswald University, 1790–40 and then at the Copenhagen Academy. From 1798 on he

lived and worked mainly at Dresden, and from 1806 painted regularly in oils, earlier works having been executed in sepia. Experiences important in the development of his painting were his travels in the mountainous regions of the Riesengebirge and Harzgebirge, 1810–11, and the character of his native Greifswald, which he revisited at intervals. Paintings inspired by the Baltic and its ships alternated with visions of melancholy mountain scenery and Gothic ruin. His work in both aspects has been interpreted as a series of allegories on life and death and Christian thought.

Strangely moving without allegorical explanation, the paintings of ships and sea contribute to the esteem in which he is now held as the greatest German painter of the Romantic era. Outstanding examples are 'Mist', 1807 (Kunsthistorisches Museum, Neue Galerie, Vienna) with its ghostly ship, 'Monk by the Sea', 1809 (Schloss Charlottenburg, Berlin), 'Ship on the High Seas in Full Sail', 1815 (Städtische Kunstsammlungen Karl-Marx-Stadt); 'View of a Harbour' (Sans-Souci, Potsdam) 1816, 'Moonrise over the Sea', 1820–6 (Nationalgalerie, West Berlin), 'The Stages of Life', 1835 (Museum der Bildenden Künste, Leipzig), 'Evening on the Baltic Sea', 1831 (Gemäldegalerie Neue Meister, Dresden), and 'Sea Piece by Moonlight', 1830–5 (Leipzig). His works are almost exclusively to be found in German, Austrian, and Scandinavian collections, especially the Gemäldegalerie Dresden and Nationalgalerie, West Berlin.

GERICAULT, Théodore (1791–1824)
A single masterpiece justifies the inclusion of Géricault among the painters of the sea – his 'The Raft of The *Medusa*', 1819 (Louvre, Paris). The subject was one of those tragic events that held a special fascination for the Romantic mind. The frigate *La Méduse* with a complement of 400 crew, soldiers, and passengers went aground on the way to Senegal. As it could not be refloated the ship was abandoned, a raft being made which the ship's boats were intended to tow. The cables were cut and the raft left to drift with 140 persons on board it. After twelve days of horror the brig *Argus* picked up fifteen dying or demented survivors. Géricault depicted the moment when the brig was sighted on the horizon. The painting made a deep impression on Delacroix and was an incitation to produce his own version of marine calamity: 'The Shipwreck of Don Juan', 1841. Both works may be compared with such pictorial dramas by Turner as 'The Wreck of a Transport Ship' and 'Fire at Sea' as expressions of the Romantic sense of violence and calamity.

The 'Raft' was a key point in Géricault's career, following his paintings of Napoleonic cuirassiers in action and a prelude to his journey to England in 1820 which inaugurated a new phase of his work. A reason for his going was the sending of the picture across the Channel at the invitation of an exhibition promoter. Its tour in England met with considerable financial success.

GOYEN, Jan Van (1596–1656)
An outstanding and prolific painter of landscape and seascapes, Van Goyen was born at Leyden and first worked under minor painters in that city. When about 19 he travelled to France, and on his return was a pupil of Esaias van de Velde at Haarlem for a year, his early work being much influenced

by that master. He married at Leyden in 1618 (in 1649 his daughter became the wife of Jan Steen). After some years he settled at The Hague. His subjects included rural genre, villages with figures in Esaias van de Velde's style, landscapes such as 'The Oak', 1634 (Hermitage, Leningrad), panoramic views, e.g. 'View of Rhenen' (Metropolitan Museum of Art, New York), beach scenes, e.g. 'Egmond aan Zee', 1646 (Louvre, Paris), winter scenes, e.g. 'On the Ice near Dordrecht', 1644 (Boymans-Beuningen Museum, Rotterdam), and many river scenes with town or landscape background, the distinction between riverscape and seascape often becoming slight. In the last-named series of works he may be compared with Salomon van Ruysdael. He is credited with some hundred seascapes between the 1630s and the time of his death at The Hague in 1656. 'Evening Calm', 1656 (Frankfurt, Städtelische Institut) and 'Fishermen laying a Net' 1638 (National Gallery, London) are fine examples. In early works he made extensive use of colour, but later, like Van Ruysdael, he developed an art of tone, many paintings being carried out in a warm almost monochrome. He also made a large number of drawings and something of the draughtsman's linear quality is discernible in his oil-paintings.

GRIMSHAW, Atkinson (1836–93)
A Victorian painter of landscapes, harbour scenes, and shipping, Grimshaw as an artist has been something of a modern rediscovery. Born at Leeds, a policeman's son, he worked in early life as a clerk on the Great Northern Railway. He was encouraged by his wife, whom he married in 1858, to paint in his spare time and was successful enough to turn professional painter by 1861. In the following decade his moonlight landscapes became popular. Harbour scenes on the Yorkshire coast, at Whitby and Scarborough, in particular, provided him with many subjects, the masts and rigging of fishing-boats being painted with delicate minuteness. He built a houes at Scarborough in 1876 and, though financial difficulties caused him to give it up, he continued to paint shipping scenes there and at Whitby. His pictures of docksides at Liverpool, Hull, and London, e.g. his 'Salthouse Docks, Liverpool', exhibited at the Royal Academy in 1885, combined town and marine interest. The Leeds Art Gallery bought his 'Nightfall on the Thames' for as little as £15 as an example of his treatment of moonlight. Eighty paintings were shown in a memorial exhibition at Leeds in 1897.

GUARDI, Francesco (1712–93)
Though Guardi like Canaletto painted the architecture of Venice, he was to a much greater extent interested in the marine atmosphere of the Venetian lagoon which he rendered with a sparkling touch that gave an almost Impressionist effect of light and colour. Born in Venice, the son of a decorative painter Domenico Guardi, he first worked with his brother Giovanni Antonio, on figure compositions but later as a view-painter. He was at one time considered as no more than a follower of Canaletto, though in fact entirely distinct in style. His vivacity of execution may have owed something to his brother-in-law, Tiepolo, but more to Alessandro Magnasco (1677–1749). Magnasco's vigorous fancy is reflected not only in Guardi's 'Caprices', paintings of fanciful lagoon islands but in such a tempestuous marine as 'The Storm' (Castello Sforzesco, Milan).

HIROSHIGE (Ando Tokitaro), (1797–1858)
An outstanding artist of the popular Ukiyo-e school, Hiroshige worked direct from nature in journeys through Japan and along its coasts and the colour-prints he derived from his sketches resolved his views of land and water into such impressive designs as that of monumental waves off the seashore at Izu, 1852. His colour and simplified design were an influence on the West, especially on the nocturnes of Whistler.

HODGES, William (1744–97)
Born in London, Hodges has a place in marine history as the appointed draughtsman to Captain Cook on his second voyage round the world. His training as pupil and studio assistant to Richard Wilson stood him in good stead then and later. His drawings were published with the narrative of the expedition. After his three years' absence he was commissioned by the Admiralty to paint scenes in the Pacific at Tahiti and other islands. He travelled extensively in later life. From 1780 to 1784 he was in India where he had the patronage of Warren Hastings. He was elected R.A. in 1787. In 1790 he toured the continent of Europe. Two of the foreign views he subsequently exhibited represented a seaport in time of peace and the same place devastated by war. They are now in the Soane Museum, London. The ill-advised investment of the proceeds of his Indian sojourn in a bank at Dartmouth, which failed two years after, hastened his death in 1797.

HOKUSAI (Katsuhika), (1760–1849)
Japanese painter and graphic artist, born in Tokyo. He studied with a well-known painter and designer of colour-prints, Shunshō, and later became a prolific illustrator and printmaker, as such especially admired in the Western World. He produced a pictorial encyclopeadia of Japanese life and a celebrated series of views of Fujiyama. The coasts of Japan incited such a classic rendering of wave form as his 'Hollow of the Deep-Sea Wave off Kanagawa', and other coastal scenes.

HOLMAN, Francis (active 1760–90)
Of Cornish origin, Holman was one of the eighteenth-century Thames-side marine painters who lived and worked in Shadwell and Wapping. He exhibited paintings of shipping and sea battles at the Free Society of Artists and the Royal Academy, 1760–84. Paintings of East Indiamen and of the shipbuilding yards at Blackwall and Deptford were subjects in which he specialized. There are examples of both in the National Maritime Museum, Greenwich. A shore scene (D. M. McDonald Collection), 1778, with many ships at anchor and foreground groups of naval officers and fisherfolk, gives a vivid representation of his *milieu*.

HOMER, Winslow (1836–1910)
The illustrative talents of Winslow Homer were directed to many themes: the American Civil War, farm life, and landscapes that trace the course of his travels in Maine, Canada, the West Indies, and Florida, but paintings of the sea and life at sea form a distinct and considerable section of his work.

His visit to England in 1881–2 and his stay at Tynemouth turned him to a dramatic rendering of the hazards and arduousness of the sailor's life. Examples are in various American collections: 'The Life Line' (Philadelphia Museum of Art), 1882–3, 'The Herring Net' (Art Institute of Chicago), 1884–5, 'The Lookout – All's Well' (Museum of Fine Arts, Boston), 1895–6, and 'The Gulf Stream' (Metropolitan Museum of Art, New York). Many studies for these and other works are in the Cooper-Hewitt Collection, Smithsonian Institution, Washington, D.C.

HUGGINS, William John (1781–1845)

A prolific painter of ship portraits and battle scenes, Huggins began life as a sailor in the East India Company's service. He first exhibited at the Royal Academy in 1817 and eventually became Marine Painter to William IV. Among the royal commissions was a series of three phases of the Battle of Trafalgar, now divided between St James's Palace and Kensington Palace. There are sixteen of his paintings in the National Maritime Museum, mainly of individual ships. A number of his works were engraved by Edward Duncan.

ISRAELS, Jozef (1824–1911)

A marine painter to the extent that he painted scenes of the life of a fishing community, Jozef Israels, born at Groningen, studied art at Amsterdam and in Paris. His early works were historical in subject, romantically treated, but from 1855 when he stayed at the village of Zandvoort on the North Sea coast he turned to the contemporary reality of Dutch peasant and seafaring life. He settled at The Hague and contributed to exhibitions in Paris and London as well as in Holland. A painting inspired by his stay at Zandvoort, 'The Shipwrecked' showing fishermen carrying a drowned man made a sensation when exhibited in London in 1862. The picture was presented to the National Gallery, London in 1910.

JONGKIND, Johan Barthold (1819–91)

Born at Latrop, near Rotterdam, Jongkind was second only to Van Gogh as the outstandingly original Dutch painter of the nineteenth century, his principal works including seascapes, coastal views, and river and canal scenes that forecast the direction of Impressionism in style. He left Holland early, thence going first to Düsseldorf and afterwards to Paris. By 1846 he was more or less settled in France, though he visited Holland at intervals. A favoured region for painting was Le Havre and the coastal neighbourhood, and it was there in the 1860s that he met Boudin and Monet. Both were stimulated by the luminous open-air effect he achieved in both oils and water-colours. Though his work was praised by the De Goncourt brothers, he lived in poverty and in later years was a victim of mental illness. He died at Côte St André (Isère) in 1891.

KUNIYOSHI, Utagawa (1797–1861)

One of the principal artists of the Ukiyo-e school, Kuniyoshi was a prolific and vigorous artist, with a feeling for complex design that appears in his colour-print of fishing-boats offshore, a striking example from his thirty-six views of Fuji. The dynamic quality of his work is more emphatic in his conceptions of legendary scenes involving sea journeys in which the stormy movement of waves contributed to the dramatic character of the chosen subject. The calming of storm by a saintly character (recalling the Western legend of St Nicolas) is a characteristic example.

LACROIX, Charles François de (Lacroix de Marseille) (c.1700–82)

Born at Marseilles, Lacroix was a pupil of Claude-Joseph Vernet. He went to Rome in 1754. From 1776 he exhibited his paintings in Paris until his death in 1782, in Berlin. He was a close follower of Vernet in Mediterranean coast scenes, their works being sometimes indistinguishable. Imaginary ports with fanciful architecture, a variety of shipping and foreground figures strongly defined against a morning or evening light were characteristic elements of his compositions. Into his paintings of rocky coasts reminiscent of southern Italy, he often introduced dancing figures of theatrical elegance. A number of his works were reproduced in engravings by Le Veau and Le Mire.

LOUTHERBOURG, Philip James de (1740–1812)

A painter of battles on land and sea and of stormy seascapes and coasts among a varied repertoire of subjects, De Loutherbourg was of Polish origin. He worked in Germany and Paris, where he became a member of the Académie in 1768 and came to London in 1771. Garrick appointed him his chief designer of scenery at Drury Lane. He exhibited at the Royal Academy between 1772 and 1812. The example of Vernet inspired his pictures of storm and shipwreck. His ingenious invention, the *Eidophusikon*, a series of views illuminated to give changing effects of light that delighted Gainsborough, included a shipwreck. He had many commissions for battle scenes which he gave the dramatic character exemplified in his 'Battle of the Nile' and 'The Battle of Camperdown', both in the Tate Gallery, London. His painting of Lord Howe's 'Victory of June 1, 1794' was sent by command of George IV, together with Turner's picture of Trafalgar to Greenwich Hospital, and with his imagined 'Defeat of the Spanish Armada' is now in the Maritime Museum, Greenwich. De Loutherbourg died at Chiswick in 1812.

LOWRY, L. S. (b.1887)

Best known as a painter of industrial landscape and town, L. S. Lowry has also produced a number of seapieces unique in their interpretation of a melancholy mood and in imparting a sense of loneliness. Study at the Schools of Art of Manchester and Salford, 1908–09, was followed by many years of effort that met with little reward, and his one-man exhibition at the Lefevre Gallery in London in 1939 first brought him into prominence as the painter of scurrying crowds in factory land. The seapieces were a development of the 1960s, first comprising seaside pictures with promenading holiday-makers, but later eliminating detail with impressive result.

LUNY, Thomas (1759–1837)

Born in London, Thomas Luny was the pupil of the Thames-side marine painter, Francis Holman. He served in the navy until 1810, but both before and after that date was a prolific and

accomplished painter of ships and sea. His dated works extend over nearly sixty years from 1778 to 1835. After leaving the service, he retired to Teignmouth but remained busy with commissions from retired naval officers. In this later period he painted a number of views of Teignmouth harbour. Luny's work included pictures of naval engagements, an example is his contribution to the old Foundling Hospital collection, 'Action off the Coast of France, 13 May 1779'. Others are in the National Maritime Museum, Greenwich, including his version of the subject much favoured by marine painters – 'The Battle of the Nile', 1798. The Museum also contains many of his paintings of individual ships.

MANET, Edouard (1832–83)
The great French exponent of the contemporary in theme and style seems far removed from the painters of naval battle, but he claims eminent place among them by virtue of a single work, 'The Battle of the Kearsage and the Alabama', 1864 (John G. Johnson Collection, Philadelphia). It has all the appearance of an eye-witness impression of the encounter off Cherbourg. Manet was at that time a centre of controversy, the 'Déjeuner sur l'Herbe' having appeared the year before in the Salon des Refusés. The sensation caused by his 'Olympia' was to follow in 1865. The battle picture is a reminder of his seafaring start in life and ships and harbour scenes, though limited in number, are distinguished in his work, e.g. 'Moonlight on the Port of Boulogne', 1869, and the masterpiece of 1871, 'The Port of Bordeaux' (Bührle Collection, Zurich), painted when he joined his family in the south-west after the Franco-Prussian war.

MARQUET, Albert (1875–1947)
Ports, harbours, and ships figured prominently in the work of the French painter, Albert Marquet. Born at Bordeaux, he went with his mother to live in Paris when a boy. He studied art at the Ecole des Beaux-Arts and in the *atelier* of Gustave Moreau, where Matisse and Rouault were among his friends. In the first decade of the twentieth century he was counted with them as one of the *Fauves* who concentrated on brilliance of colour, but his work was subsequently to show a reaction towards quiet tones and an economy of means that gave the essence of a scene with absolute simplicity. He also showed an insatiable appetite for travel, and liking for the seaports of the countries he visited. Hamburg and Naples in 1909, Tangiers in 1913, the Netherlands 1914, Marseilles 1916, Norway 1925, Egypt and Algeria 1928–9, Romania and USSR 1933–4, Venice 1936, Stockholm 1938, Algeria again 1940–45 provided him with a variety of sea-fronts and craft. Liners, tramp-steamers, motorboats, and sailing boats all played their part in compositions that set them in placid waters convincingly suggested with a minimum of detail. Marquet died in Paris in 1947. His work is represented in the Musée d'Art Moderne, Paris and numerous modern collections.

MEARS, George (active late nineteenth century)
The nineteenth-century steamship had a careful portraitist in George Mears, who worked at Brighton and is described as 'marine painter to the L.B. and S.C. [London Brighton and South Coast] Railway'. A subject of which he painted several versions was Queen Victoria's principal yacht *Victoria and Albert II*, the two pictures of this subject in the National Maritime Museum are presumably by him though listed as by P. Mears.

MESDAG, Hendrik Willem (1831–1915)
A pioneer of open-air painting in Holland as applied to marine subjects, Mesdag, born at Groningen, was the son of a banker and for many years worked in his father's banking business. He was married when 25 to Sientye van Houten, also an artist, but was 35 before he felt able to devote himself entirely to art. A visit to the coast decided him to become a painter of the sea. He settled at The Hague in 1869, and thence made regular visits to Scheveningen, where he set himself to capture the moods of water and sky, as well as to portray the picturesque incident of flat-bottomed surf-boats. A picture of Scheveningen beach brought him notice at the Paris Salon in 1870 and launched him on a prolific and successful career in which he gained European celebrity. He and his wife were patrons of their Dutch contemporaries, the Maris brothers, Israels, Mauve, and others, and collectors of the French Barbizon School, works by Millet, Théodore Rousseau, Daubigny, and others that had influenced the Dutch. They presented their collection, now forming the Mesdag Museum at The Hague, to the State in 1903. Mesdag is noted for a panoramic view of Scheveningen finished in 1881 and also preserved at The Hague, and is represented in the Rijksmuseum, Amsterdam.

MONAMY, Peter (c.1670–1749)
Born of a Channel Islands family, Monamy was sent to England as a boy and apprenticed to a house-painter with premises on Old London Bridge. He profited by the study of the marine paintings of Van de Velde the Younger to practise independently as a painter of seapieces in the Dutch manner, thus having a part of some importance in the continuance of this tradition in England. Characteristic works were paintings of men-of-war and merchant ships becalmed. Van de Velde's 'The Cannon Shot' (Rijksmuseum, Amsterdam) provided a type of composition that Monamy frequently made use of in paintings of ships firing a salute or a signal gun at sundown, the National Maritime Museum, Greenwich containing several examples. His oil-painting 'Old East India Wharf, London Bridge' is in the Victoria & Albert Museum, London. Monamy was one of the contributors to the decorative paintings for Vauxhall Gardens. He died at Westminster.

MONET, Claude (1840–1926)
Born in Paris, Monet lived as a boy at Le Havre, where his father took a shop, c.1845. He there gained a liking for coast and sea as subject that he retained throughout his career as a painter. Meeting the painter of sea and ships, Eugène Boudin in 1858, first encouraged Monet to attempt similar themes and work in the open air. To Boudin's influence was added that of the Dutch artist Jongkind, whom he also met on the Normandy coast. After study in Paris and early efforts in landscape in the forest of Fontainebleau, he went through a

long period of struggle in poverty before attaining celebrity as a leader in the Impressionist movement. The 'Impression' from which the name derived was his oil-sketch of the harbour at Le Havre at sunrise exhibited in 1874.

Though Monet's subjects became very varied, with the overriding aim of translating open-air light into colour, he produced many paintings of sea and coast from the 1860s to the 1880s. His first two pictures in the Salon of 1864 were seascapes. He was working on others in the company of Boudin at Trouville in 1870 just before the outbreak of the Franco-Prussian war. After his sojourn in London 1870-1 he returned to France via Holland and Belgium painting harbour views at Zaandam and Antwerp. In Normandy at intervals he painted at Sainte-Adresse, near Le Havre (subject of an early masterpiece in the Metropolitan Museum of Art, New York), Honfleur, Fécamp, Pourville, and Etretat (subject of memorable works). An impressive series of seascapes resulted from his visit to the barren island of Belle Isle off the coast of Brittany, 1886. Though his later years were much occupied with the great series of cathedrals, poplars, haystacks, and water-lilies, he painted also on the Mediterranean coast at Antibes and elsewhere with a heightened employment of colour. He died in 1926 at his country house at Giverny. His work figures in most of the important collections of modern art.

MOORE, Henry (1831–95)
Born at York, Henry Moore was the ninth son of the portrait-painter William Moore and the brother of Albert Moore. He had tuition from his father and for a short while (1853) at the Royal Academy Schools. He shared the enthusiasm at that time general among young artists for Pre-Raphaelitism, but about 1858 devoted himself almost exclusively to seascape, becoming a painter of the sea and its moods, rather than of ships, like John Brett. He exhibited at the Royal Academy, British Institution, and Old Water Colour Society of which he became a member in 1880. He was elected R.A. in 1893 and was the recipient of medals of honour at the Paris Exhibition in 1889 and the Antwerp Exhibition of 1894. He died at Margate. His 'Catspaws off the Land' was a Chantrey Purchase for the Tate Gallery in 1885.

MOORE, John (1820–1902)
An East Anglian painter born at Woodbridge, Moore worked mainly at Ipswich from 1850 onwards, painting landscapes, beach scenes, and seascapes off the East Coast. The seascapes showed a capacity for conveying an authentic open-air freshness of atmosphere that places him in the Constable tradition.

NEER, Aert (Aernout) van der (1603/4–77)
Born at Amsterdam, Van der Neer seems to have come to painting at a comparatively late period of life when he returned to Amsterdam after time spent in some household position with a family at Gorkum. He is best known for the winter and skating scenes in which his work may be related to that of Avercamp, and more especially for the pictures of moonlight over water admired and emulated in England by Turner and Crome. An unpractical character is suggested by his failure as an inn-keeper at Amsterdam where he became

bankrupt in 1662. A poetic sensibility in compensation appears in early river scenes owing something to Esaias van de Velde ('Duck Hunting' Städtelisches Institut, Frankfurt), and even a Hercules Seghers-like mountain panorama ('Mountain Lake', Institut Néerlandais, Paris), but especially in the nocturnes, variously represented in the world's public galleries. 'A Landscape with a River at Evening' with its distant focus in a seagoing vessel (National Gallery, London) is a striking example. His son Eglon Hendrik van der Neer (c.1634–1703) was a portrait- and genre-painter but Johannes (1637/8–65) seems to have followed his father.

NIBBS, Richard Henry (1816–93)
A marine painter who worked at Brighton, Nibbs exhibited at the Royal Academy between 1841 and 1889. He painted in both oil and water-colour (two water-colour seascapes being in the Victoria & Albert Museum, London) and produced numerous views of the Sussex coast, though French and Dutch subjects are also recorded.

NOOMS, Reynier (Zeeman) (c.1623–6?)
Dutch marine painter, whose work marks the revival of or renewed emphasis on the battle scenes that were a distinctive product of the earlier years of the seventeenth century. A major example was the large and elaborate 'Battle of Leghorn' (Rijksmuseum, Amsterdam), commemorating a Dutch victory in 1653, a *trompe l'œil* paper at the corner of the canvas giving a description of the action. A version of the 'Battle of Leghorn' is in the National Maritime Museum, Greenwich.

POCOCK, Nicholas (1740–1821)
Painter of naval engagements and other marine subjects, Pocock was born at Bristol. As a young man he captained merchant vessels owned by the Bristol merchant Richard Champion and taught himself to draw, illustrating in his journals scenes met with in the course of the voyages which took him to America and the West Indies. He settled in London as a painter in 1789, being encouraged to combine landscape- and ship-painting by Sir Joshua Reynolds. He exhibited at the Royal Academy, 1782–1815, at the British Institution, 1806–10, and was a founder-member of the Old Water Colour Society. Two scenes of naval battle by him are in the Royal Collection, Buckingham Palace, and numerous others are in the National Maritime Museum, Greenwich.

PORCELLIS, Jan (1584–1632)
Born in Ghent, Jan Porcellis was an early master of tonal marine painting in seventeenth-century Netherlands. He was one of the first to depart from the paintings of battle and ceremonial occasions that occupied others such as his contemporary, Hendrick Vroom after the long drawn-out struggle with Spain, and to seek for fresh and truthful effects of light and atmosphere in paintings where ships had a secondary role. His free outlook and lightness and delicacy of method had a considerable influence on younger artists such as Simon Vlieger. He worked in both the northern and southern cities, Antwerp as well as Amsterdam, but mainly in Holland, and died at Leiden. Works by him are in the museums of

Berlin, Munich, Madrid, Stockholm, and Vienna. His son Julius Porcellis painted in his father's manner and also made copies of his pictures.

RALEIGH, Charles S. (1831–1925)
Born in Gloucester, England, Raleigh ran away to sea at the age of 10. He is said to have served in the U.S. Navy during the Mexican War and was later in the merchant service until 1870, when he settled at Bourne, Massachusetts. From 1877 he devoted himself to painting ships and marine subjects.

RAVILIOUS, Eric (1903–42)
Born in London, Ravilious showed early promise as water-colourist, engraver, and graphic designer. He was instructor in design at the Royal College of Art, 1929–38. In 1940 he became an Official War Artist attached to the Royal Marines and made vivid water-colours of ships and naval action. His 'Midnight Sun' painted from a destroyer Norway-bound is in the Tate Gallery. The Imperial War Museum, among other works, has two water-colours of 'H.M.S. *Ark Royal* in action'. He was killed when on a reconnaissance flight off Iceland in 1942.

REDMORE, Henry (1820–87)
A marine painter who was born and died at Hull, Henry Red-more specialized in views of the Humber estuary and the Yorkshire coast. Little is known of his career and training though he may have learned from the example of William Anderson when at Hull and of the local master John Ward. Two of his works were hung in the Royal Academy of 1868, but though his output seems to have been large, he long received little notice outside the East Riding of York-shire. A conscientious observer and painstaking in detail, he gave a picturesque record of shipping in the Humber between 1854 and 1887. Whitby, Scarborough, and Flamborough Head provided distinctive backgrounds for views painted from the sea. He also painted some pictures on the Devon and Cornish coast. His son, Edward King Redmore (living in 1939), fol-lowed him in subject but was more elementary in style.

ROSA, Salvator (1615–73)
An artist of varied gifts, born at Arenella near Naples, Sal-vator Rosa painted battle scenes, legendary subjects, and dramatic landscapes and marines, inspired by the rocky coasts in the region of Naples, a good example being his 'Harbour' (Pitti Gallery, Florence). His later influence was complementary to that of Claude, suggesting in contrast a romantic wildness of setting, and can be traced in the pictures of stormy coasts by Marco Ricci, Vernet, and De Louther-bourg.

RUISDAEL, Jacob van (c.1628–82)
One of the greatest European landscape painters, Jacob van Ruisdael was born at Haarlem, the son of the art dealer who was also a landscape painter, Isaack van Ruisdael (originally De Gooyer), who may have given him his first lessons in art. He probably studied under his uncle Salomon van Ruysdael. He became a member of the Haarlem Guild in 1648 and trav-elled in the eastern parts of Holland and west Germany, 1650–

5, and after 1650 developed an increasing depth and force of light and shade. That in middle age he took a degree in medi-cine at Caen, France (1676) and was registered as a physician at Amsterdam seems a comment on the need for alternative employment that many seventeenth-century Dutch artists experienced. His was a broad, unspecialized outlook. The sand dunes and stretches of water in the undrained Haarlem lakes provided him with many subjects, but his prolific output was very varied, including panoramic views of the Nether-landish plain, forest scenes, winter scenes, imagined Scandi-navian landscapes inspired by the fir-crowned heights and water-falls of Van Everdingen, and numerous seascapes. The seapieces, have no reference to men-of-war or naval events, and like Ruisdael's other works, convey the artist's own mood, achieving that effect of grandeur that Constable estimated as going 'far beyond van de Velde'. The great influence, however, of Ruisdael on European art was less in his marine paintings than in the pictures of woodlands that had inspira-tion to give both to painters in England and to the Barbizon School in France in which his grave intensity of feeling found a romantic echo. Ruisdael, who was buried at Haarlem in 1682, left many minor Dutch followers and imitators. He is repre-sented in most of the great picture collections of the world.

RUYSDAEL, Salomon van (1600/03–70)
Born at Naarden in Gooiland, Van Ruysdael (originally De Gooyer from the region of his birth) was a prolific and influ-ential painter of landscape and sea, who worked at Haarlem. In his early pictures the thread of naturalism could be traced back to Porcellis, but more nearly linked with Van Ruysdael are Esaias van de Velde and Peter de Molijn, and there is some parallel with Jan van Goyen in his subdued tones and restraint of colour. After the mid-1640s his style was de-veloped to advantage in pictures of wide stretches of river and inland sea with sailing-boats and water ruffled in a deco-rative pattern of ripples. He was the uncle of the great Jacob van Ruisdael (who always spelt the name with the letter 'i'). Salomon's son, Jacob Salomonsz van Ruysdael (1629/30–70) painted wooded landscapes after the manner of his cousin. Salomon's work is widely distributed in the world's public galleries.

SAILMAKER, Isaac (1633–1721)
An early representative of marine painting in England whose identity has not been clearly established, Sailmaker was possibly of Netherlandish origin. The works attributed to him stemmed from the Dutch in style, though rougher in character than that of his contemporary, Willem van de Velde the Younger. Of the pictures by, or attributed to him, in the National Maritime Museum, Greenwich, 'H.M.S. *Britannia*', 1682 is regarded as the most likely example of what may be considered his style.

SALM, Adriaan (c.1663–1720)
Born at Delfshaven near Rotterdam, Salm became a painter of seascapes and river scenes in a form of grisaille – a method of working on a prepared white ground with pen and indian ink or sepia. A number of these monochrome works depict-ing whaling scenes and the Dutch herring fishery are in the

National Maritime Museum, Greenwich. Salm's son, Roelof, used the same medium in the production of similar subjects.

SALMON, Robert (1775–1844)

Born at Whitehaven, Cumberland, the marine painter Salmon was baptized Robert Salomon, but altered his name about the time (1828) he left Britain for the United States. He exhibited a picture of Whitehaven Harbour in the Royal Academy of 1802. He was busily occupied with scenes of shipping at Liverpool, 1806 to 1811 and at Greenock, 1811 to 1822. Paintings of various ports and harbours indicate a wide range of travel, though central to his work were his views of the Mersey and its ships. He took with him to America 118 paintings produced between 1826 and 1828. These, sold at auction in Boston, financed his journey and settlement. He remained active as a marine painter in Boston until 1840. The MS. copy of his record of pictures painted, especially referring to those done at Boston, is now in the Boston Public Library. His 'The Wharves of Boston' is in the Boston State House. He is represented in the Peabody Museum, Massachusetts, and the National Maritime Museum, Greenwich.

SCOTT, Samuel (1701/3–72)

Painter of sea and London Thames views, Samuel Scott was born in London at a date approximately fixed by the date of his death, October 12, 1772, and the statement of his pupil, William Marlow that he was then 70. Details of his early life and training are lacking, but he married early and had a daughter, Anne Sophia, baptized at St Paul's, Covent Garden, in 1724. He began to produce seapieces in that decade, the earliest-known example being signed and dated 1726. He held an appointment as Accomptant in the Stamp Office at £100 per annum, 1727–55, but had time enough to paint the while, naval engagements and ships at sea being his main subjects until the 1740s. In 1732 he accompanied his friend William Hogarth with three other companions in the voyage along the Medway that produced the humorous, illustrated *Five Days Peregrination*. He collaborated also at that time with George Lambert in six paintings of the East India Company's settlements, Scott's function being to add the ships to the views of trading centres and harbours (India Office Library). In the 1740s he turned to the views of ships·in the Thames with London background that are among his most original works, ranging from Greenwich to Twickenham. In the 1750s he had as apprentices in his studio in Covent Garden the landscape painter, William Marlow and the animal painter, Sawrey Gilpin. By 1762 he could be described by Horace Walpole as 'one whose works will charm in every age' and as excelling Van de Velde in variety. He moved to Twickenham in 1765, later to Ludlow, and from 1769 to 1772 lived at Bath where he died. He is represented in the National Maritime Museum, Greenwich, the Tate Gallery, London, the Guildhall Art Gallery, London, the Whitworth Art Gallery, Manchester, and at Bristol and Plymouth.

SERRES, Dominic (1722–93)

Born in the ancient capital of Gascony, Auch, Dominic Serres rebelled as a youth against his parents' wish that he should enter the Church, and ran away to sea. He eventually became master of a vessel trading with the West Indies, but this was taken as a prize by an English frigate about 1758 during the war with France. He was brought to London, where he settled and married. He turned for a living to marine painting in which he had some help to begin with from Charles Brooking, and exhibited seapieces with success from 1761, at the Incorporated Society of Artists, the Free Society, and the Royal Academy of which he was a founder-member in 1768. He became Librarian to the Academy in 1792 and was also marine painter to George III. He is well represented in the National Maritime Museum by paintings of men-of-war and naval actions. A series depicting the royal visit to the fleet at Portsmouth in 1773 is in the Royal Collection at Buckingham Palace.

SERRES, John Thomas (1759–1825)

Born in London, John Thomas Serres, son of Dominic Serres, was also a marine painter and succeeded his father as marine painter to the King. From 1780 he exhibited seapieces and topographical works at the Royal Academy and British Institution and was for a time drawing-master at Chelsea Naval School. He visited France and Italy in 1790 and in 1793 was appointed draughtsman to the Admiralty, one of his duties being to make sketches of enemy ports during the war with Revolutionary France. In 1791 he married the amateur landscape painter Olivia Wilmot with unfortunate results. Her claims to be 'Princess Olive of Cumberland' and daughter of Henry, Duke of Cumberland involved Serres in ruinous legal expenses. They were separated in 1804, but troubles still pursued him and he was imprisoned for debt, dying 'within the Rules of the King's Bench' in 1825. Paintings and drawings by him are in the Royal Collection at Buckingham Place, Kensington Palace, and Windsor Castle; also in the National Maritime Museum, and the Victoria & Albert Museum.

SEURAT, Georges (1859–91)

Born in Paris, Seurat studied art at the Ecole des Beaux-Arts, 1878–9, and after a year of military service he began to paint in Paris and its suburbs. Like his friend Signac, whom he met in 1884 he became much influenced by the scientific studies of the nature and properties of colour by Chevreul and others. He and Signac evolved the 'divisionist' method which Seurat used in his great picture of the Parisian scene 'Un Dimanche à la Grande-Jatte', shown in the eighth Impressionist exhibition of 1886. The method of applying the colours of the spectrum in separate touches proved well suited for paintings of the sea and coastal atmosphere which from 1885 onwards formed a distinct and beautiful phase of his work. They alternated with his compositions of urban life. His first seascapes were painted at Grandcamp in Normandy in 1885. 'Le Bec du Hoc' (Tate Gallery, London), with its empty sea and strangely shaped headland being a striking example. In the summer of 1886 he found inspiration in Honfleur, lighthouse and the masts and funnels of ships adding geometric design to the vibration of atmosphere. In 1888 he painted at Port-en-Bessin near Grandcamp, 'Sunday at Port-en-Bessin' with its boats and flutter of flags (Kröller-Müller Museum, Otterlo) being memorable. A final triumph was the series of paintings resulting from his visit to Gravelines, between Calais and

Dunkerque, in 1890, in which the coastal calm of summer as in the 'Harbour at Gravelines' (John Herron Art Institute, Indianapolis) becomes the most exquisite of visual sensations. His paintings at Gravelines left the way open for such more abstract works as those of Nicolas de Staël.

SIGNAC, Paul (1863–1935)
Born in Paris, Signac showed an early attachment to both painting and sailing. At the age of 19 he left the Lycée to paint on the *quais* and by then also owned the first of many boats. Later he worked with Seurat at the latter's favoured painting grounds, Port-en-Bessin on the coast and the Parisian suburb, Asnières. He was associated with Seurat in devising the colour technique variously known as divisionism, pointillism, and Neo-Impressionism. Both he and Seurat were invited by Camille Pissarro to exhibit in the eighth and last Impressionist exhibition, by that time their experiments in colour causing much debate. Signac about this time was nearer to Seurat than he later became, e.g. 'Phare à Pontrieux' (Kröller-Müller Museum, Otterlo) combining geometrical perspective with atmospheric effect. Later in his oil-paintings of various ports he developed a more assertive system of colour. They resulted from travels by sea that took him to the South of France, Venice, Holland, and Istanbul. From 1892 he added water-colour to his repertoire and between 1920 and 1930 executed water-colours in 200 French ports. To a greater extent than with other French artists the sea was an essential part of Signac's experience. In the course of the years he owned and sailed in eight boats, the last in the 1930s being a small drifter, *La Ville de Honolulu*. In the last year of his life his journeys extended from Dieppe to Marseilles and Corsica. Signac was exceptional in combining his love of sailing with a theory of art. His book outlining a history of modern colour, *D'Eugène Delacroix au Neo-Impressionisme* was published in 1899. In 1935 he wrote an article for the Encyclopaedie Française on 'Subject and Composition in Painting'. The sea was essentially his subject.

SOMERSCALES, Thomas Jacques (1842–1927)
Born at Hull, the son of a shipmaster, Somerscales was for seven years a schoolmaster in the Navy and later at Valparaiso, where he painted and gave art lessons. He returned to England in 1892 and exhibited seapieces at the Royal Academy. His 'Off Valparaiso', exhibited in 1899, was a Chantrey Bequest Purchase in that year for the Tate Gallery and has remained in reproduction perhaps the most popular of all marine paintings. He painted a large picture of the Congress Buildings, Santiago in 1910. 'Man Overboard' is in the Walker Art Gallery, Liverpool, and 'After the Gale' in the Ferens Gallery, Hull.

SORGH, Hendrick Martensz (1611–70)
Besides being a painter of peasant genre, market scenes, portraits, and still-lifes, Sorgh was a painter of seascapes in which he adopted the grey tonality of Jan Porcellis. A fine 'Storm on the Maas' by him (1668) is in the Rijksmuseum, Amsterdam, and an 'English "snow" off the Dutch coast', 1670, in the National Maritime Museum, Greenwich. The artist was born and died at Rotterdam.

STANFIELD, Clarkson (1793–1867)
Born at Sunderland, the son of an Irish writer, Clarkson was apprenticed as a boy to an heraldic painter at Edinburgh, but went to sea in a merchant ship at the age of 15. After four years he was pressed into the Navy, but a fall from a ship's rigging led to his discharge in 1818. He became a scene-painter at Drury Lane and for other theatres and meanwhile began to paint small oils. After early exhibits at the Royal Academy in the 1820s he gave up scene-painting to devote himself to easel pictures. A constant exhibitor at the Academy, he was elected an R.A. in 1835. He travelled extensively between 1829 and 1839, his contributions to the exhibitions including views of sea and coast of England, Holland, Normandy, Italy, and the Mediterranean and Adriatic. He excelled in estuary views with heaving waters, of which his 'Tilbury Fort, Wind against Tide' (Port of London Authority) is an example. He was capable also of imaginative effect as in the 'Abandoned' of 1856. As well as seapieces, he produced landscapes and paintings of episodes in the Napoleonic campaigns. Ruskin admired him as one 'acquainted with every wave and hue of the deep sea'. His scene-painting skill delighted his friends Charles Dickens and Wilkie Collins, and Stanfield's backdrop for Collins's melodrama *The Frozen Deep* was long preserved at Gadshill. Works by Stanfield are in the Tate Gallery, Victoria & Albert Museum, National Maritime Museum, and other public galleries. His son, George Clarkson Stanfield (1828–78) also became a painter. He studied under his father and at the Royal Academy and contributed seascapes and topographical views to the Academy and the British Institution between 1844 and 1876.

STANNARD, Joseph (1797–1830)
A painter of the Norwich School and pupil of Robert Ladbroke, Stannard studied the works of the Dutch masters in Holland, 1821–2 and subsequently specialized in marine and coastal subjects, favourite themes being the shore at Yarmouth and Yarmouth Roads. He exhibited at Norwich 1816–30, and also for some years in London.

STEER, Philip Wilson (1860–1942)
Boats and beach scenes were recurrent themes in the work of Wilson Steer, a series of paintings conveying the marine atmosphere of Walberswick on the Suffolk coast being a beautiful product of the 1880s. Fresh from study in Paris at the Ecole des Beaux-Arts, 1883–4, Steer first stayed at Walberswick in 1884, on his return from Paris and thereafter at intervals until 1890. A method of using colour somewhat akin to that of French Neo-Impressionism gave a sparkling clarity to the Suffolk paintings and others of similar style, e.g. 'Boulogne Sands' (Tate Gallery, London), 1888–91.

Another remarkable series was that of yachts first inspired by a visit to Cowes in 1892, from the 'Procession of Yachts' (Tate Gallery, London), 1892–3 to 'The White Yacht' of 1912. Harbours, estuaries, and inlets with their stranded craft were later the subject of many paintings and water-colours. Harwich, Bosham, Alum Bay, Southampton Water, Shoreham, Whitstable, Greenhithe, Walmer, were in turn fruitful sources. In 1918 as an official war commission he produced the studies of Dover Harbour now in the Imperial War Museum. In

many of his later water-colour brush-drawings he achieved a vividly simplified rendering of ships and sea.

STEVENS, Alfred Emile Leopold (1823–1906)

Though the Belgian painter, Alfred Stevens may still be best known by his portrayal of fashionable women of the Second Empire period, he produced many marine paintings in his later years that place him in sympathetic relation with Boudin and the Impressionists in the study of effects of light on sky and sea. Born in Brussels, Stevens after early success in Belgium settled in Paris and was the friend of Manet and his circle in the 1860s. He gained wealth and celebrity through his pictures of the fashionable world exhibited in the Paris Salon but in 1880 was advised by his doctor to take sea air. In consequence he began regular journeys to the Normandy coast, during which he painted his many small and atmospheric seascapes. Stevens is represented in numerous public galleries in Europe and the United States but a considerable number of his sea pictures are still in private collections.

STORCK, Abraham (c.1635–1704+)

Born in Amsterdam, Abraham Jansz Sturckenburg, who later simplified his name to Storck worked in Amsterdam and painted seascapes and Dutch harbour scenes in a style derived from Willem van de Velde the Younger and his follower, Bakhuizen. He also painted fanciful Italian seaports with imagined architecture after the manner of Jan Beerstraaten (1622–66) and Jan Baptist Weenix (1621–c.1660). Probably the brother of Storck was Jacobus Storck (1641–87), marine and landscape painter who painted harbour scenes of crowded detail.

SWAINE, Francis (d.1783)

One of the English followers of Willem van de Velde the Younger's style, Swaine was an accomplished painter of naval actions in the Seven Years War and general views of shipping. He exhibited marine paintings in London from 1762 to the year of his death.

THOMPSON, Thomas (1776–1852)

Born in England, Thompson went to the United States, c.1813 and worked as a portrait and marine painter, exhibiting many pictures from 1831 to 1852 at the National Academy of Design of which he became an Associate in 1835. Though his paintings are now rare, the catalogues of the exhibitions to which he contributed indicate his specialization in marine subjects; in particular views of New York Harbour, the Hudson River, and the New England coast. He died in New York. Hard outline and clear colour gave something of a primitive attraction to his work, an example being 'Scene from the Battery with a portrait of the *Franklin*' (Metropolitan Museum of Art, New York – on deposit at the Museum of the City of New York).

TURNER, Joseph Mallord William (1775–1851)

Turner's lifelong attachment to the sea was already well in evidence by the time he was 21. The early sketchbooks of South Wales and the Isle of Wight, 1795, and near Brighton, 1796, show the beginning of an interest, manifested in the first oil-painting of the period – the moonlight scene 'Fishermen at Sea' (Tate Gallery, London), 1796. He set himself to rival Van de Velde in 'Calais Pier' (National Gallery, London), 1803, its rough sea a prelude to evermore dramatic pictures of storm, e.g. 'Wreck of a Transport Ship', c.1810 (Gulbenkian Foundation, Lisbon). The calm and glowing atmosphere of 'Dordrecht: The Dort Packet-Boat from Rotterdam becalmed', 1818 (Mellon Collection, Washington, D.C.) shows his admiring study of Cuyp, as 'Dido building Carthage', 1815 (National Gallery, London) shows his effort to rival Claude, though his own imagination was without precedent in the richness of 'Ulysses deriding Polyphemus', 1829 (National Gallery, London). Later oils range from the calm of 'The Evening Star', 1830–5 (National Gallery, London) and the 'Old Chain Pier, Brighton', 1830–1 (Tate Gallery, London) to the intense marine dramas of 'Fire at Sea', c.1835 (Tate Gallery, London), 'The Slave Ship', 1840 (Museum of Fine Arts, Boston), and 'Peace: Burial at Sea', 1842 (Tate Gallery, London). 'The Fighting "Téméraire"', 1839 (National Gallery, London) was at one time considered his last major work, but he had still to produce the tremendous spectacle of the 'Snowstorm at Sea', 1842 (Tate Gallery, London) and such chromatic abstractions of seascape as the 'Yachts approaching the Coast', 1842 (Tate Gallery, London). Turner's understanding of both ships and sea had expression in many water-colours, ranging from the freshness and topographical delicacy of the water-colours for *The Ports of England* in the 1820s to the experimental notations of sea and sky, c.1840–5.

VAN DE VELDE, Adriaen (1636–72)

Born at Amsterdam, Adriaen van de Velde was a younger brother of the marine master, Willem van de Velde the Younger and a pupil of Jan Wynants. His work was wide in range, including animals, landscape, genre, and portraiture and nearest to the marine category in the beach scenes painted at Scheveningen. These were remarkable for their sense of space, the unerring placing of small figures and objects at varying distances from the eye heightening the effect of reality. 'The Beach at Scheveningen' (Kassel Museum), 1658, is a masterpiece of this kind. Van de Velde sometimes painted incidental figures and animals in works by other artists, including those of Jacob van Ruisdael and Philips Koninck.

VAN DE VELDE, WILLEM the Younger (1633–1707)

Willem van de Velde the Younger, born at Leiden, was the son of the sea-painter of the same name, Willem van de Velde the Elder (1611–93) also born at Leiden. It is likely he would have received some art instruction from his father, though the latter mainly confined himself to pen-drawings of ships and naval actions with an effect of grisaille. Willem the Younger is recorded to have been the pupil of the sea- and landscape-painter, Simon de Vlieger, and his early work followed de Vlieger in the treatment of tone and light and a preference for scenes of evening calm with sailing-boats at anchor reflected in placid waters. He worked at Amsterdam until 1671, but finding conditions unpropitious to painting, both he and his father crossed over to England in 1672 and in 1674 were taken into the service of Charles II. Their appointment at £100 a year each as retainer proposed a collaboration, with the Elder

'taking and making of Draughts of seafights' and the son 'putting the said draughts into Colours' – though the division of labour may not have precluded the father from painting. They remained in the royal service with short excursions to Holland, working in the studio provided at the Queen's House, Greenwich until 1691 and afterwards in Westminster. The records of seafights and ship portraiture increasingly occupied Willem the Younger in the English period generally with an increased use of colour and stress on factual detail, representations of storm, however, providing some outlet for the freer exercise of his abilities. He had little influence in Holland, but many imitators and followers in England. More than 600 paintings have been ascribed to him, and he is well represented in the Rijksmuseum, Amsterdam, the National Gallery, London, and the National Maritime Museum, Greenwich.

VAN GOGH, Vincent (1853–90)

Original in his approach to every subject, including portraiture, landscape, and still-life, Van Gogh is associated with the sea by reason of his short visit to the fishing village on the Mediterranean coast, Saintes-Maries-de-la-Mer in July 1888. The famous 'Boats on a Beach' (Amsterdam, National Museum, Vincent van Gogh Collection) was a product of this stay in which his appreciation of the traditional lines of the Mediterranean fishing-boat is marked. But the sea itself produced such speculations on colour and movement as appear in his seascape produced at this time in which as always he was animated by the search for truth of impression rather than any reliance on convention.

VERBEECK, Cornelis (c.1590–1635)

Born at Haarlem, Cornelis Verbeeck was one of the early Dutch marine painters, whose work was parallel with that of A. van Eertvelt, H. C. Vroom, and C. van Wieringen. He painted ships with careful attention to detail, giving full heraldic value to their flags. The sea was treated in a less precise fashion not always in clear relation to the ship, though he aimed at realism of effect. He is typically represented in the Frans Hals Museum, Haarlem and the Museum of Maritime History, Amsterdam. His son was the genre painter, Pieter Cornelisz Veerbeck.

VERNET, Claude-Joseph (1714–89)

Born at Avignon, Vernet was introduced to painting at an early age by his father, Antoine, a painter of decoration for carriages and sedan chairs. The interest of aristocratic patrons enabled him to go to Rome in 1734, and the spectacle of Marseilles and its shipping visited en route determined him to become a marine painter. He worked in the studio of an obscure marine painter at Rome, Bernadino Fergioni, and was influenced by the example of Salvator Rosa, quickly gaining a reputation for his landscapes and seapieces. Remaining in Rome until 1753, he married Cecilia Virginia Parker, daughter of an Irish naval commander of some celebrity and received many English landscape painters in his studio, among them Richard Wilson. At the prompting of Mme de Pompadour and her brother, the Marquis de Marigny, Louis XV commissioned Vernet to paint the principal ports of France,

twenty-four in number. This undertaking occupied him, on and off, from 1753 to 1762, though only seventeen were completed. Thirteen are now preserved in the Musée de la Marine, Paris. From 1762 to his death he worked in Paris. The growing Romantic feeling of the time created a demand for paintings of storm and shipwreck, seaports by moonlight or at sunset, and other marine subjects, which he executed with great virtuosity. Many characteristic examples are in the Louvre, Musée d'Avignon, and in England in the Dulwich College Gallery and Wallace Collection. Vernet's son Carle was a painter of sporting subjects and his grandson Horace of battle scenes.

VERSCHUIER, Lieve (c.1630–86)

Born at Rotterdam, Verschuier, said to have been the pupil of S. de Vlieger was a painter of naval actions, ceremonial occasions, and peaceful views of the Meuse at Rotterdam (e.g. in the Rijksmuseum, Amsterdam), often showing a somewhat mechanical convention for rippling water. Unusual in his work are oil sketches in warm tones poetically rendering morning and evening (Boymans-Beuningen Museum, Rotterdam). His conception of the Fire of London, 1666, with groups being taken off in boats is in the Museum of Fine Arts, Budapest.

VLIEGER, Simon de (c.1606–53)

Born at Rotterdam, Simon Jacobsz de Vlieger was an inspiring force in the development of Dutch landscape and marine painting, leading to the achievements of his pupils, Jan van de Cappelle, Hendrick Dubbels, and Willem van de Velde the Younger. He first worked at Rotterdam where he was married in 1627, in 1634 became a member of the Guild of Luke at Delft and subsequently lived at Amsterdam. In 1650 he settled at Weesp, some ten miles from Amsterdam, where he died in 1653. His work included landscape, animal and figure subjects, representations of beaches, dunes, and forests, but his principal paintings were seapieces as wonderfully spacious as the 'Beach near Scheveningen', 1633 (National Maritime Museum, Greenwich) and other works in which a grey tonality and sense of space were beautifully combined. He was a key figure in an aesthetic tradition that stemmed from Jan Porcellis.

VROOM, Hendrik Cornelisz (1566–1640)

Born in Haarlem, Vroom founded a marine tradition in Dutch painting based in style on Flemish example and in subject reflecting events in the struggle for independence from Spain and the progress of Dutch expansion overseas. He travelled extensively as a young man, visiting Rome and other cities in Italy before settling at Haarlem about 1590. In middle age he began to concentrate on sea battles, maritime occasions of ceremony, and other pictures in which ships are portrayed in beautifully precise detail. The vigour of his battle scenes is exemplified in 'The Battle of Gibraltar', commemorating a Dutch victory over the Spanish in 1607 (Rijksmuseum, Amsterdam); overseas adventure is summed up in 'The East Indies Merchantmen setting out' and 'The Return from Brazil of Paulus van Caerden' (also in the Rijksmuseum). His style has some parallel in the work of A. van Antum and A. van Eertvelt.

WADSWORTH, Edward (1889–1949)

Born at Cleckheaton, Wadsworth first studied engineering in Munich, but took up painting on his return to England and was at the Slade School, 1910–12. Until 1914 he exibited with the Vorticists led by Wyndham Lewis. He was an intelligence officer in the R.N.V.R. in the Eastern Mediterranean until 1917 when he was invalided home. He was later employed on dazzle camouflage work at various English ports. His interest in marine subjects declared itself in the 1920s in paintings of Marseilles and other ports and his line engravings of 'The Sailing Ships and Barges of the Western Mediterranean and Adriatic Seas' published in book form in 1926. Later he produced many still-lifes with marine motifs. He contributed to the decoration of R.M.S. *Queen Mary* in 1935 and was elected an A.R.A. in 1943.

WALLIS, Alfred (1855–1942)

An outstanding example of the 'primitive' marine painter, Alfred Wallis was born at Davenport. He had no formal education and went to sea at the age of 9 as cabin boy on one of the ships that fished off Newfoundland. About 1880 he settled as an inshore fisherman at Mousehole and Newlyn. In 1890 he gave up fishing and set up as a marine scrap-merchant at St Ives. He was able to retire in 1912. After the death of his wife in 1922 he began to paint – as he put it, 'for company'. Using any material that came to hand he put down his memories of windjammers, steamers, and fishing-boats, much admired in 1928 by the visiting professional artists, Ben Nicolson and Christopher Wood. He continued to paint until his last years in the workhouse at Penzance, where he died in 1942. Examples of his naïvely vivid work are in the Tate Gallery.

WARD, John (1798–1849)

The leading artist of the local school of marine painting that developed at Hull in the first half of the nineteenth century, John Ward was born at Hull, the son of a master mariner. He was apprenticed to a house- and ship-painter and continued in this occupation while gaining much local repute for his pictures. He formed his style on the work of William Anderson, seen at Hull, and began to exhibit in 1827. A visit to the Arctic regions produced excellent whaling pictures, but except for a painting tour of the south coast, he concentrated mainly on views of the Humber and its shipping. Many of his pictures were engraved and lithographed, and he published books of plates of naval and mercantile vessels. Other house- and ship-painters formed the 'school'; Robert Willoughby (1768–1843), Thomas Binks (1799–1852), William Griffin (active early-nineteenth century), and William Settle (1821–97) – Ward's cousin and pupil. Works by all these artists are in the Hull Museums.

WHISTLER, James Abbott McNeill (1834–1903)

The sea was a subject that recurs throughout the course of Whistler's art. His first major seascape was 'The Coast of Brittany' (Wadsworth Atheneum, Hartford, Connecticut), painted on his visit to Brittany in 1861. It was exhibited at the Royal Academy in 1862 under the title 'Alone with the Tide', a title he later rejected as too suggestive of a story. In 1863 he painted 'The Blue Wave, Biarritz' (Hillstead Museum, Farmington, Connecticut). He joined Courbet at Trouville in 1865, a time when Daubigny and Monet were also painting there. In 1866 he made his sudden voyage to South America, spending most of the time at Valparaiso where he produced some half-dozen seascapes – among them the 'Crepuscule in Flesh Colour and Green' (Tate Gallery, London) that already foreshadowed his Thames nocturnes. A nocturne 'The Solent' appears to give the title of a ship he travelled in on this journey unconnected with the approach to Southampton.

The 1870s were the years of the Thames nocturnes and the great portraits, a phase unfortunately interrupted by the libel action against Ruskin in 1878, Whistler's subsequent bankruptcy and visits abroad to produce pastels and etchings. After his return from Venice in 1880 he returned to the seascape style of the early sixties, producing at intervals shore scenes and studies of waves on small panels about the size of a cigar box lid, some in England others on the French coast, e.g. 'Coast Scene: Bathers' (Art Institute of Chicago), possibly painted in Dieppe in 1885, and 'Bathing Posts, Brittany' (University of Glasgow), probably painted in 1893.

WHITCOMBE, Thomas (c.1760–1824)

A prolific painter of ship-portraits and naval actions, Thomas Whitcombe exhibited fifty-six paintings at the Royal Academy from 1783 until 1824. Over fifty of his works were reproduced in aquatint engravings. There are numerous pictures by him in the National Maritime Museum, Greenwich, mainly of individual ships, but also records of naval actions including the Battle of the Nile and the Bombardment of Algiers.

WIERINGEN, Cornelis Claesz, van (c.1580–1633)

Born at Haarlem, Van Wieringen was the pupil of H. C. Vroom and one of the founders of Dutch marine painting. In the fashion typical of this early period he painted warships in careful detail, battle scenes, and records of voyages and ceremonial occasions, sea and sky being only a background of comparative unimportance. His 'The Spanish Armada off the English Coast' is in the Rijksmuseum, Amsterdam; other works are at Haarlem, Madrid, and Greenwich. Likeness of initials has sometimes confused his work with that of Claes Claesz Wou (c.1592–1665), a painter of similar subjects and style.

WILKINSON, Norman (1878–1970)

A specialist in painting ships and naval actions, Norman Wilkinson was an official war artist in the wars of 1914–18 and 1939–45. He is credited with the invention of the naval camouflage used in the First World War. He is represented in the Imperial War Museum and National Maritime Museum, Greenwich, to which he presented a comprehensive series of pictures illustrating the war at sea, 1939–45.

WILLAERTS, Adam (1577–1664)

Born at Antwerp, Willaerts combined Flemish and Dutch characteristics in paintings of sea battles, harbours and rocky bays, and wild scenes of shipwreck. His later work included beach scenes with picturesque setting and figures of fisher-

men in the Bruegel style. He died at Utrecht. His son, Abraham Willaerts (1603–69) marine and portrait-painter produced pictures of sea and shore in a style close to that of his father, the monogram A.W. sometimes making for confusion between them.

WITTE, Emanuel de (1617–92)
A Dutch master of varied themes, church and domestic interiors, market and genre scenes, De Witte painted some views of harbours, one outstanding work being the 'Harbour at Sunset' (Rijksmuseum, Amsterdam), showing exceptional resource and subtlety in composition.

WOOD, Christopher (1901–30)
Various influences affected the painting of Christopher Wood, not least that of the 'primitive' ex-fisherman painter, Alfred Wallis, whom he and Ben Nicholson 'discovered' in 1928 at St Ives. In the short period following, before his untimely death, Wood painted fishing-boats in harbour at the Breton village of Tréboul in a delightful adaptation of the naïve style.

WYLLIE, William Lionel (1851–1931)
Painter, etcher, and a devotee of Turner, Wyllie lived and worked near Rochester on the Medway and from 1907 at Portsmouth, producing both contemporary and historical marine pictures. He became an R.A. in 1907. He is represented in the Tate Gallery, London, National Maritime Museum, Greenwich, and the Victory Museum, Portsmouth.

ZEELANDER, Pieter de (active mid-seventeenth century)
Dutch marine painter, active at Haarlem, for a time Zeelander worked at Rome where he was nicknamed 'the pirate'. His paintings were characteristic of the tonal grey school.

Bibliography

Books and catalogues of general reference include: *Ships and Seamanship in the Ancient World*, Lionel Casson, 1971; *Old Sea Paintings*, E. Keble Chatterton, 1928; *Sea and River Painters of the Netherlands in the Seventeenth Century*, Admiral Sir Lionel Preston, 1937; *Dutch Landscape Painting of the Seventeenth Century*, Wolfgang Stechow, 1966; *The Netherlandish Painters of the Seventeenth Century*, Walter Bernt, 1970; *Dutch Seascapes and River Scenes of the Seventeenth Century* (Dordrecht Museum), 1964; *Shock of Recognition: The landscape of English Romanticism and the Dutch Seventeenth Century school* (Arts Council, London), 1971; *An Introduction to British Marine Painting*, Oliver Warner, 1948; *Early Marine Paintings* (Ferens Art Gallery, Kingston-upon-Hull), 1951; *Dictionary of British Marine Artists*, Arnold Wilson, 1970; *The Floating World. Japanese popular prints 1700–1900* (Victoria & Albert Museum), 1973; *American Naive Painting* (Arts Council, London), 1968.

Biographies and individual studies include: *Eugène Boudin, sa vie et son œuvre*, Gustave Cahen, 1900; *Charles Brooking*, Colin Sorenson (Paul Mellon Foundation for British Art), 1966; *Canaletto*, W. G. Constable, 1932; *Claude Lorrain*, Marcel Rothlisberger, 1962; *John Constable*, C. R. Leslie (ed. Mayne), 1951; *The Constable Collection, Victoria & Albert Museum*, catalogue by Graham Reynolds, 1973; *J. S. Cotman*, S. D. Kitson, 1937; *John Crome*, Derek and Timothy Clifford, 1958; *Raoul Dufy* (Arts Council and Association Française d'Action Artistique), 1954; *Caspar David Friedrich* (Arts Council), 1972; *Jan van Goyen*, H. van de Waal, 1941; *Atkinson Grimshaw* (Ferrers Gallery, London), 1970; *Francesco Guardi*, G. Simonson, 1904; *Monet and his world*, Raymond Cogniat, 1966; *Claude Monet* (Arts Council, London), 1957; *Salvator Rosa*, B. Cattaneo, 1929; *Jacob van Ruisdael*, J. Rosenberg, 1928; *Salomon van Ruysdael*, W. Stechow, 1938; *Samuel Scott* (Guildhall Art Gallery, London), 1972; *Wilson Steer* (Arts Council, London), 1972; *J. M. W. Turner*, A. J. Finberg, 2nd ed., 1961; *J. M. W. Turner*, Sir John Rothenstein and Martin Butlin, 1964; *Turner* (Royal Academy), 1975; *Turner Drawings and Watercolours* (British Museum), 1975; *Van de Velde Drawings*, M. S. Robinson, 1958; reference also to the van de Veldes in C. Hofstede de Groot (Catalogue raisonné of Dutch painters, VII, 1923) and Walpole Society volumes XVIII and XXVI; *Les Vernet*, A. Dayot, 1898; *Alfred Wallis* (Arts Council, London), 1968; *Whistler Landscapes and Seascapes*, D. Holden, 1969.

Index

264